THE HOMESTEADERS

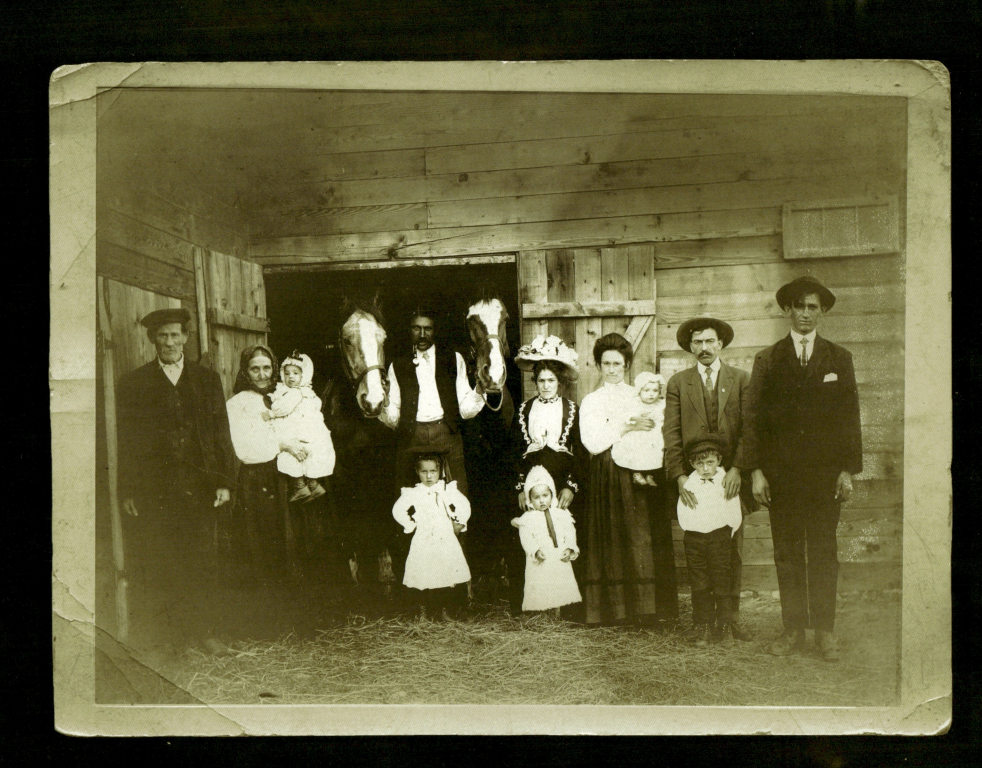

The
HOMESTEADERS

SANDRA ROLLINGS-MAGNUSSON

Foreword by Nadine Charabin, Provincial Archives of Saskatchewan

© 2018 Sandra Rollings-Magnusson

All rights reserved. No part of this work covered by the copyrights hereon may be reproduced or used in any form or by any means—graphic, electronic, or mechanical—without the prior written permission of the publisher. Any request for photocopying, recording, taping or placement in information storage and retrieval systems of any sort shall be directed in writing to Access Copyright.

Printed and bound in Canada at Marquis. The text of this book is printed on 100% post-consumer recycled paper with earth-friendly vegetable-based inks.

COVER AND TEXT DESIGN: Duncan Campbell, University of Regina Press

COPY EDITOR: Kirsten Craven

PROOFREADER: Kristine Douaud

COVER ART: Settlers out for a picnic at Notre Dame d'Auvergne, Saskatchewan, in 1905. PAS R-A19713-1

FRONTISPIECE: Three generations of Croatian settlers at Kenaston, Saskatchewan, in 1910. Note the pride they had in their two horses (centre of photo). To many homesteaders, owning horses signalled that they were doing very well financially. Library and Archives Canada, c-089701

Library and Archives Canada Cataloguing in Publication

Rollings-Magnusson, Sandra, 1960-, author
 The homesteaders / Sandra Rollings-Magnusson ; foreword by Nadine Charabin (Provincial Archives of Saskatchewan).

 Includes bibliographical references and index.
Issued in print and electronic formats.
ISBN 978-0-88977-515-2 (softcover).—ISBN 978-0-88977516-9 (PDF).—ISBN 978-0-88977-517-6 (HTML)

 1. Frontier and pioneer life--Saskatchewan. 2. Pioneers—Saskatchewan—Social life and customs. 3. Saskatchewan—History. I. Title.

FC3518.R65 2018 971.24 C2018-903215-4
C2018-903216-2

10 9 8 7 6 5 4 3 2

University of Regina Press, University of Regina
Regina, Saskatchewan, Canada, S4S 0A2
TEL: (306) 585-4758 FAX: (306) 585-4699
WEB: www.uofrpress.ca

We acknowledge the support of the Canada Council for the Arts for our publishing program. We acknowledge the financial support of the Government of Canada. / Nous reconnaissons l'appui financier du gouvernement du Canada. This publication was made possible with support from Creative Saskatchewan's Creative Industries Production Grant Program.

I liked Saskatchewan when I first came and I still think it's the best place in the world. As for the people…there are none better.

—ERNEST P. LINE, A SETTLER FROM MAZENOD, SASKATCHEWAN

Contents

Foreword—**ix**

Preface—**xiii**

Introduction—**1**

Chapter 1: A Land of Opportunity—9
The Right Kind of People—**10**
People Were Talking about the Prairies—**11**
To Try Something New—**16**
Seasick and Homesick—**18**
Through the Wilderness—**22**
There Were No Roads to Follow—**28**

Chapter 2: Getting Settled—35
Hewed Logs with a Thatched Roof—**36**
Snakes in the Bed—**40**
Made by Hand—**44**
A Lot of Hard Work—**46**
Mother Was Killed—**47**

Chapter 3: Working the Fields—51
Into the Furrow—**56**
To Haul Grain to Market—**61**
Less Neighbour Trouble—**64**
I Have Experienced Them All—**64**

Chapter 4: Feeding the Family—73
Wild Fruit and the Valleys Near—**82**
We Made Well with Rabbits—**87**
Mother Used to Melt Snow for the Cows—**92**

Chapter 5: Health and Illness—97
We Lost a Boy of Nine and a Girl of Two—**100**
Any Neighbour Would Go and Help—**103**
They Sent for the Doctor—**104**
Purify the Blood, Entirely Remove Flatulence—**106**
Dressed in His Best Sunday Clothes—**109**

Chapter 6: The One-Room Schoolhouse—113
One Year in the Wild West Was As Much As They Could Stand—**117**
Those Who Had No Water, Spit on the Slate—**119**

Chapter 7: Fun and Festivities—129
Father Would Read Aloud to Us—**131**
Singing the Old Folk Songs and Hymns—**134**
A Man and His Dog Are Never Lonely—**135**
All Atremble When I Saw a Woman—**137**
A Lot of People Frowned on Card Playing—**140**
In the Kitchen, Bedroom, Anywhere You Could Move—**141**
All Out for an Enjoyable Time—**144**
Occasionally, a Travelling Minister Would Come—**147**
The Rule of Etiquette...Had to Be Thrown Overboard—**151**
Mincemeat, Puddings, and Pies—**155**

Chapter 8: Laying a Good Foundation—163

Author's Note—**166**

Endnotes—**167**

Bibliography—**171**

Pioneer Questionnaire Participants—**173**

Foreword

I have worked as an archivist at the Provincial Archives of Saskatchewan (PAS) for over twenty-five years, and I have come to learn that people in this province love to hear and share stories about Saskatchewan's homesteading era. The telling and retelling of old familiar tales seems to bring comfort and a sense of connection with a common past. How fortunate it is, then, that Sandra Rollings-Magnusson has discovered some of the archives' richest resources related to Saskatchewan's settlement period, and has brought together a wealth of archival images and first-hand reminiscences to illuminate the experiences of hundreds of the province's pioneers.

Sandra has been known to spend entire summers at the Provincial Archives of Saskatchewan in the past, and continues to be a perennial visitor. She has explored in depth some of the archives' most significant collections relating to the homestead period, including the Department of Interior Lands Branch pre-1930 homestead files, the expansive photograph collection, personal reminiscences, and, most recently, the Pioneer Questionnaires.

As Sandra explains in the introduction to this book, the Pioneer Questionnaires were developed and distributed by the Provincial Archives of Saskatchewan in the 1950s, after which they were answered and returned by early settlers of the province during the 1950s, 1960s, and 1970s. There were ten different questionnaires (plus a separate appeal for Christmas-related stories), each including dozens of questions intended to explore various aspects of the

> *I have experienced them all, with varying degrees of severity and damage in each case. We had lots of blizzards, and lots of drought, some hail even up to 100% damage and down to slight. Frost, wind and dust, more than you could shake a stick at. Cutworms, hoppers, skeeters, gophers, oodles and oodles, blast them!* —ALBERT ELDERTON, SETTLED IN 1909 AT KYLE, SASKATCHEWAN[1]

> *...a vivid, cohesive, and personalized storyline about the settlement of Saskatchewan...*

pioneers' experiences. The pioneers identified both the communities and the year in which they settled in Saskatchewan, dating back as early as 1873. Participants could decide which of the questionnaires they wanted to answer: some answered all or most of the questionnaires; others only answered those questionnaires that interested them. Participants eventually answered over 3,500 questionnaires, and Sandra has reviewed every questionnaire that was answered by pioneers who settled in the province between 1873 and 1914.

Sifting through the mountains of detail and the abundant individual stories that are found in the questionnaires, Sandra has woven together a vivid, cohesive, and personalized storyline about the settlement of Saskatchewan, focusing on the boom years of the homesteading era. She has taken the information she gleaned from the questionnaires and organized it into seven chapters that come together to tell the settlement story of Saskatchewan.

In "A Land of Opportunity," Sandra combines an overview of the key historical events and policy decisions related to immigration from the end of the nineteenth century—such as the implementation of the Dominion Lands Act in 1872 and the immigration policies of Clifford Sifton between 1896 and 1906—with the personal stories told in the Pioneer Questionnaires about individual immigrant experiences. In "Getting Settled," Sandra draws on information from the housing questionnaire to describe the many types of homes pioneers built in the early days of settlement. In "Working the Fields," the many challenges of life on a Saskatchewan homestead are illustrated through first-hand settler accounts. In "Feeding the Family," Sandra examines in detail the very first questionnaire that was circulated by the archives, entitled "Pioneer Diets," which posed questions about food and beverage supply and production. In "Health and Illness," the health questionnaire answered by pioneers highlights the challenges of staying healthy while facing trying conditions on the homestead. In "The One-Room Schoolhouse," answers found in the schools questionnaire describe the schoolhouse setting, the experience of getting to the schoolhouse by horse or by foot, the teachers' experiences, and the curriculum. In "Fun and Festivities," the social and recreational life of pioneers is examined, including hobbies such as reading, music, the enjoyment of pets, attending church, visiting with neighbours to chat or play cards, attending community events such as picnics or sports days, and participating in festivities such as weddings, chivarees (a social custom welcoming

x THE HOMESTEADERS

newlyweds), dances, Christmas concerts, and skating parties:

We were enthusiastic skaters and would have skating parties on sloughs when they froze in fall. It then became a custom at various times during the winter to congregate at one of the homes on the way to Grenfell and make up a load and drive into Grenfell to skate on the covered rink there. and these evenings were considered the last word in entertainment. At times the sleigh might upset but this only added to the merriment. I may say that these years represented the high point of community life in our district for all time and it was the younger generation that initiated it and carried it through.—THOMAS R. BROWNRIDGE, M.D., BORN IN 1891 IN BROADVIEW, SASKATCHEWAN

Although her scrutiny and analysis of the content found within the Pioneer Questionnaires utilizes an academic's training and perspective, the resulting book is entirely approachable, entertaining, and enjoyable to read. After surveying the questionnaires, Sandra has identified trends and patterns that underlay the story of settlement in Saskatchewan. At the same time, her storytelling allows the homesteaders' voices to sing out, to share their own personal tales of triumph and tragedy, of calamity and community, of fortitude and fear. The uniqueness and the variety of individual experiences lived by Saskatchewan's early settlers is amplified in this treatment.

All these things seemed to be taken in stride, as it were. Those who stayed accepted things and did all they could to eradicate the menaces to comfort and success. Some became discouraged and gave up, went back East or to other parts, but many stayed and made the best of things as we did.—EDITH STILBORNE, SETTLED IN 1883 AT PHEASANT FORKS, SASKATCHEWAN

For readers with a passion for the type of pioneer stories that have been shared in this publication and who would like to read the Saskatchewan Pioneer Questionnaires in more detail, the original questionnaires may be viewed at or obtained from the Provincial Archives of Saskatchewan.

—Nadine Charabin, Manager, Reference Services Unit, Provincial Archives of Saskatchewan, Saskatoon

FOREWORD

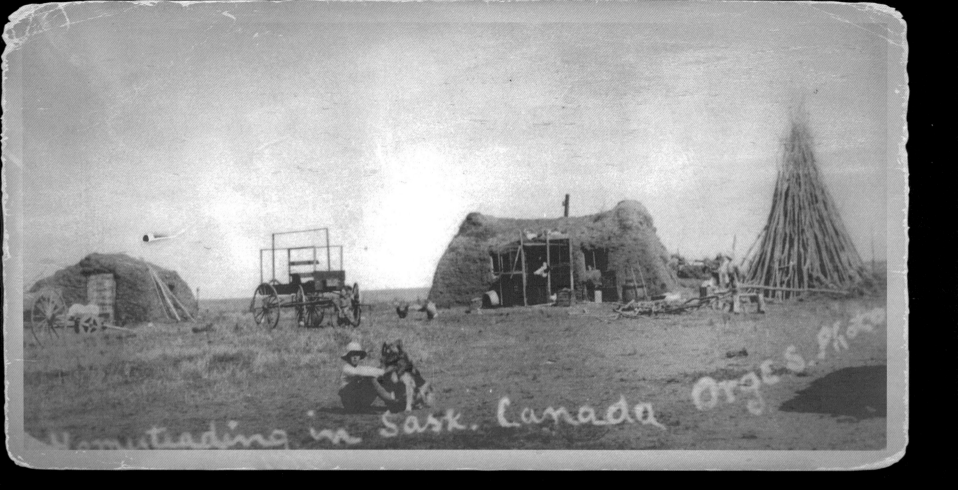

Preface

I was raised in the city of Regina, Saskatchewan; however, as a special treat I stayed with my grandparents on their mixed family farm every summer until I was fourteen years old. From the youngest age, I was playing with the farm cats and dogs in the yard and in the barn, or going with my grandmother to fetch the cows for milking from the pasture. As I grew up, I learned how to feed all of the animals and birds around the farm. Filling up buckets of chop to feed the cows, taking scraps out for the pigs, getting ground grain for the chickens and turkeys, and pumping water for all of the farm animals were daily tasks. I also collected eggs, learned how to work a cream separator, and I hand-churned pounds of butter. I helped out in the garden and dug up carrots and onions, cut cauliflower at the stem, gathered currents and raspberries (as well as the odd mushroom that would appear from time to time). I became so adept at shucking peas that I could shuck peas as fast as those who had done it for years! My grandparents also took me out into the fields where I helped to drive the tractor. I learned all about combining and stacking bales on the wagon.

In the farmhouse, my grandmother taught me how to make delicious meals from scratch and she often showed me how she knitted, crocheted, sewed clothes, and made patchwork quilts and hooked rugs. In the evenings, she and my grandfather would take me to visit the neighbours, where I made friends with farm kids my own age. When someone my grandparents knew got married, they would take me into town (after all of us got spruced up in our finest duds) and we would attend wedding dances. It was wonderful, as everyone, young and old, danced the night away to two-steps and reels. I often remember being lifted off my feet and swirled around on the dance floor.

OPPOSITE PAGE: The Louis Orge homestead near Herschel, Saskatchewan, in 1907 included a house and a shed, both made of sod. Given the flat treeless prairie in the background of the photograph, and the thin trunks and limbs of trees that were gathered (on the right), it is obvious that there were no suitable trees available for building a log home. It is also interesting to note that many settlers of German and English descent settled in the Herschel area and that this area was named after a famous English astronomer and mathematician, Sir John Herschel. PAS S-B7539.

Throughout all of those summer months, year after year, I learned all about farm life. I came to appreciate all aspects associated with the farm and the hard work involved. I experienced happy times with my grandparents, but I also saw the sadness that occurred when a favourite cow had to be sold at auction, a pig or chicken slaughtered, or when the farm dog had to be put down.

When I do my research and write about the lives of the homesteaders, I recall the happy and special moments on the family farm. I remember my grandparents, who have since passed away, and their stories of their parents who were original homesteaders on the prairies. Writing about farming brings back many fond memories for me.

As such, it was not a surprise that I ended up studying farming and homesteading in Saskatchewan while I pursued a master's degree in sociology at the University of Regina. In particular, for my thesis, I focused on the importance of women's work during the homesteading era and how they contributed to the success of the family farm through their work within the home (bearing and raising children and being responsible for domestic chores) and also helping their husbands in the fields during times of seeding and harvesting. In order to fully comprehend the lives of homesteaders, my advisor, Dr. Robert Stirling, introduced me to the archival material that was housed at the Provincial Archives of Saskatchewan office in Regina. I went in search of more information from the Saskatoon office on the University of Saskatchewan campus. While at the Saskatoon office, I met Nadine Charabin, who brought out a number of files relating to questionnaires that settlers had filled out in the 1950s. To my amazement, the questionnaires covered a remarkable amount of material relating to all aspects of the settlement period. From that moment on, I was captivated by the stories and anecdotes that were hidden within the pages of those questionnaires.

Since that time, I have continued my never-ending quest to fully understand the social, political, and economic life of those who lived during the settlement era. When I am not researching and learning about settlers, I am writing about them. I have written numerous articles relating to life on the western prairies using information from those questionnaires and I have written a book, based on my doctoral thesis, about children's labour on the Canadian prairies between 1867 and 1914. Eventually, the day came when I realized the information from those questionnaires could be compiled and made into a book for the general public. Over the past year, I have taken on this task and have thoroughly enjoyed writing up the experiences and adventures.

In addition to my appreciation of those settlers who documented their experiences, I also feel an obligation to bring their stories to light. Sometimes the stories describe hardship and starvation, while at other times they highlight the good times and the community

> *In addition to my appreciation of those settlers who documented their experiences, I also feel an obligation to bring their stories to light.*

spirit that prevailed. Either way, all of the settlers' recollections are important in understanding life on the prairies, particularly from the settler's point of view. As one research assistant said to me, "You have to give these people a voice. You have to write about them or they will be forgotten."

As such, I am honoured to have had the opportunity to work with this data. I would like to thank Nadine Charabin and all of the archival staff for all of their help over the years. Their wisdom, skill, and patience have benefitted my research and my academic career and I am most grateful for their assistance. I would also like to express my appreciation to the provincial archivist, Linda B. McIntyre, for allowing me to use the many archival photographs found throughout this book.[1] In addition, I would like to express my gratitude to those who have spent weeks or months working with me in the archives over the past years: Rita Hamoline, Stan Yu, and Nolan Martens. Their camaraderie, their ability to highlight and discuss interesting aspects of settler life, and their encouragement all helped to motivate me with my research endeavours. I would like to extend an additional thank you to Nolan Martens and Sharon Kaminski for their contributions to this book. Their personal family histories are interesting, compelling, and essential in identifying how important heritage is to Saskatchewanians.

I am also grateful for the optimism, enthusiasm, and industriousness of the University of Regina Press staff. There is a lot of work that goes into a manuscript in making it ready for publication and I appreciate all of the efforts of those involved. In particular, I would like to thank editors David McLennan, Donna Grant, Sean Prpick and Kelly Laycock, as well as designer Duncan Campbell and publisher Bruce Walsh. I would also like to thank my MacEwan University colleagues, as well as my best friend, Eileen Woo Tsui. Their friendship and support has been invaluable. As a final note, I would also like to thank my family, especially my mother, MaryEtta Rollings. She and I have spent many hours discussing farm life and family homesteading history, and she has made insightful comments on the various drafts of this book. I would also like to thank David Shiers and Christina Magnusson for their continuous encouragement.

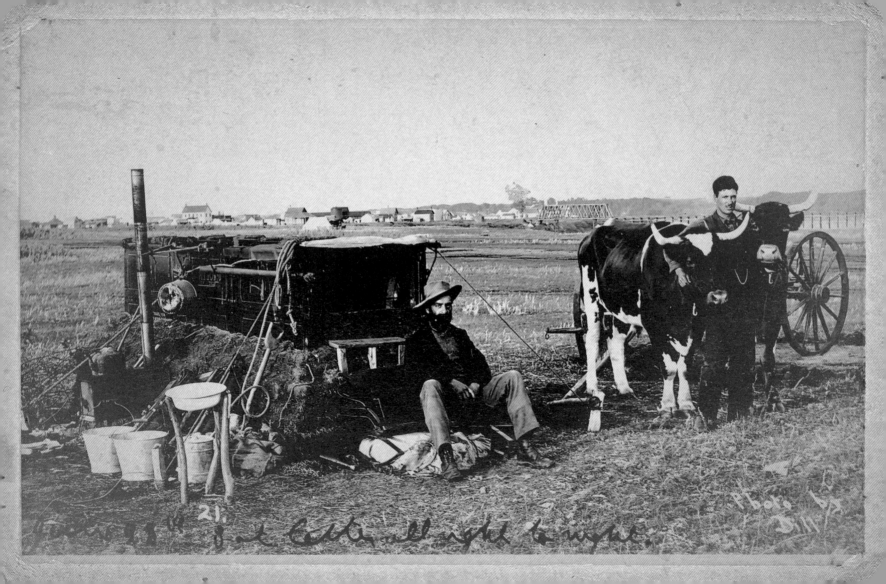

Introduction

Any mention of homesteading among Saskatchewanians brings forth immediate pride, followed by recollections of ancestors who had come to the province in the late 1800s or early 1900s.[1] With pleasure, they detail a vast array of stories, tales that have been passed down from generation to generation. Whether they are humorous anecdotes, accounts of impressive accomplishments, or more serious stories about ailments or injuries, the stories are held close to the hearts of Saskatchewanians as these pieces of information provide a snapshot into the lives of their ancestors and how they used to live.

However, as the Canadian public continues processing the harrowing testimony of the Truth and Reconciliation Commission given earlier in this decade, testimony that was buttressed by deepening scholarship, there is growing realization of the need to re-evaluate those good feelings about settling Saskatchewan. That's because we now know that the Indigenous populations in the West were dispossessed to make room for these homesteaders. As shown by scholar James Daschuk in his seminal *Clearing the Plains* and in other recent works, beginning in the late nineteenth century the federal government moved ruthlessly to isolate Indigenous people well away from prime settlement areas. These Indian reserves, as they came to be called, were often located on marginal, near-barren lands. Great suffering ensued. Disease, starvation, poverty and isolation remained common features of life on the reserve, as does a legacy of poor health and social and economic disadvantage that continues for many Indigenous people until this day.

Settlers from distant mother countries such as Russia, Germany, Poland, England, Norway, and Switzerland had little to say to say about Indigenous

OPPOSITE PAGE: A settler camp with a team of oxen in 1906. Note that their lodging is an overturned wagon and that Saskatoon, Saskatchewan, can be seen in the background. These settlers would have found it beneficial to be living fairly close to Saskatoon, given its amenities. By 1906, the city had a mercantile and hotel, a Mounted Police barracks, and a dozen homes, as well as a rail line that passed through it. PAS R-A2016.

people and their lives in the accounts collected for this book. With official encouragement from the Government of Canada, these settlers learned to ignore the past of their new homeland and instead focus on the present and the future. The colonial mythmaking machine, meanwhile, successfully spun the tale of the "Vanishing Indian" and the vast, empty grasslands just waiting for the bite of the farmer's plough.

So, the most you'll hear about Indigenous peoples from the settler voices collected here is the wonder they experienced in finding arrow heads and old stone tools in their furrows. Another talks about the fine recipe he collected for pemmican.

The evidence I've collected instead shows settlers were focused on the difficulties that were encountered as they left friends and family members behind and the hope of obtaining a better life in Canada in the province of Saskatchewan. Other stories highlight how ancestors escaped from political and religious purges, poverty, pollution, wars, economic recessions, and famines and how they saw potential in Canada, a country that promised democracy, equality, and property ownership. To many, the opportunity to own their own land and become a homesteader in a newly developed country was a dream come true. It was a country in which they hoped to prosper and one where they hoped their children would be able to succeed and live in relative comfort and security.

Along with these tales of optimism were stories of how ancestors were able to survive the odds of living on the open and barren prairie of Saskatchewan. Building their homes from the sod or trees that were growing on their land, digging wells, clearing and ploughing fields, coping with dangerous wildlife such as bears and wolves, dealing with biting insects like mosquitoes and flies, and trying to survive the extremes in temperature during the summer and winter months were all problems and difficulties that were remembered and told to the younger members of the family. In addition, stories relating to ancestors fighting vicious prairie fires, facing starvation during the winter when provisions ran low, and managing through gopher and rabbit infestations (with the resulting loss of gardens and crops) also became part of family folklore. Even the stories of ancestors being injured or killed, as well as those who had suffered from such illnesses as diphtheria, smallpox, German measles, or typhoid, were ones that had been passed down through the generations, as were the stories about the lack of medical care and medicines. The high level of anxiety caused by watching a family member pass away due to lack of medical help lingers in the family's history, and a sense of sorrow is still keenly felt generations later when such stories are recounted.

Homesteading stories also revolve around more light-hearted topics. Accounts of how babies were born at home and delivered by their fathers are common legends, as are stories of how newborns were placed in handmade wooden boxes with blankets close to the stove so they would stay warm during chilly evenings. Descriptions of little girls playing with dolls sewn by their mothers or little boys playing with toy guns made from a tree branch were stories that were recounted, as were tales of older children who snared rabbits, collected berries, played games with their brothers and sisters, went to school, and did chores at home, such as milking cows and feeding chickens or helping out with domestic tasks. Eating special treats, such as pieces of

chocolate or other candies bought from the local town merchant, were remembered given the rarity of the event, as were new clothes when they were purchased. Even good recipes were passed down to new generations, with relatives relating the stories of how their great-great-grandmothers were known far and wide for their cooking. Whether they were making soup out of chicken hearts and gizzards, cooking beef stews, frying fish, roasting rabbit, baking bread and biscuits, or making pies, cookies, and cakes, the reminiscences of those meals and desserts capture the interest of those generations who came afterward, each hoping, with the help of those recipes, to replicate the homesteading meals of the past.

Regardless of what type of story is told, the memories that have been passed down from generation to generation are important to current Saskatchewanians. It not only links them to the homesteading past of their ancestors but the transmission of this knowledge ensures a continuation of cultural heritage and provides a sense of belonging and a feeling of accomplishment at what their family had achieved during their early years in the province.

RESEARCH MATERIALS

As one can imagine from the stories mentioned above, the homesteading era in Saskatchewan was one filled with adventure and excitement, commitment and dedication, resoluteness and determination, happiness and enjoyment, and hardship and suffering. It is a tale of the time when the Canadian federal government offered any man and his family 160 acres of free land for only the cost of a $10 registration fee.[2] This great opportunity appealed to many people, and they migrated and immigrated by the hundreds of thousands to the province to settle their families and harvest their crops.[3]

In order to gain a deeper understanding of what life was like during the homesteading era in Saskatchewan, the Provincial Archives of Saskatchewan created a series of questionnaires in the 1950s. These questionnaires were distributed to those who had lived during the homesteading period in the province. Ten separate questionnaires, each including dozens of questions, were developed that covered such topics as pioneer experiences, farming experiences, health, diet, housing, education, religion, and recreation.[4] These questionnaires were sent to a variety of nursing homes, church groups, social clubs, and other locations, and responses were provided on a voluntary basis. Individuals used their own discretion as to which questionnaire they wished to complete based on their own recollections of the era and personal preference. In general, approximately two hundred to three hundred different people completed each of the questionnaires.

The information that was provided by these homesteading pioneers is unique in that many of their responses provided fascinating particulars and insights into prairie life. For example, as a reader, not only could I find out why these people moved away from family and friends in their home countries to homestead in Saskatchewan but I could also learn about their experiences along the way. Whether these pioneers were travelling by ship from

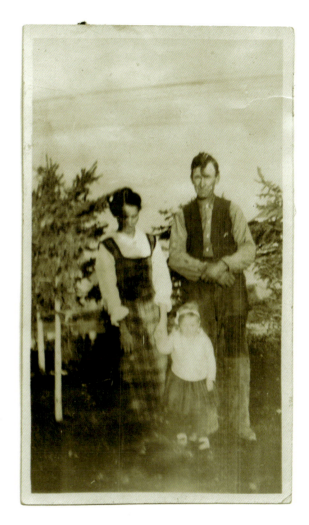

ABOVE: An English couple with their daughter. Many individuals of English background settled widely across the province, while others congregated and homesteaded close to each other in such places as Cannington Manor, Saskatoon, and Lloydminster. n.d. Author's personal collection.

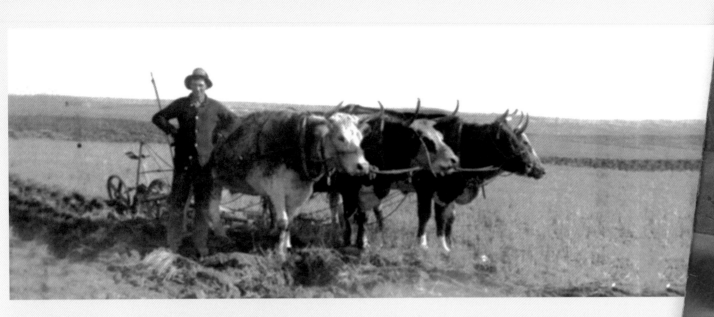

Recollection of Ancestors

By Sharon Kaminski of White City, Saskatchewan

My grandfather, Charles Williamson, owned the first team of oxen in the district of Vanguard. He was born in Toronto in 1889 and was of Scotch-Irish descent. His grandparents came from Ireland. His mother, Katie Wilkins, came from Nashville, Tennessee, following the Civil War. His father, Thomas, was born in Toronto. They were married there in 1886, later moving to Lombardy, Ont. Charlie had one older brother, Frank, two younger sisters, Ada "Maud" and Ethel, and one younger brother, William "Harold". Charlie came west on a harvest excursion in 1907 to Lang, Sask. He married Ethel Meters in 1909. Her parents emigrated from England a few years before Confederation. Her father, Richard Meters, pioneered the area near Hensell, Ontario. Her mother, Ann Looker, arrived some years later. My grandma Ethel's sisters had come to Lang, Saskatchewan in 1905 and Ethel had come there to visit her sisters when she met Charlie. Ethel's parents moved out and joined the family in 1909. Charlie and Ethel farmed at Lang in 1910 and 1911. The rest of Charlie's family came from Lombardy, Ont. to join him [in] the same area in 1911. Their first child, Doris, was born at Lang, December 19, 1909. In 1912 they moved to Vanguard, Saskatchewan and farmed there. Their second child, Harold, was born in 1912 at Vanguard but died as an infant. Their third child, C. Goldwin, was born in Vanguard, May 31, 1913. Their fourth child, Ralph, was born in Vanguard in 1920. Their fifth child, Norman, was born in 1923 at Vanguard, but also died as an infant. Their sixth child, my mother, Phyllis, was born at Vanguard in 1926.*

ABOVE RIGHT: Winnifred 'Doris' Williamson (1909-2003) and her grandmother, Ann Looker Meters (1859-1916). n.d. Photo used with permission.

ABOVE LEFT: Charles Williamson with his famous oxen in Vanguard, Saskatchewan, 1912. Photo used with permission.

* Permission to use the description is set out in an email to the author dated April 14, 2014, and December 18, 2014.

Europe and encountering fierce storms at sea, journeying for a week by colonist car on the Canadian Pacific Railway from the eastern coast of Canada, or dealing with stubborn oxen hitched to wagons for the final trek to the homestead, all of these accounts give the reader a greater appreciation for the courage of the pioneers and the effort that was expended in reaching Saskatchewan.

Upon further examination of the questionnaires, I also admired the tenacity and drive of these pioneers to settle on their homestead and make it habitable. Temporarily living in tents or under wagons until a more permanent dwelling could be constructed would have been difficult and uncomfortable, particularly during the cold winter months. Decisions in the spring as to whether a house made of sod should be built or whether they should construct one with logs would have to be made, keeping in mind the availability of trees on their land and the amount of labour and time that would be needed. Building additional structures, such as barns for livestock and sheds for equipment, wells for water, as well as fencing, were all considered by the pioneers in their initial years on the prairies.

Along with constructing a home, making sure there was enough to eat was also an imperative. While many pioneers would purchase a grubstake, which included basics such as flour, sugar, coffee, tea, and oats from the merchant at the local town, others were reliant on the edible items available to them in their immediate vicinity. Collecting wild berries and mushrooms, snaring rabbits, shooting ducks and geese, or catching fish from the local stream were common tasks for family members. Purchasing seeds and planting vegetables in their gardens added diversity to the family meal once they could be harvested.

Clearing the land, ploughing, harrowing, seeding, and, finally, harvesting the fields were also essential duties on the homestead in order to make the farm viable. The importance of fieldwork was reflected by the accounts of intensive labour that involved all members of the family. Men were aided in the fields by their wives, who were also responsible for completing household tasks such as baking, sewing, cleaning, and gardening. Children as young as four years old also lent a hand with clearing the land of small rocks and weeds, while older children worked with their parents, shoulder to shoulder, helping with the arduous dawn-to-dusk task of working the fields.[5] Other farm tasks would also need to be completed. Caring for livestock such as oxen, horses, cows, and pigs, as well as chickens and turkeys, all had to be carried out on a daily basis. Ensuring that animals and fowl had enough water and feed so they could survive were all essential tasks that needed to be completed by the various members of the family.

While children were expected to help with work around the homestead, they were also expected to attend school once a school had been established in their vicinity. People recounted how they walked or rode their horse to school, attended a one-room schoolhouse with the teacher teaching eight grades of students over the course of each day, sat on rough-hewn benches in the classroom, used slates to do their work, and tried to interact with a diverse number of children (many of whom did not know English). Punishment for incorrect schoolroom behaviour was also highlighted, as were the more fun times of playing games during recess.

The lack of medical facilities, medical personnel, and medicine on the prairies were also issues that had to be dealt with by many of the pioneers. Many homesteaders had to rely on local remedies such as goose grease and turpentine compresses for respiratory problems, or coal oil for sprained ankles, while those who had aching teeth were reliant on neighbours who owned a set of

> *Clearing the land, ploughing, harrowing, seeding, and, finally, harvesting the fields were also essential duties on the homestead...*

INTRODUCTION 5

Recollection of Ancestors

By Nolan Martens of Prince Albert, Saskatchewan

The Martens family, originally from Germany, had immigrated to Russia. My great-great-great-great grandfather was Johann Martens and he was born in 1812 in Neuendorf, Chortitza, south Russia. He married Maria Harder (b. 1814) in 1832 and they along with some of their children came to Canada by ship, the S.S. Peruvian. The couple arrived in Quebec on July 13, 1875 and moved to Blumenfeld, West Reserve, Manitoba. One of their twelve children was my great-great-great grandfather, Abram Martens (b. 1836). He also initially settled in the Blumenfeld area and became a member of the Reinlaender Mennoniten Gemeinde (a Mennonite church-based community later known as the Old Colony Church). Abram married Susanna Neudorf (b. 1836) and they had nine children. Eventually, Abram and his family moved to Reinland, Saskatchewan to homestead in 1898. Between 1898 and 1901, the family had broken and cropped 60 acres of land, they owned three horses and five cattle, had built a 20' by 32' home worth $250 and a granary valued at $100. They received the patent to their homestead land in 1902.

My great-great grandfather, Johann (b. 1871) married Anna Peters (b. 1872) a midwife who delivered many babies. She was also the local undertaker. Like Johann's parents (Abram and Susanna), the couple lived in Reinland, Saskatchewan and homesteaded. Between 1898 and 1901, they broke 50 acres of land, and cropped 35 acres. They owned two oxen, seven cows, bought a 20' by 34' home and built a stable. They received their patent in 1902. They were also members of the Old Colony Church.

My great-grandfather, Heinrich (Henry) Martens was born in 1907 in Reinland, Saskatchewan. My grandfather, Ruben Martens (see photo) was born in 1933 while my father, Gavin Martens was born in 1958 and I was born in 1985.

One of the important aspects of life for a Mennonite Martens family member was being part of the Church. Following in the footsteps of the Old Colony Church in Manitoba, emphasis was placed on traditional values, clothing and lifestyle. The Mennonites were known as the "quiet in the land" and lived a simple lifestyle. Their primary reason for coming to Canada was for religious freedom where they could freely worship God.

Regarding the maternal side of my family, my mother Patricia's father is Charles Hordyski (originally Horodyski). Growing up, his name was actually Karl, but in his latter years he changed his name to Charles. When his father, Joseph Hordyski, came to Canada in 1907 from the United States, he purchased land in St. Boniface, Winnipeg. Unfortunately, the land contained too much clay and was unworkable. He left it and decided to move to Saskatchewan. Upon arriving in Prince Albert, Saskatchewan, Joseph worked for the CN Rail round house and built the walls that surround the turnaround point for trains. He was also a shoemaker, blacksmith and later a farmer. He built a house in Prince Albert using scrap from the various box cars that came through while he was building the turnaround. This house was located on 16th Street. He had built it for his wife and three children when they came to Canada from Poland. He later sold the house after his wife died during childbirth.

Having found out that free homestead land was available, Joseph acquired a quarter section in Honeymoon, Saskatchewan. In order for title to be given, he had to clear roughly 20 acres, with no known timeline before he could call the land rightfully his. He paid $11 the first year for taxes. There were no roads to his land as the roads were built on high ground to avoid

Ruben Martens

flooding. The roads were also very windy as they crisscrossed through the rolling sand hills. In addition to these problems, my great-grandfather had the tedious job of clearing his land of trees and brush so that he could eventually crop his fields. In order to acquire funds, he sold and hauled wood so that he could purchase groceries. He also worked off-farm and helped to build the Prince Albert Steel train bridge. He was in charge of making steel rivets. He would heat them up and form them, and then with tongs throw the super-heated rivets up above to the workers. He was told that hundreds dropped into the water below. During this same time, he met a widow with seven children whose name was Barbara. They ended up marrying and eventually, my grandfather Charles was born.*

OPPOSITE PAGE: Ruben Martens. n.d. Photo used with permission.

* Permission to use the description is set out in an email to the author dated September 25, 2015.

pliers. Separating family members who contracted a disease by placing them in an animal shelter was an option for some, while others tried to separate the ill family member from others with sheets hung as dividers within the home. For others who suffered from serious farm injuries such as axe cuts to arteries, horse kicks, broken backs, or gunshots, there was very little that could be done to ease their pain and eventual demise.

Not all aspects of homesteading revolved around hard work, school instruction, or injury and illness, as settlers made sure to enjoy their leisure time whenever it became available. In the evenings after the day's work was done, it was not uncommon to find settlers and their families working on their hobbies (collecting stones or Indigenous artifacts, knitting or crocheting, reading, singing, or practising a musical instrument). Settlers were also entertained by the antics of their family pets, whether they were dogs, cats, wolves, owls, or a pet moose. When the opportunity came for visiting neighbours and relatives, games like horseshoes were played outdoors, while other games like checkers, crokinole, and cards were played inside the home. The entertainment could also become more energetic, particularly if someone could play some polka tunes on their harmonica, and everyone would get up to dance.

At other times, the whole community of settlers would get together for the annual picnic and everyone would enjoy a good meal, children would run and play together, and all sorts of races and competitions would be held. Weddings were also times of great enjoyment for the settlers, as were the chivarees that occurred afterward. Playing jokes on the newly wedded couple, all in good-natured fun, ensured the couple were appropriately accepted into the community. At the end of the year came the Christmas gatherings, with special meals being cooked and cakes, cookies, and candies being made. Cutting down a tree and decorating it was a highlight for many settlers, as was the gift giving that occurred on Christmas morning. A week later, many settlers also celebrated the New Year, sometimes with friends and family, while at other times enjoying quiet festivities at home.

Using information gleaned from the PAS questionnaires, this book will help to provide useful, valuable, and insightful information about homesteading life in Saskatchewan. It is a unique book in that the actual words written by the pioneers themselves are used to highlight the experiences they encountered while travelling to and living in the province as homesteaders. Relating personal and family experiences, as well as documenting pioneers' encounters with others along the way, not only provides historical evidence of homesteading life but also allows the reader to adopt an interesting and compelling relationship with those whose words describe an era that existed many years ago. In addition, to immerse the reader in the homesteading era, photographs from the Provincial Archives of Saskatchewan, the National Archives of Canada, and my own personal collection will be included in order to convey a more complete picture of pioneer life.

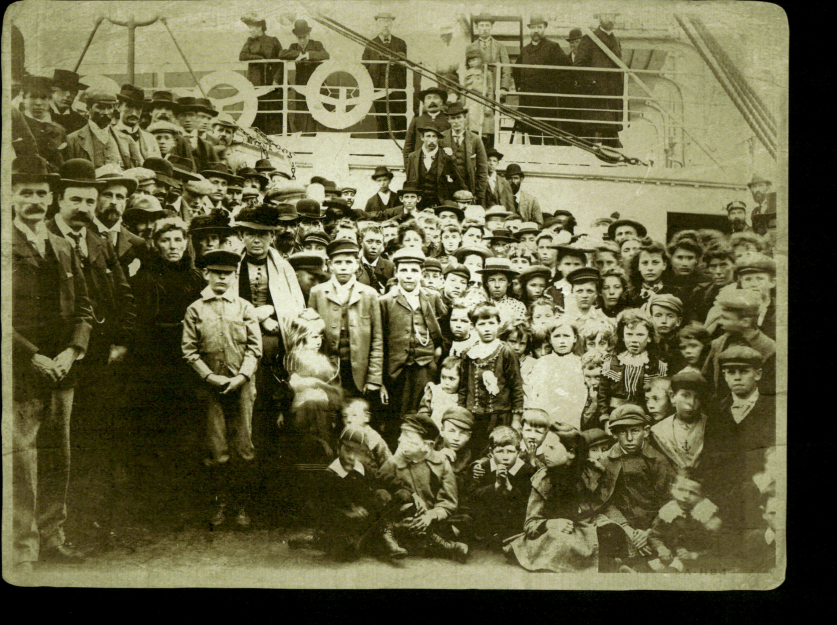

Chapter 1
A Land of Opportunity

With the implementation of the Dominion Lands Act by Sir John A. MacDonald's federal government in 1872, individuals were offered the opportunity to obtain 160 acres of free land in the prairie provinces of Manitoba and what would become Alberta and Saskatchewan.[1] Men over the age of eighteen and of any marital status, as well as women who could prove they were heads of their households, were able to apply and register. This opportunity to own land motivated hundreds of thousands of migrants and immigrants to move to the region. According to the *Fifth Census of Canada*, conducted in 1911, 1,162,831 British (including English, Irish, and Scottish), 140,022 Germans, 107,757 Austro-Hungarians, 78,458 Scandinavians, and 74,246 French people had moved and were living in the western Prairies. Those who were Jewish, Dutch, or Russian had approximately twenty-five thousand people each residing in the area.

Along with the promise of land ownership, there were also factors in place that influenced people and their families to move from their mother countries. Economic deprivation, political and religious purges, industrialization and pollution, overpopulation, starvation, climatic and geographical hardships, as well as conscription, class discrimination, and cultural barriers were all problems that were ongoing across Europe. A world depression that had occurred between 1873 and 1879 also encouraged many people to seek alternative means for survival, as this event significantly altered the economic landscape of many European countries.[2] When information about the opportunity to own land in Canada was made available, many people enthusiastically decided to move themselves and their families to the new country and become homesteaders. Possessing land was an ultimate goal for many as it meant economic security, a condition they would never be able to

OPPOSITE PAGE: Welsh immigrants leaving Liverpool, England for Canada on S.S. *Numidian* of the Allan line, ca. June 12, 1902. For those looking for homestead land in Saskatchewan, many Welsh immigrants settled in the Llewelyn area near Bangor, Saskatchewan. Library and Archives Canada, C-037613.

ABOVE: Hon. Clifford Sifton, Minister of the Interior, 1900 (b. March 10, 1861–d. April 17, 1929). Library and Archives Canada, PA-027943.

RIGHT: In order to attract immigrants, Sifton developed a massive advertising campaign that spread across Europe. In this photo, a group of Londoners examine a window display advertising farms in Saskatchewan, ca. 1912. PAS R-A259.

obtain in their own homeland. In addition, the assurance of living under a democratic state meant that a brighter future could be envisioned for themselves and future generations of their family.

THE RIGHT KIND OF PEOPLE

There were obstacles that needed to be overcome before many immigrants could make their way to Canada. Clifford Sifton, the Minister of the Interior in the Canadian federal government between 1896 and 1906, formulated strict policies that were to be followed with regard to the type of immigrant that would be allowed into the country. He believed the western prairie region was to be "Canada's future source of national prosperity and that this potential would only be realized if the Prairies were settled by the right kind of people, that is, farmers and farm labourers."[3] In addition, like his predecessor, Edgar Dewdney, who was Minister of the Interior between 1888 and 1892, Sifton also believed that immigrants had to be not only a culturally good fit with Canadian society but also from what he considered the right racial backgrounds. As such, Sifton sought immigrants with an Anglo-Saxon background from such countries as Great Britain, Ireland, the United States, Holland, Germany, Belgium, France, Sweden, and Switzerland. However, over time, he became cognizant of the fact that other European peoples were also agriculturally fit, in that they had generations of farming experience in their blood. As a result, under Sifton's direction, employees of his department extended their activities to southeastern Europe in order to attract Slavic peoples such as Russians, Ukrainians, and Poles.[4]

Along with drawing immigrants from countries across Europe, Sifton also encouraged American settlers to move north to the Canadian prairies. Many of these people had been immigrants who had travelled to the American Midwest and western region of the United States in order to obtain free land under the Homestead Act of 1862,[5] which also offered them 160 acres. Sifton recognized these people likely had agricultural ability and experience with farming techniques that could also be used in a beneficial way on the Canadian prairies. In addition, he realized these people were culturally socialized into a North American way of life, they could adapt to new situations and exist peacefully with a diverse number of other people, they knew (or had learned) to speak the English language, and they were used to a government

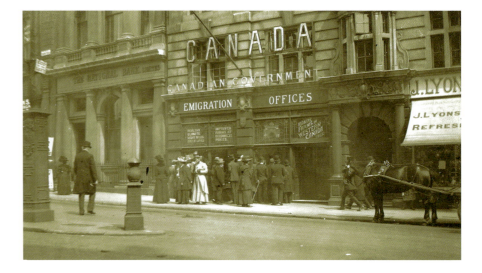

system based on democracy. Given these advantages, Sifton strongly promoted the free homestead land that could be obtained by Americans if they left the United States and immigrated north into Canada.[6]

Sifton also welcomed farmers who had lived in Central Canada (Ontario and Quebec) and eastern Canada.[7] They were used to the Canadian way of life, with some having lived in the country for generations. Many had been farmers or had worked on farms, while others had visited western Canada on harvest excursions and were familiar with the territory and the climate.[8] Given their background, many of these people saw the free homestead program as a multi-varied opportunity. Some could increase their standard of living by selling off their farms in Ontario and Quebec or the Maritimes and reinvest the profits into homestead land. Others, who were less financially able and only envisioned working for others or renting land in the east, took advantage of the opportunity to own their first piece of property in the West and begin a new life, while others simply wanted to take part in a new adventure of meeting new people and moving to a vast land of open space.

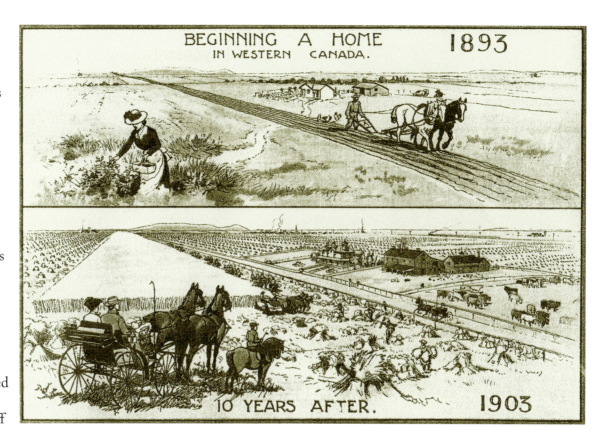

PEOPLE WERE TALKING ABOUT THE PRAIRIES

As mentioned above, political, economic, and social conditions in Europe were less than desirable and people were looking and hoping for a better opportunity in western Canada. Several people detailed the bleak circumstances under which they had lived in their mother countries and their anticipation of improved futures.

Robert Wood, a young man from Scotland, reported that conditions were poor in his country and that people were looking for something better. He stated,

In the 1890s a great many of the young people of the British Isles were thinking of emigrating. The old land was getting crowded and stories were coming through about the fine

ABOVE: This is an example of one of the advertisements Sifton used to encourage people to emigrate. It depicts how successful a homesteader could become in just ten years. PAS R-1109.

A LAND OF OPPORTUNITY 11

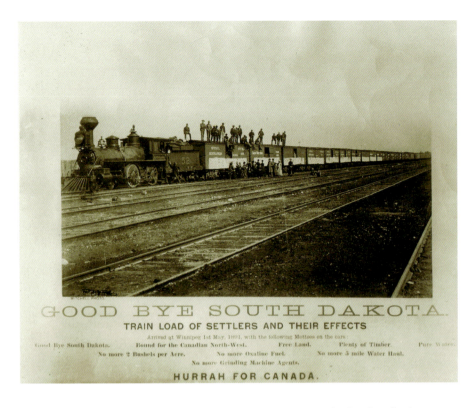

ABOVE: American settlers leaving the United States to homestead in Saskatchewan. Note that each rail car had a poster glued to its side and included such exclamations as "Bound for the Canadian North-West," "Free Land," "Plenty of Timber," "No More 3 Mile Water Haul," and "No More 2 Bushels per Acre." "Goodbye South Dakota, Hurrah for Canada." n.d. PAS R-B3278.

opportunities in the colonies, and particularly in Canada, where a quarter section of good land could be got free.

William Evans from England was also excited by the great advantage of moving to western Canada. He wanted to change the course of his life for a better opportunity and felt that becoming a farmer in Saskatchewan was his only chance. Andrew Salamon of Hungary indicated that western Canada "looked promising for a young man," while Detlof Helstrom of Sweden also envisioned Canada as the "land of opportunity, where land was cheaper and the soil...the best in the world." George Bruce also predicted great benefits with moving: "There was a serious depression in Britain, chances of employment poor—long waiting lists in white collar occupations." Florence Kenyon mentioned her father also faced financial difficulties in his English-based business, while Arthur Kelly was laid off work in a cabinet factory in 1907 because of the depression in England. Frank Baines wrote that his father also faced economic hardship in England, so he was very attracted to western Canada and the promise of employment and a financially stable future.

Joseph Mohl, a twenty-seven-year-old Austrian, also wished to relocate to western Canada because "conditions in Austria during the first decade of this century were rather depressed with prospects for the future not very bright." He also indicated he had a political reason for moving from his country, as he "got sick and tired of the eternal strife between old Austria's fourteen different nationalities which seemed to be encouraged by the government in order to evade progressive legislation in any field." He longed for elbow room and wide open spaces and felt he could find a better place to live by moving to Saskatchewan.

Others became enamoured with the prospect of moving to the Canadian prairies as they were adventurous and wanted to discover an unknown and undeveloped land. Alfred Riley from England felt drawn to the area and became excited about the prospect of homesteading in the wild. Windsor Witt, a teenager from England, was just "full of the desire to emigrate," while William Carson from Ontario felt he was driven to search and discover new lands as he had inherited a frontier spirit from his ancestors. Herman Ehrlich, from Germany, wanted to travel and see a wild and natural environment because when he was an inquisitive "boy going to school, western Canada, on the map was black and [he] wondered what [he] might find there."

Other immigrants offered a different reason for wanting to move to western Canada. They had heard that bloc settlements or colonies (where people who shared an ethnicity or religion could live together in the same vicinity) were being created in

Discriminatory Homesteading Practices

While Clifford Sifton promoted his acceptance of a large number of people from a diverse number of countries, the actions of some groups that may have wished to homestead were limited. For example, regardless of whether they had agricultural expertise or not, efforts were made by the Canadian federal government to exclude African Americans from the homesteading program by approving an order-in-council that would stop them from entering Canada.[*]

People of Asian descent also faced high levels of discriminatory behaviour that hampered their ability to obtain homesteads[†] In fact, to date, only three homestead files in Saskatchewan have ever been found relating to the acquisition of land by Asian individuals. For example, one of those files referred to the application of Lai Men, a twenty-seven-year-old single man who worked as a laundryman in Wolseley, Saskatchewan. He applied for a homestead and entered his land on May 26, 1903. He was quite industrious, as he built a fourteen-foot-by-sixteen-foot home in 1904 (worth $70), as well as a stable worth ten dollars. He also owned two horses, and he had broken and cropped thirty-five acres in three years. He received title on May 18, 1909.[‡]

Like Lai Men, Lai Noon also worked as a laundryman in Wolseley, Saskatchewan. He applied for a homestead in 1904 and built a sixteen-foot-by-sixteen-foot frame house worth $150. He built a stable worth ten dollars and a well worth fifteen dollars. He also owned two horses and was able to break and crop thirty-two acres in three years. He obtained title on March 9, 1909.[§]

The third file related to Wong Sing, a thirty-six-year-old single man who had come from China. He applied for a homestead on December 6, 1911, but was not successful in meeting all of the homestead regulations and lost his land.[¶] As a result, another man by the name of William Veevers (a twenty-four-year-old married Englishman with one child) applied for the land and eventually obtained title.[**]

[*] See R. Bruce Shephard, *Deemed Unsuitable* (Toronto: Umbrella Press, 1997), 3.

[†] For more information on discriminatory practices and beliefs in Canada, see McLaren, "Stemming the Flow"; Mariana Valverde, "Racial Purity, Sexual Purity, and Immigration Policy," in *The History of Immigration and Racism in Canada*, ed. Barrington Walker (Toronto: Canadian Scholar's Press, 2008), 175–188; and Francine Govia and Helen Lewis, *Blacks in Canada* (Edmonton: Harambee Centres Canada, 1988).

[‡] PAS, Homestead File #1227247, Lai Men.

[§] PAS, Homestead File #858323, Lai Noon.

[¶] PAS, Homestead File #2582016 (1), Wong Sing.

[**] PAS, Homestead File #2582016 (1), William Veevers.

ABOVE: A Chinese individual sweeping his front step. n.d. PAS R-A12677.

RIGHT: The Yanaluk family travelled from Germany to Canada in 1911. They were of Slavic descent. It is interesting to note that only a small percentage of people actually came from the country of Germany. Rather, those of Slavic descent tended to emigrate from Russia, Hungary, Austria, Ukraine, Poland, and Romania. Library and Archives Canada, PA-010254.

FAR RIGHT: A group of English immigrants in 1910. (The name of the gentleman seated just right of centre is Mr. J. Gaston.) Those of English descent tended to homestead as individual families across the province with the father registering for homestead land, rather than homesteading with others in ethnic blocs. Library and Archives Canada, PA-010399.

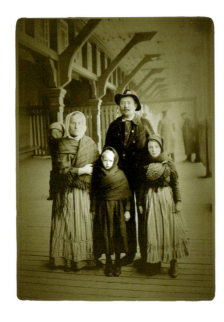

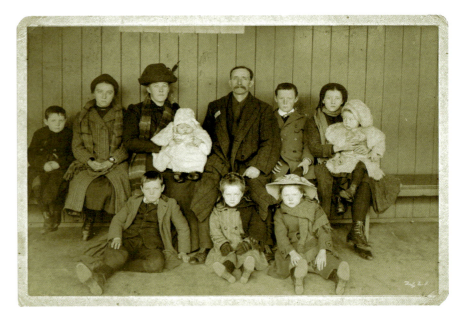

Saskatchewan. This concept, of being able to live in a relatively comfortable and traditionally based locale appealed to settlers like Sam Vickar of Lithuania, who was of Jewish descent. He recounted the experiences he had faced in Europe prior to settling in a colony in Saskatchewan:

> *I run away from Europe to avoid Czarist rule which consisted of regimentation, and dictatorial rule, which my race and religion was scapegoats. Went to South Africa, because I heard so much about British justice and Democracy. The reason for coming West to Saskatchewan was due to the fact that a Canadian paper carried an ad advising that homesteads consisting of 160 acres were available for only $10.00 which my race always cherished and was denied in Europe. And having a taste of British Democracy which prevailed in Canada, myself and a group came here as Jewish homesteaders and pioneers which consisted of 12 people, forming a Jewish farming colony in Saskatchewan.*[9]

Joseph Bonas and his family, who lived in the United States, were also desirous of living among people from the same ethnic and religious background (German Roman Catholic). As Bonas stated,

> *We were a large family, six sons, one daughter, together with father and mother. We were spread apart as a family, one son even having gone to Europe with Barnum and Bailey circus, one in Montana, and so forth. We decided to come to Canada to unite and establish a new home together. We learned*

14 THE HOMESTEADERS

about the West through the settlement society, St. Paul, forming the St. Peter's Colony (in Muenster) in what is now Saskatchewan.[10]

Other people had personal reasons for wanting to move to the province of Saskatchewan. Ethel Law, a twenty-six-year-old woman from England, wanted to undertake housekeeping duties for her brother who had already taken up homesteading in Saskatchewan. Meanwhile, Ethel Jameson from Ontario recounted an often-heard phrase that encouraged young women like herself to head west, particularly if they were looking for a marriage partner: "Go West Young Man to Find Some Land; Go West Young Woman to Find a Man." Elizabeth Homersham, from England, had the same idea in mind when she travelled west. She wanted to get married. Her future spouse, whom she had met in England and was homesteading in Saskatchewan, was waiting for her when she arrived in the town of Regina. She "arrived in Regina at 7:00 a.m. and was married at St. Paul's Anglican Church in Regina at 11:00 a.m."

For those who were migrating from Central or eastern Canada, economic problems tended to be the impetus for their wish to move west. Ernest Ludlow knew his prospects for the future were limited if he continued to live in Ontario. He had been "born and raised on a rented farm with no hope of becoming an owner of a home," and so he and his older brother went west, where they could acquire 160 acres for a ten-dollar registration fee. Eric Neal from Manitoba moved to Saskatchewan to get a new start in life, while Alexander Cameron, an eighteen-year-old from Ontario, wanted to "improve his position and work [himself] into useful employment in the west."

Alice Geddes, from Ontario, was from a family with nine children. Her parents felt they could offer their children a better quality of life and a better chance for the future if they moved to western Canada. Lena Purdy recounted the economic problems that affected her family when they had lived in Ontario, especially those faced by her father, who was laid off from his full-time job:

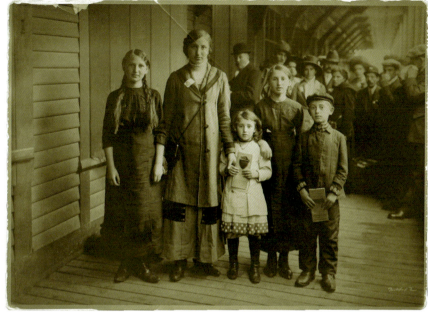

LEFT: Russian Jewish Immigrants in 1911. As set out by Sam Vickar above, Jewish people faced high levels of discrimination in Russia. As such, many travelled to Canada in order to become part of a bloc settlement in Saskatchewan where they could live in peace and harmony with others of the same religious and ethnic background. Library and Archives Canada, PA-010400.

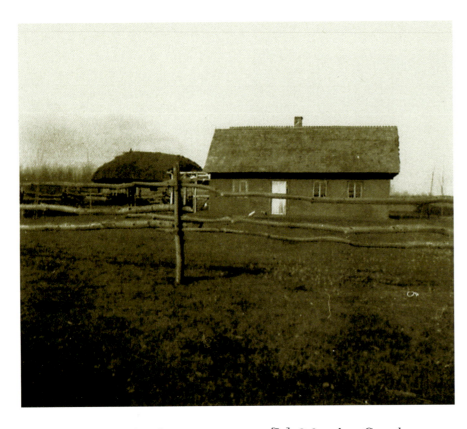

ABOVE: A homestead on St. Peter's Colony, 1904. PAS S-A54.

OPPOSITE PAGE: Two immigrants from Finland, 1911. Many individuals of Finnish descent homesteaded as an ethnic bloc in New Finland (located in the Qu'Appelle Valley in southeastern Saskatchewan). Library and Archives Canada, PA-010262.

[In] 1878 and 79, Canada had what we later called a depression. Many companies dismissed employees. My father tried many short term employments, but failed to find a permanent position. People were talking about the prairies. Father was acquainted with some of the organizers of the Temperance Colony and was offered a position in the survey gang that was to survey land near the elbow of the Saskatchewan.[11]

In order to improve his lot in life, and in order to provide for his family, Lena's father accepted this paid position and the family moved west.

Marion Anderson, a small child from Ontario, reported that her mother and father also "wanted the chance of making a home for [their family] in a new country where land was plenty and they were young and ready to work." Another Ontarian, Isaac Emery, had an uncle who lived in Moose Jaw, Saskatchewan, and, as such, decided to move west in order to improve his lifestyle, while Ada Christian, also from the same province, stated,

My mother's brother had gone to Wolseley in 1881 and came home in the fall of '82 with such glowing reports of this wonderful prairie country where one could break the sod the full length of a section without having to cut down a tree or pick out stones. Father, who had done so much of that and was still doing it on 100 acres [in Ontario] said that is the place for me, made a sale in the spring...and [we moved] west.

A few other interesting reasons were given for why people wished to migrate to western Canada, including the one given by both John Singleton and Clarissa Stewart. Both reasoned that with large numbers of people and their families moving to Saskatchewan, school teachers would be needed to instruct the children. As such, John wanted to teach school in the West. It "was a desire which [he] had had since early teen age." As for Clarissa, she had been a teacher in Ontario but found it difficult to find a teaching position, given the province was overcrowded with teachers, so she decided to move west as well.

TO TRY SOMETHING NEW

Despite their birthplace, future homesteaders pulled up their roots in their hometowns and countries and said goodbye to friends and loved ones. Many of these people were quite happy for those who chose to immigrate to Canada, while others were far less enthused. David Campbell's friends and

family were fully in favour of the idea, as was William Vicars's family, who indicated the prospect offered great opportunities. Thomas Burn's parents were also quite optimistic about Thomas moving west. As Thomas stated, "I was the oldest of a family of seven. Next to me were five sisters, then one brother. My parents were pleased with my decision as it would pave the road for the rest of our family to all come West."

William Hosie's parents also encouraged him to move west, as there were a number of people from that part of Scotland who were also immigrating to Canada at the same time. Courtney Tower, from Ontario, was advised to move by his parents given the province's poor economic conditions and that it made sense to "try something new," while Lena Purdy's mother was also encouraged to move and, in fact, was given presents and many well wishes before she began her journey. Lena recounted, "When mother was getting ready to join father in 1883, she was given a good deal of help. She pieced many quilts, friends gathered to quilt them, some dried a sack of apples for her and did other things that suited the occasion."

Friends and family members also admired their courage and sense of adventure for moving to Saskatchewan. Ernest Griffiths said, "As far as I can remember, they were amazed at the courage it took to pluck out the roots of the connections and family ties back home to carve out a future in a new country." Frank Baines's family and friends felt it would be a great adventure for him, while Stephen Hall reported there was even some envy among his friends when they found out he was moving to the West with his parents. He wrote, "The boys at school envied me going west where I could snare gophers and ride ponies."

Others faced negative reactions as their friends and family members were completely against the notion of them moving west. Frederick Humphrey's English family was horrified at the prospect, while others indicated their family and friends were shocked and tried to persuade them not to go. Christopher Atkings recounted that some people in England thought he and his family "were going too far from civilization into too wild a country with too little knowledge of what was before

A LAND OF OPPORTUNITY 17

"God Be with You till We Meet Again" *By Jeremiah Rankin*

Verse 1
God be with you till we meet again,
By His counsels guide, uphold you,
With His sheep securely fold you,
God be with you till we meet again.

Refrain
Till we meet, till we meet,
Till we meet at Jesus' feet;
Till we meet, till we meet,
God be with you till we meet again.

Verse 2
God be with you till we meet again,
'Neath His wings securely hide you,
Daily manna still provide you,
God be with you till we meet again.
(Refrain)

Verse 3
God be with you till we meet again,
When life's perils thick confound you,
Put His arms unfailing round you,
God be with you till we meet again.
(Refrain)

Verse 4
God be with you till we meet again,
Keep love's banner floating o'er you,
Smite death's threat'ning wave before you,
God be with you till we meet again.
(Refrain)*

* This hymn was written by Jeremiah Rankin (1828–1904) and was often used as a farewell song. HymnSite, accessed June 23, 2014, http://www.hymnsite.com/lyrics/umh672.sht.

[them]." In other accounts, some friends and family members were timid about the Canadian climate and told them they should not go to a land of frost and snow. Edgar Bowering was warned that he would "freeze to death in that cold country," as was Mary Kajewski, who was advised she would be travelling to the North Pole. Maria Fabien deSion was also informed that she would freeze; however, she was given "all sorts of woolies to keep [her] alive and a pair of long kid boots lined with fur." Others, like Nellie Buckingham from England, reported her family thought she "would be eaten up by wild animals and would be out of civilization altogether," while Ethel Law's parents told her she would be isolated and there would be few luxuries available in the new country. Robert Wood's family and friends thought it would be perilous given his young age (Robert was sixteen years old when he travelled to the West and his brother was seventeen). William Evans's parents also felt he was foolish, but William continued with his plans and had to leave "under a cloud," his parents were so upset.

Some settlers did not care about other people's opinions about their desire to move west. As James Tulloch of Scotland wrote, "My friends and my relatives had no say in this business as I left home when I was seventeen years of age. My mother died when I was born and my grandfather looked after me till I was seventeen years of age." Sorine Franks also recounted her family's position on the matter: "It was our future we had to think about and nobody [was going] to tell us what to do."

SEASICK AND HOMESICK

The immigrants who came from Europe had to cross the Atlantic Ocean by ship in order to reach the shores of Canada. Such journeys could take up to fourteen days. Many immigrants recounted a variety of different experiences relating to leaving ports in Europe, travelling across the ocean, and docking in Canada. Elsie Campbell remembered what it was like when leaving the docks of Liverpool, England. She was an eight-year-old English girl travelling with her

OPPOSITE PAGE, CLOCKWISE FROM TOP LEFT: People leaving Liverpool, England, for Canada and looking forward to a new beginning. n.d. PAS R-A 9804-1; Immigrants on a passenger ship, n.d. In this case, the majority of immigrants were men, all hoping to register for homestead land on the prairies. PAS R-A25855; A Scottish immigrant family waiting on the ship after landing at Quebec City in 1911. Many Scottish people settled in Moosomin, Wapella, Dunleath, Stornoway, and Kessock, Saskatchewan. They also homesteaded in the Qu'Appelle Valley and at Indian Head. Library and Archives Canada, PA-010226; People on a ship with their belongings. n.d. PAS R-A 12676.

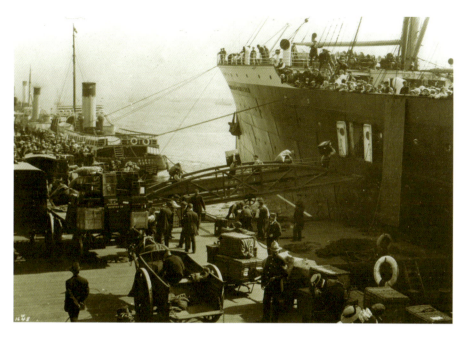
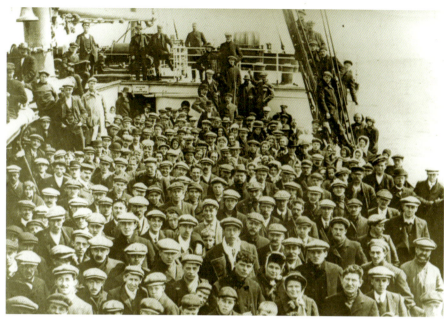
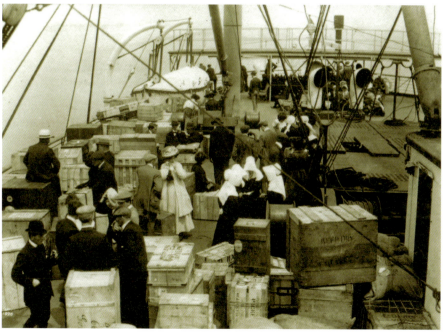
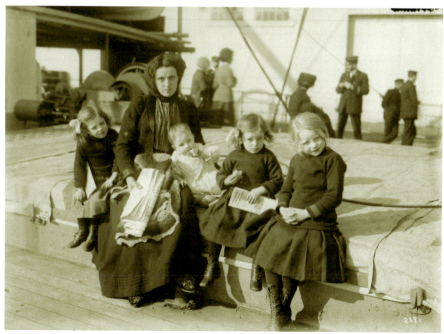

A LAND OF OPPORTUNITY 19

parents and siblings in 1905, and she recounted the fond farewell they received from the Salvation Army Band who played "God Be with You till We Meet Again" as they sailed away from the city.

Twenty-one-year-old Ernest Line remembered how his ship was delayed in London, England, the same day he and his family left the London docks and, once underway, the problems they encountered with the tide in France. He also related his thoughts on the rest of his journey. He wrote,

> *Leaving London on the boat, the boat got stuck on a sand bar in the River Thames, which delayed us, so we got to La Havre, France as the tide was coming out. We had to wait till the tide was in before we could dock. We stayed at La Havre 2 days. We were 14 days crossing the Atlantic. The accommodation was very poor. 6 of us in a small cabin, the food was not nice. I was very seasick and home sick. About the only meat we had was pickled pig's feet. . . . One passenger died and was buried at sea.*

Like Ernest, others also commented on the poor accommodations, their subjection to seasickness, and even the deaths of other passengers on their voyage across the ocean. George Bruce, a seventeen-year-old Scottish fellow who travelled in 1904, stated his ship, the SS *Anshora*, was filled with European immigrants who were all "packed in like sardines." He and his fellow passengers also experienced heavy storms in the Atlantic that kept them below deck for almost a week. John Allan, another Scotsman, aged thirty-three years, also remembered how he and his fellow passengers were crammed into their ship (the SS *Corinthian*) "like herring in a barrel" in 1906. One man died en route and was buried at sea. Another settler, Mary Davis, a nine-year-old from Wales who travelled with her family in 1883, reported on the extreme misery of the steerage passengers who were crowded in so closely together. She also mentioned she and her family experienced stormy weather on the ocean, as well as seasickness. John Potts, a twenty-year-old Englishman who undertook his voyage in 1894, also wrote about the rough weather and illness:

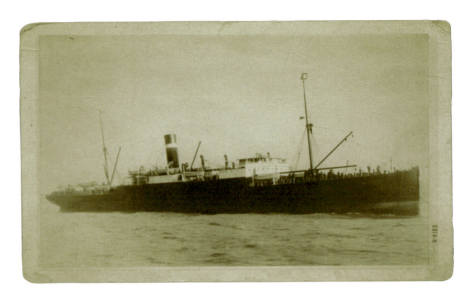

ABOVE: The SS *Corinthian* of the Allan line. This passenger ship was launched in 1900 and was lost in the Bay of Fundy in 1918. As set out by John Allan, he travelled on this ship in 1906. In that year, records indicate that the ship travelled from Liverpool to Quebec and then on to Montreal. Source: Norway Heritage, accessed December 21, 2016, http://www.norwayheritage.com. Permission courtesy of Borge Solem.

"I lost in the tens of pounds weight from seasickness. My cabin (4 berths) was on the stern of the boat." His sister's cabin was midship, where she and her family fared somewhat better. They lost a man overboard during one of the tumultuous storms at sea.

Twenty-eight-year-old Kenelm Luttman-Johnson also commented on his experience when he ventured to Canada from England as a first-class passenger. While he did not suffer from seasickness on the ship, he and his fellow passengers did go through stormy seas. As he recounted,

> *My first trip to Canada on the "Lake Eire" was exciting for we had a storm in mid-Atlantic. The "Lake Eire" was a flat-bottomed boat of about five or six thousand tons and shallow draft, built for the West African trade, and never intended to face heavy weather in the Atlantic. I was*

travelling First Class, but as all the First Class cabins were occupied, I slept in a made up bed in the smoking room, on the upper deck. The night of the storm, while the Steward was making up my bed, I sat on a settee on the opposite side of the room. The ship gave a tremendous roll, it was impossible to retain my position, and I slid across the floor, where the Steward had pitched head first into the bed he was making up. Then the ship rolled the other way, and I went sliding back, but managed to grab hold of the leg of a fixed smoker's table and got up.... Some of the First Class passengers in deck cabins had a bad time as the seas penetrated. The smoking room proved water tight and I was alright. What it must have been like in steerage. I could not imagine. I paid them a visit. They were overcrowded, the accommodation left much to be desired. Partitions appeared to be flimsy curtains, and the atmosphere decidedly unpleasant. They had one consolation, their passage only cost them 9 pounds; just over $43.00.

Along with storms on the ocean that had to be dealt with, other emigrants described further problems they and their fellow passengers had to face. Regina Morhart, an eighteen-year-old Austrian woman who journeyed by ship in 1905, related the anxiety that was felt on board when the crew found their supply of coal in the coal bunker was burning. They realized that if this problem was not corrected, the ship could start on fire and sink. Due to the seriousness of the situation, the captain decided to turn back. The crew continued working on the coal by shovelling it into the boiler and, eventually, after twenty-four hours, they finally got the smoldering embers under control. Once everything was settled, the ship turned around once again and continued its journey across the ocean to Canada.

Paul Barschel, an eighteen-year-old German man who was travelling in 1893, also recounted a life-threatening accident he and his fellow passengers faced on their trip:

A Game to Pass the Time on the Ship

According to Albert Elderton, games would be played to pass the time on the ship. One of the favourite games of the male passengers

was to form two long lines of men facing each other. Each two opposite men would grasp hands and wrists. One of us younger ones would then be laid on about six or eight sets of locked hands and wrists being swung gently too and fro a few times, would be tossed into the air with a forward motion and land on another set of locked hands further along, and so on to the end of the line.

We left Tenzig, which was our nearest railway station, by train to Hourburg where we boarded our ship, the Pickhuberr, which carried us to Montreal.... The most outstanding incident...was on board the ship. We entered the Gulf Stream. Towards evening our officer told us "tomorrow we will see the icebergs". About 10 o'clock in the evening it was very dark. I was sitting on a bench below deck, when an awful crash came, then another and another. There was a fearful quietness. All at once, the pumps of the ship together with screams from the people were terrible. The ship had struck an iceberg, luckily it pulled off. It was, however, badly banged in and had a hole, but was able to proceed.

Edwin Jamieson and his fellow passengers also faced the terrifying prospect of their ship sinking. In 1883, he was

A LAND OF OPPORTUNITY 21

sailing from Quebec across the Great Lakes when his ship hit a rock. He stated,

Being shipwrecked was the most outstanding thing I can remember. I was young but I well remember the ship hitting a rock about one half mile from land, twenty miles from Sarnia. They [the crew] were frightened the boat was going to upset, so they rushed us off into life boats and took us to shore. Then they pushed the livestock off into the water. In our party, we had two teams of oxen and four cows. I well remember how worried Mother was. She did not think the stock would ever reach land. When they did reach shore, one of our cows would not come out of the water, and in spite of all they could do she swam back to the ship, swam several times around the boat, and then came back to land. Everyone thought she was finished, and how they cheered the old cow on when she landed. They had no trouble keeping her that time.

Edwin also mentioned that after this event they had to live in tents until help arrived to take them to Sarnia. Since they were unable to retrieve their belongings, the "only clothes the party had were the ones they were wearing."

THROUGH THE WILDERNESS

Along with travelling by ship, many people also used a train for part or all of their journey to the West. Sometimes these railway journeys lasted only a few days (if they were travelling from Ontario), while for others, who came from the Maritimes, they could be on the train for up to a week. Many people identified travelling on the Canadian Pacific Railway (CPR) across the country, while others indicated they used a more southern route and came north from the United States on the Soo Line Railroad. Regardless of which train they took, many people had a variety of stories to tell.

One of the main experiences people wished to discuss related to the accommodations available on the train. An English fellow, Herbert Young, explained that during his travels in 1897, he

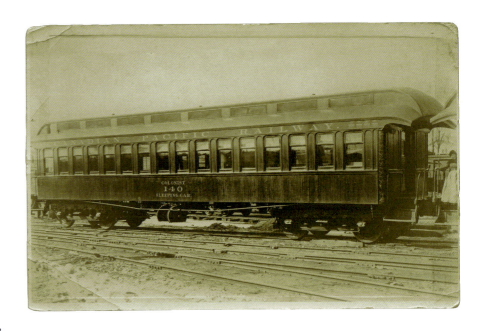

ABOVE: The exterior of a colonist sleeping car. n.d. PAS R-B3274.

travelled in a CPR colonist car from Halifax to Winnipeg. He noted the passengers could pull the seats out to make a bed for two people and the let-down shelf that was located above could also be made into another bed for two people. Alfred Gibson, an eighteen-year-old from England, who made the journey in 1900, also commented on the sleeping conditions. However, he remembered the discomfort he felt sleeping on the beds rather than how they were made. He wrote, "I will always remember the hard wooden berths in the colonist cars where we used our overcoats for blankets and coats for pillows, as we didn't want to spend the money for pillows." George Harris, who was travelling to Saskatchewan in 1901 with a friend from Ontario, improvised when they realized how uncomfortable the sleeping arrangements were going to be. He wrote,

The bunk on the train was pretty hard for sleeping. In northern Ontario, the train stopped in a sparse settled district and there were

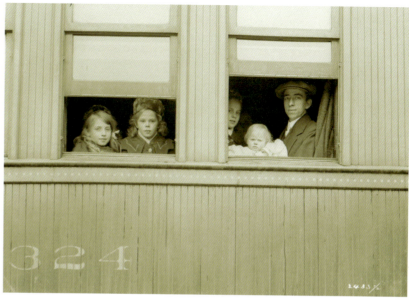

coils of hay beside the track so my schoolmate George Taphorn and I got some of the hay for our bunk, it was fine from there on.

As many people discovered, aside from sleeping arrangements, there was very little else offered in terms of amenities. Herbert Young described a small stove at the end of the car for boiling water for hot drinks like tea; however, as reported by Ethel Law, one had to be quick in the morning in order to obtain water. As she mentioned, "One had to be up by 5 o'clock to secure enough water to make a cup of tea." Given the limited amount of water, people were not able to acquire enough for washing themselves. William Evans, a twenty-one-year-old Englishman, said there were no facilities for cleaning oneself, so when the train stopped at Winnipeg, "half a dozen of us went up main street where there was a wooden pump.... We stripped off coats and one pumped while the rest had a good cold wash. This was in March."

As for meals, Ethel Law commented on the lack of food on the train and wrote that she and her family made sure to have some provisions on hand. They were able to supplement their provisions by purchasing bread at the various train station stops. Fellow passengers bought their entire meals in one of the towns when the train stopped for a short stay. Alfred Gibson described the mass of people that crowded the railway lunch counters. He wrote that the "charge was 25 cents for sandwich, pie and coffee," which the proprietors insisted on getting before they served the food. He continued, "One boy had paid his quarter, but the 'All Aboard' cry was heard before he got his meal, so he picked up a sugar bowl, as he was bound to have something

ABOVE RIGHT: Immigrants from Scotland on a train in 1911. It is interesting to note that passengers who purchased seats in the colonist cars were able to open and close the windows. While opening the windows for fresh air was a great advantage, sometimes the immigrants had to keep the windows closed even during the hottest days if the black smoke from the coal-fired train engines blew in their direction. Library and Archives Canada, PA-008497.

ABOVE LEFT: The interior of a colonist sleeping car. Note the sleeping berth on the upper level. Immigrants would pay for individual seats, the cheapest being made of wooden slats, or they would opt for sleeping berths at extra cost. n.d. PAS R-B3275-2.

A LAND OF OPPORTUNITY 23

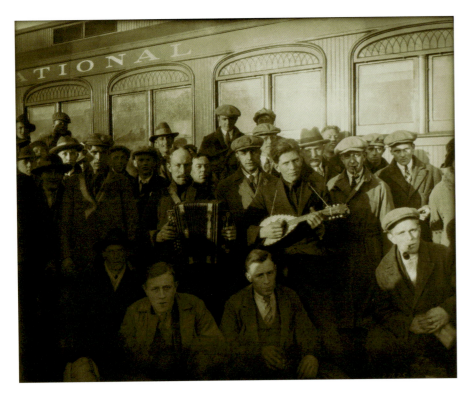

ABOVE: Immigrants departing from the train at Winnipeg, Manitoba. Note that two of the immigrants are holding on to musical instruments, an accordion and a ukulele. It is likely that these two gentlemen entertained other passengers with their music throughout the long trip west. n.d. Library and Archives Canada, R231-2232-9-E.

for his money, [ate the sugar] and threw [the bowl] out of the window of the train as soon as it started."

With regard to travelling arrangements, some people reported that rather than staying in the colonist cars, they stayed in the coaches that carried freight (settler effects) and cattle cars. They did this to not only protect their possessions and animals but they found it was cheaper to travel in this fashion. As set out by George Hartwell, a seven-year-old-boy who migrated with his parents in 1875, he and his father travelled "in an old coach at the rear of a trainload of settlers' effects. [My] father had charge of a car of ten oxen, which were used on red-river carts to make the trip overland to Saskatchewan." Andrew Veitch, another young fellow who travelled with his parents to Canada in 1903, explained he and his family members all travelled using this cheaper method:

> *My elder brother and sister aged about 6 and 9 years old respectively and myself were transported from Pierson, Manitoba to Fort Qu'Appelle, Saskatchewan, together with oxen, cows and chickens, also some furniture and implements by freight care on the…railway. My father was with us of course.… Travelling in the above manner was for the purpose of saving money to be spent later on other things.*

Christopher Atkings, a nine-year-old boy from England, also mentioned he travelled with his parents in 1898. His memory of the trip included the train ride from Winnipeg to Star City, Saskatchewan. He rode in the cattle car, while the rest of his family rode in the passenger train. Throughout the five-day trip, the "railway failed to place [their] car so that the cattle would be watered." The cows were very nearly dead on their arrival at Star City, Saskatchewan.

For others who travelled by train in colonist cars, many of them recounted other highlights of their trips, particularly the various types of people they met on the train. Ellen White, an eighteen-year-old from Ontario who was travelling in 1899, was impressed with her fellow passengers: "I met people on the train; all in the car were very friendly. We sang songs together. We went around North Bay, changed cars there. Men helped me carry my luggage. All were very kind." Joseph Mohl also found people very agreeable to travel with. When travelling from Montreal to Regina in 1908, he found "the train was full of French-Canadians apparently out for a good time. I could speak some French and English so it was not long before we got talking. They had a good supply of beer and whiskey and treated me and a few other immigrants most generously. Needless to say,

I received a good impression of Canadian hospitality right at the door step." Other people were less inclined to be as friendly, and, in fact, kept their distance. Mrs. John Knaus explained she and her family wore bags of asafetida (a herb with a strong, unpleasant smell) around their necks to ward off any diseases and illnesses they could potentially catch from the other passengers.

For other people who travelled the rails, their memories of the event focused more on the passing landscape than on their travelling companions. Flora LaRose, a ten-year-old girl from Ontario, who was journeying with her mother, commented, "It was rather interesting watching the passing towns and country pass by. Going around the Great Lakes when you could see both the engine and rear of the train at the same time." Alexander Cameron, who travelled from Ontario in 1902, stated that what he remembered most vividly were his first sighting of the vast prairie and his thoughts about settlement. He wrote, this sighting "struck me forcibly. I figured that it would be a great country if the government ever got immigrants into it." Some people had a somewhat different take on the passing geography. John Andres, an eighteen-year-old from south Russia, who came to Canada in 1892, wrote, "[The] trip from Montreal through the unsettled wilderness was a little discouraging and somewhat alarming. Some of the prospective settlers feared similar conditions awaited them in the west." Rachel Wallace, forty years old, from Ontario, who travelled in 1910, felt the same way. She was apprehensive about the "the bald prairies and complete lack of trees."

The trip on the train for other people was more difficult given they were involved in, or saw, railway accidents along the way. Mrs. John Knaus wrote of a harrowing experience that happened to her family before they actually boarded their train. She wrote, "A trainman pushed my mother and us three children off a railway track seconds before a train came thundering by." Harry Winder, a twenty-nine-year-old from the United States, also wrote of an accident that occurred early in his trip: "On my first trip to Canada, 1902, one of our party was instantly killed by a train at Willmar, North Dakota, USA." George McConwell, a thirty-one-year-old Englishman who travelled in 1910, wrote that he was also involved in an accident that happened "in the railway yards in Minneapolis, a switch engine in the night pushing some cars, sideswiped my car and another, on a switch, they turned the other car on its side, and tore some of the boards off the one I was in and tilted it enough to roll me out of my bed." He mentioned he was delayed for a day while the damage was repaired. Ada Christian, an eight-year-old from Ontario, gave a detailed account of

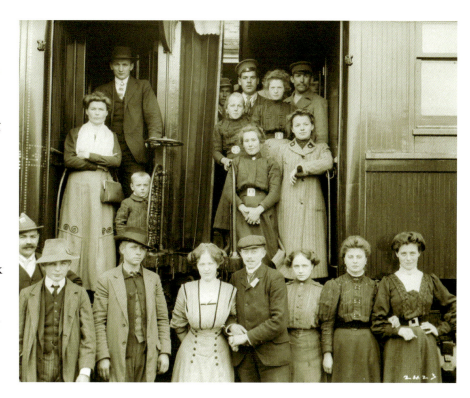

ABOVE: Immigrants from Hamburg, Germany, ca. 1911. Many Germans wished to homestead in a bloc settlement, while others were more independent and homesteaded throughout the province of Saskatchewan. For those who were attracted to living in areas surrounded by other Germans, many decided to settle in bloc areas near Balgonie, Humboldt, and Prelate, Saskatchewan. Library and Archives Canada, PA-010398.

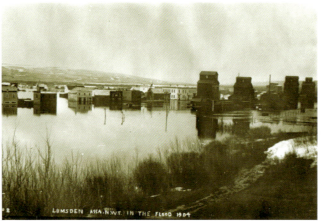

ABOVE LEFT: A group of people standing around the wreckage of an unidentified train accident. n.d. PAS R-A15577.

ABOVE RIGHT: Lumsden, Saskatchewan, during a flood in 1904. Given the town's low-lying area in a valley, Lumsden was susceptible to flooding. In fact, there had been an earlier flood in Lumsden in 1892. In order to solve this problem, the river was eventually straightened and dikes were built. PAS S-B88.

a dangerous train accident they were involved in, in 1883:

After several hours stay in St. Paul, U.S.A., we set out for Winnipeg. In the evening about 11 o'clock p.m. we were awakened by a terrible racket. The train was travelling faster than usual, bumping and swaying everyone in the coach. Got up as quickly as possible, pulling boots, coats, etc when suddenly we came uncoupled from the rest and they went on at a mad rate. The men went out to find something had torn the track so followed on for a short way perhaps a ½ a mile, and found cars of settlers' effects, stock etc. rammed into a bank upside down. Cattle bawling, pigs squealing, horses groaning, a horrible sight. Meanwhile the women and children in the coach on the track with no light. Saw a train coming. Mother dipped the broom in coal oil and sent my brother to signal the oncoming train and saved us!

Andrew Tait, a twenty-one-year-old from Scotland who came to western Canada in 1906, was not directly involved in a train accident. However, he and his fellow passengers saw one as they passed by. He wrote, "We passed the scene of a train wreck in Western Ontario—several horses were lying dead beside the wreckage near the track."

Other people had different experiences on the trains. Some remembered the snowstorms that occurred while they were travelling across Canada. William de Balinhard, a sixteen-year-old Nova Scotian, was travelling in 1882 when he and his companions "got stuck in a train in a snowstorm and had nothing to eat for three days." Wilfred Cobb, an eighteen-year-old young man from England, also reported on his experience on the train from Ontario:

[It was] just a good old fashioned blizzard which stayed with us for eleven days.... You couldn't see a thing for storm. The last three days was terrible. We got to Alameda at midnight. The livery barn had feed and water for the stock and men to rub them down.... The town stayed up and pitched in and we were soon eating our first good meal for eight days. I went to the store to get a plug of tobacco and all I had was a ten dollar bill. They just gave me the tobacco.

Instead of having to deal with snowstorms, Joseph Wilson explained he and other passengers faced problems associated with flooding in certain areas. When he journeyed in 1904, he had great difficulties in trying to reach Saskatoon, Saskatchewan. He took the "train to Regina and train to Lumsden, we were taken through here by boat as Lumsden was flooded out, and then into box cars to Saskatoon. When we got there, the bridge was out from spring flood so we were taken over to Immigration Hall by boat and had to stay there about 10 days on account of bad roads."

Three other people remembered other obstacles they had experienced while travelling by train. Wava Spratt, who travelled to Canada in 1906, stated that during the train ride, her family, which included her mother and nine-year-old brother, lost their trunks. Also,

there was no depot at Girvin and we wouldn't have known to get off train away down the track if a Girvin merchant hadn't happened to share a seat with me, and talking, learned we were to get off at Girvin. Having always lived in town and always used to a depot at every place,

ABOVE LEFT: North Battleford, April 1906. Margaret Smith and Edward Wilmot and their families had landed in North Battleford in 1905, and by 1906, when this photo was taken, a fair amount of development had already occurred in the town: two hotels had been constructed, a variety of stores were being built, and over two hundred homes were being erected, along with municipal buildings. PAS S-B5138.

ABOVE RIGHT: New settlers unloading at Arcola, Saskatchewan. Prior to 1903, few amenities were available in this village; however, by 1905 a hotel and a town hall had been built as well as a variety of stores. n.d. PAS R-A23903.

A LAND OF OPPORTUNITY

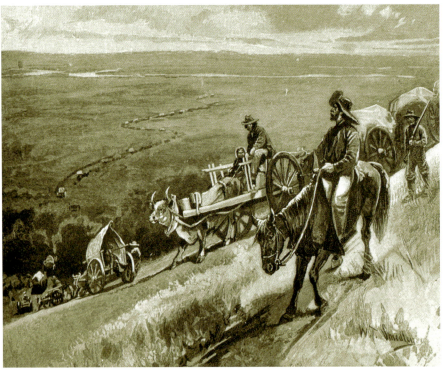

it took some getting used to jumping off anywhere. You could hardly see Girvin anyway, it was so small.

Margaret Smith, who was forty years old in 1906 when she and her family travelled to Saskatchewan, had the same experience. When they arrived in North Battleford, there was "not a house, nothing but the prairies. We expected a village, no where to eat and no where to sleep." Edward Wilmot, travelling with his wife in 1905, reported their train "finally crawled into what was to be North Battleford on what was possibly the first passenger train. Our luggage was dumped out on the ground."

THERE WERE NO ROADS TO FOLLOW

Individuals and their families said they used horse-drawn carts or wagons, covered wagons, or rode horseback for part, or all, of their journey. Joseph Kirkby, a thirty-year-old from the United States who undertook his journey in 1900, wrote,

My father and I took homesteads in the province of Saskatchewan near the town of Arcola. Before leaving our home in North Dakota, we constructed a covered wagon for our trip to the northwest. We also took a second wagon

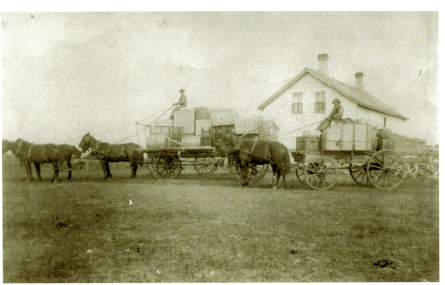

TOP LEFT: A line of carts descending a hill and crossing a valley. Going down a steep hill with oxen or horses and wagon could be very dangerous. Not only were manual brakes used (which were pushed against the wheel rim), sometimes the settlers would get off their wagons and push against them so that the wagon didn't pick up too much speed. If the wagon got loose and became uncontrollable, animals and people could be crushed by the wagon. Going uphill was a bit easier, as large rocks could be placed behind the wheels to give the animals, which were pulling the wagons, a break from time to time. n.d. PAS R-B3385.

BOTTOM LEFT: Horses and loaded wagons. Most settlers arrived in Saskatchewan with goods piled high on their open wagons. They would sit on top of the loads. Very few settlers could afford the extra cost of purchasing canvas-covered wagons, n.d. PAS R-A6797.

containing settler's effects; i.e. farm machinery and other necessary equipment. The trip by wagon required nine days.

Mrs. Charles Pickard indicated that once having reached Reston, Saskatchewan, in 1903, she and her family then had to venture on by horse and wagon to reach their homestead. She wrote,

We left Reston in the morning, camped out for lunch and fed our team. Then started on again. There were no roads to follow, no fences or anything to stop us so struck out and angled to the southwest. The prairie had been swept by fires every year so was [sic] no trees or anything in sight, just everywhere you looked was black. The land is a little hilly and some sloughs were full of water, so we just angled around these, would see piles of whitened buffalo bones now and then. This was where the buffalo had roamed early days. Saw plenty of game, wild turkeys, geese, prairie chickens, ducks and different kinds of birds. They were quite tame, would stand and look at us. . . . Arrived at our new home at dark. . .and held my baby daughter on my knee all the way.

Susan Therens, a thirty-six-year-old married woman who travelled to the West in 1914, described her family's experiences travelling to their new home near Myronne during the bitter cold of winter:

My husband located a man from the livery barn to bring us in an open two seated cutter, it was 60 below and 2 feet fresh fallen snow, we had blankets we offered the children, all up and went, no track broken, no fence to go by, for miles my husband and the driver changed off walking alongside the horses to stay on the hard road, we made it to LaFleche the first

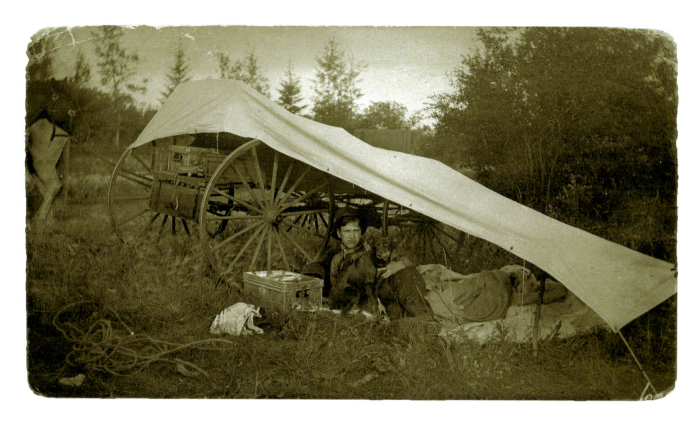

ABOVE: Camping for the night, Saskatchewan. n.d. Library and Archives Canada, PA-044604.

A LAND OF OPPORTUNITY 29

ABOVE: A Red River cart.
n.d. PAS R-A6596.

brothers' wagon crossed a creek, their wickered jug of blackstrap molasses fell out of the wagon and smashed into the creek. One of the Goodwin brothers gave Frank a broken piece of jug with molasses on it. He also wrote that because of this experience, the creek was later named "Blackstrap Creek," near Dundurn, Saskatchewan.

Frank Baines, a young child who travelled with his parents in 1883, recounted the experiences they had when travelling through a valley in the Qu'Appelle area:

The first great event was going down the hill into the Valley of the Qu'Appelle. Of course, we kids thought it a great picnic to run or walk behind the wagon. The wheels were chained together for the steepest parts of the descent and the road was very rough. When we came to the river, the...ferryman, pulled us across on an overgrown boat or barge, wagon, horses, and people all at once. Going up the hill was quite different. We were allowed to walk again. Progress up the hill consisted of a number of spurts. Some carried blocks to put behind the wheels at suitable places to give the horses a short rest. After much shouting [and] puffing, the top was reached!

Other people travelled to their homestead in Saskatchewan by using a team of oxen, rather than horses. Some had positive experiences travelling to Saskatchewan, while others less so. On a positive note, Marion Anderson, who was four years of age when she travelled to Saskatchewan from Manitoba with her parents in 1883, referred to notes her mother had written while they were on the trail. She wrote that her family travelled by "covered wagon drawn by a yoke of oxen.... There were 2 cows, 16 hens and some pigs along." In one day they had travelled "32 miles [which] was as much as the oxen could go in a short day. Next day—Saturday— went 25 miles—cows about played out. Sunday—glad to rest at Portage La Prairie.... A most beautiful country, well inhabited, hundreds of stacks in view all the time. Saw droves of cattle coming in from the United States."

George Hartwell explained that while travelling west to

day 30 miles, stayed there over night, started out at 9 in the morning, got to Woodrow at 4 in the afternoon, it was very tough going, we stopped gave the children something warm and started out again, got to Myronne in the evening.

Another settler, Frank Kusch, who had been a three-year-old child from Ontario when he travelled west with his parents in 1883, only remembered one thing about the entire trip. He said two brothers by the last name of Goodwin joined his family. When the Goodwin

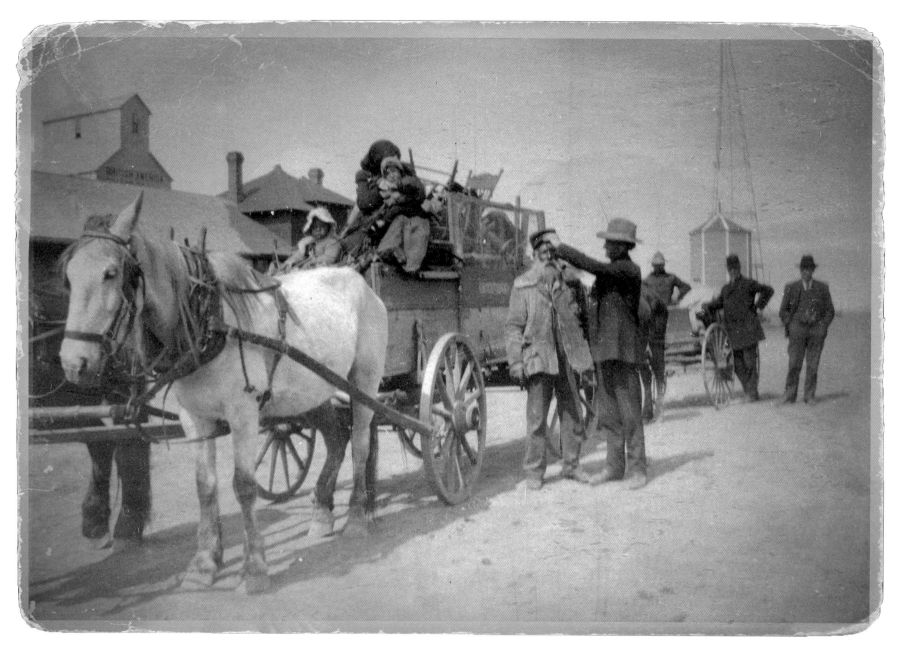

ABOVE: A horse-drawn wagon with early settlers and belongings. n.d. PAS S-B1846.

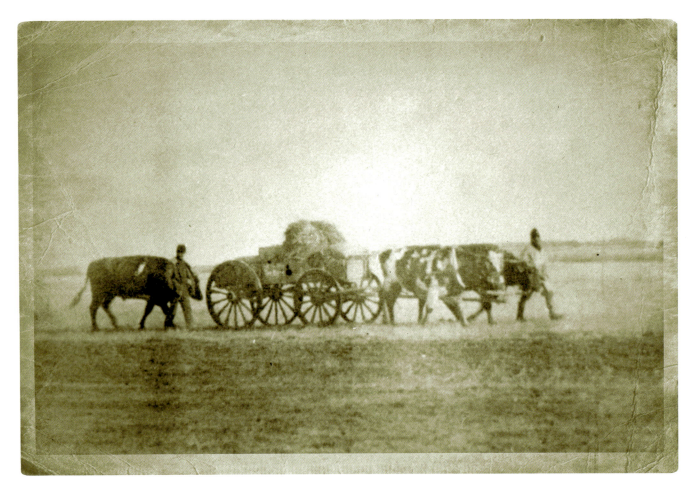

ABOVE: Early settlers walking with oxen and a wagon near Yorkton, Saskatchewan. n.d. PAS S-B4095.

Saskatchewan by oxen and Red River carts he and his family and other acquaintances in their party were delayed by a snowstorm in June for two days, then they got "stuck in the mud crossing the Saskatchewan valley where [their] carts sunk down to the hubs and which [they] were unable to move with even two and three yoke of oxen." He also remembered

squalling children, squealing cart wheels, singing humans, swearing men, bellowing oxen, laughing women, scolding women, quarrelling children, arguing men,
barking dogs and, at the end of a day, setting up tents, building campfires, visiting other families and always evening prayers.

Ernest Line, who had previously travelled from England to Ontario by ship, and then from Ontario to Moose Jaw by train, continued his journey to his homestead in Saskatchewan with oxen. He recounted the problems he experienced: "It took exactly a week to get from Moose Jaw to my homestead, 65 miles. The oxen were green and so was I. Their feet got sore. One day I only made 5 miles." Joseph Wilson, a thirty-two-year-old from Ontario, who came west in 1904, documented other problems he and his cousin and an acquaintance had when trying to drive oxen to their homesteads. He wrote,

[We] met a Mr. Newman, a painter by trade, and he bought a pair of steers that had just been tied together by the neck for about a week as broken oxen. My cousin William Softley and I bought a pair of small steers just nicely broken in and an old

32 THE HOMESTEADERS

wagon and harness all for $170.00 which was nearly all the money we had outside of supplies to do us for the summer. Mr. Newman had a nice team of steers, new wagon, a box with spring seat, a first class outfit. Oxen would weight about 1 ton and a half, but he did not know the first thing about them and was stuck so I told him to come with us and I would handle his oxen which he was pleased to do so. . . . What experiences we had on the road. I drove Mr. Newman's oxen for 2 days or at least rode with him until he learned something about them. After about 2 days, the oxen were tired enough to not be much bother. Mr. Newman was a green Englishman and I told him to say "Gee" when he wanted them to go right and "Haw" when he wanted to go left. He kept practicing saying Gee and Haw. He said "Aw" and about the fourth day about 4 o'clock, I got the gun and went out to get some prairie chickens or rabbits to cook for supper. I was out from the trail a piece when I heard Mr. Newman yelling "Aw, Aw, Aw". I ran out to see what the trouble was, and on account of the mosquitoes being so bad, his oxen headed on the run for a bluff on the right pulling down the small trees at edge of bluff and running in as far as they could go and it took us 2 or 3 hours to get the oxen and wagon out as the small trees flew up behind the wagon and the neck yoke was nearly choking them. It did not take me long with our axes to relieve the oxen.

Rather than having direct difficulties with their oxen, William Kenyon, Andrew Veitch, and Margaret McLellan had similar stories to tell about their sleeping arrangements while trekking toward their homesteads. William, who travelled west in 1905, wrote that he and his family "found it very cold sleeping in the covered wagon, as [they] had no stove. One night it was too cold to sleep in it, so [they] had to stay at a farm, at which there was no room, only in the stable with a lot of cattle." Andrew, a Scottish lad, wrote that his father had arranged with a settler "to give us shelter until he had gotten a sod house built for protection on his own homestead about ½ mile away." On arriving with their oxen and cart, the only space available was a roofed log shed that had formerly housed pigs. Margaret also had an interesting story to relate about her family's experiences while staying at a stopping place on the way to their homestead:

There was nothing unusual about our trek in. We stayed at Greenbanks all night, that was the stopping place. And Mrs. Greenbanks made beds for all of us. . .all over the floor, but we had a comfortable sleep. There were several others beside our family bedded down for the night. Mother, unable to sleep got up when she heard Mrs. Greenbanks moving around. The men had hung their wet socks up on a line over the kitchen stove to dry. Mrs. Greenbanks made a huge pot of rolled oats porridge and left the lid off. Mother going around the kitchen shortly after the porridge was boiling saw one of these heavily knitted socks fall in. Mrs. Greenbanks fished out the sock and stirred up the porridge. At breakfast, mother drank tea and took bread and a boiled egg. We children and father tucked in a goodly supply of porridge and enjoyed it. Mother told us afterwards. ❦

A LAND OF OPPORTUNITY

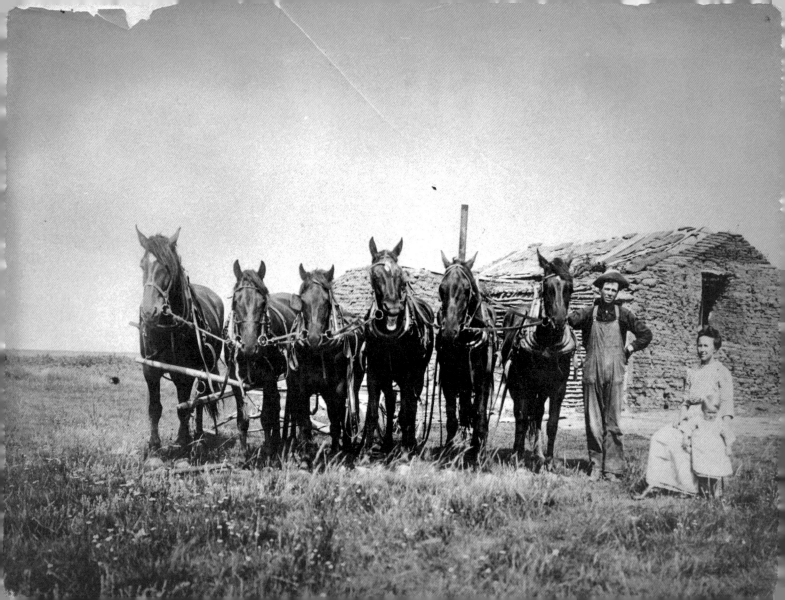

Chapter 2
Getting Settled

Once the homestead land was reached, settlers had to decide how they would build their homes given their financial means and the natural resources that were readily available. Settlers' homes were constructed using different types of building materials. If the settler and his family had extra finances they could draw upon, they would build homes with cut timber, manufactured shingles, and glass windows. For those who had little or no money, they would be reliant on the natural resources found on their land. They would build their homes out of logs or sod. Their roofs would have been made out of the same material, while the window coverings might be made of paraffin-dipped flour bags, paper soaked in lard, or the thin hides of deer. Along with their financial situation and ability to purchase products, the type of home built was also determined by the geography, such as the number of trees or shrubs available for construction purposes; the climate, where the extremes in seasonal weather made homes constructed of sod more popular given sod's natural insulating properties; and the past home-building and cultural experience of the settler, where they might have previously constructed log or sod homes in their mother country and were familiar with the practice.

When describing their first buildings on their homesteads, a number of settlers said they had built a log house for themselves and their families. Typically, the size of a log house was dependent on the length and consistent thickness of the trees available nearby or on the homestead. Depending on which part of the province a settler homesteaded in, various types of trees such as eastern cottonwood, trembling aspen, white birch, lodgepole and Jack pines, tamarack, balsam fir, spruce, and poplar trees would have been appropriate for use in house construction. One settler family, the Aikenheads, used spruce trees for their log home, while settler John

OPPOSITE PAGE: Mr. and Mrs. Charles Stewart Day with daughter, Lucille, posing with their horses in front of their home made of sod in 1906. PAS R-B1312.

Homestead Regulations

Under the homesteading program, as set out in an order-in-council in March 1871, settlers had to follow homestead regulations if they wished to obtain title to their land. Not only would the settler applying for the homestead land have to be male, or the head of the household, and twenty-one years of age or over, but the settler was also expected to take physical possession of his registered land within six months after applying and was required to live on the land for at least six months of every year for five years. In April 1871, a second order-in-council lessened the residency requirement to three years. In 1872, the federal government enacted the Dominion Lands Act to replace the 1871 orders-in-council. Requirements became more restrictive, with amendments in 1884 such that homesteaders were required to break at least forty acres and have twenty-five acres cropped by the end of the three-year period. This was subsequently reduced to fifteen acres broken with ten cropped within two years in 1886, when an additional duty, constructing a habitable house (also within two years) on the property, was added. An amendment in 1891 stipulated that homesteaders were required to build a house within six months of entering on the land, and break at least forty acres and crop twenty-five within a three-year period. In 1908, the number of acres broken and cropped was reduced to cropping twenty acres and breaking a total of thirty acres within three years. Other statutory requirements included an 1874 amendment, in which the age limit was reduced to eighteen years of age for single male homesteaders, and pre-emption rights were granted, enabling those who obtained their homestead patent (title) to obtain an adjoining quarter section of land to expand farming operations. In 1876, women became eligible to apply for homestead land, but only if they could prove they were the sole head of their family. If homesteaders did not meet the federal government's requirements regarding age, gender, productivity, and home development within the specified time frame, they faced the possibility of their registrations being cancelled and losing their lands and homes.*

* Lambrecht, *The Administration of Dominion Lands*.

Zacharias used poplar trees for the building of his house, barn, and stables. While not identifying the type of trees he used on his homestead, Arthur Wheeler wrote that he built a fourteen-foot-by-sixteen-foot log house in 1906 and then a log stable for his animals in 1907. The logs were from his homestead; however, he went to town and bought glass for his windows and lumber for framing. N. Scott Branscombe also used logs for his house and stable, both built in 1905. Kate Stirling's family relied on the same materials for their home, but they did not have any trees on their property and, as a result, had to haul logs from Cypress Hills, which was over fifty miles away.

HEWED LOGS WITH A THATCHED ROOF

For those settlers who resided in the areas of Saskatchewan where trees were sparse, many of them decided to construct a "soddie," a home made with sod bricks. Both Arthur Tilford's and Koozma Tarasoff's homes and barns were made from the prairie sod they had broken for cropping, while Nathan Covey's home was made out of "sod taken out of a slough." Martin Deusterbeck used sod as a building material in 1891 for his home. His walls were made of sod, as was his roof, with only a few poplar poles to hold the sod in place.

Instead of relying on just one type of material for their building supplies, some settlers used an assortment of different building materials to construct their homes. John Peacock's father

> built a lumber shack when he first homesteaded. When the family moved to it, the shack was too small so we built an addition out of sod. Our barns were of sod with walls four feet thick on the bottom. Poles and straw were used on the roof.

Similarly, George Hickley used diverse construction materials for building his first home, a log shack, in the spring of 1912. He had built it by himself, without the help of any neighbours or relatives. In fact, he mentioned

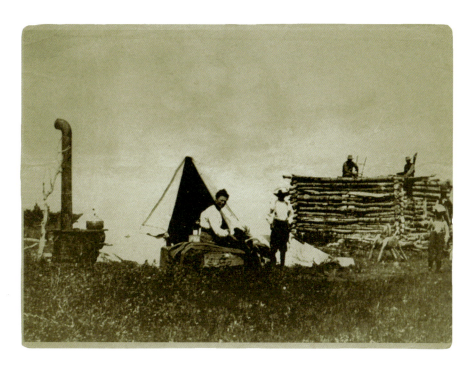
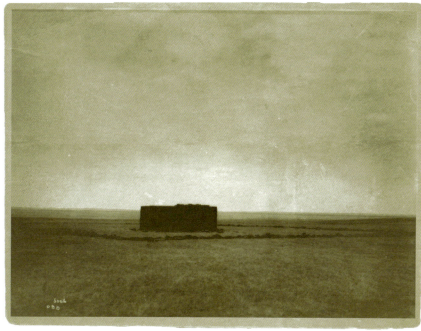

that the closest person to him lived over six miles away. He cut down trees he found on his own land for building the walls of the structure. However, he desired lumber for the roof, so he purchased it from the Cunningham Mill, which was twelve miles from his homestead. He mentioned the difficulty of returning home with his lumber, given there were no roads or wagon trails, so instead he floated the wood down the river and then dried it out before using it for building. James Tulloch also used a variety of building materials in 1904 for his home and stables. He wrote, "I built sod stables, one for cattle and one for horses. Also, I built a small shack built of dressed lumber and sods built all around it and on the roof." The lumber used in his shack was purchased from Yorkton, a town over one hundred miles away, and the sod used in construction was from a nearby slough on his homestead.

Like George and James, Joseph Wilson also used various materials when constructing his buildings. He built a house made out of logs, but his barn was made out

ABOVE LEFT: Italian settlers living in a tent while building their log home in 1903. The length of the logs, which often determined the size of the home, can clearly be seen in this photograph. Notching the logs at the corners was particularly important as it provided support and stability if done properly. It is also interesting to note the wood burning stove with stovepipe (on the left side of the photograph), ready to be installed in the newly constructed log home. PAS R-A10060.

ABOVE RIGHT: A soddie on the bare Saskatchewan prairie. No trees in sight. Eagle Creek, Saskatchewan, 1908. Library and Archives Canada, PA-039825.

GETTING SETTLED 37

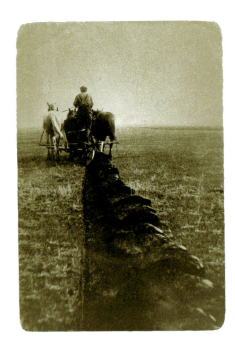

ABOVE: Ploughing the land into ribbons of sod. Once done, the sod was cut by knife into rectangles. The sod pieces could then be hauled over to the building site where the soddie was to be constructed. n.d. PAS R-A496.

RIGHT: Hauling logs by horse and sled in the winter. A man named Guy Hunter is standing on his logs. Travelling into the bush to cut down logs would have been a labour intensive task. Not only would the logs have to be chopped down with an axe, but all of the tree limbs would have to be removed as well. n.d. PAS R-A17721.

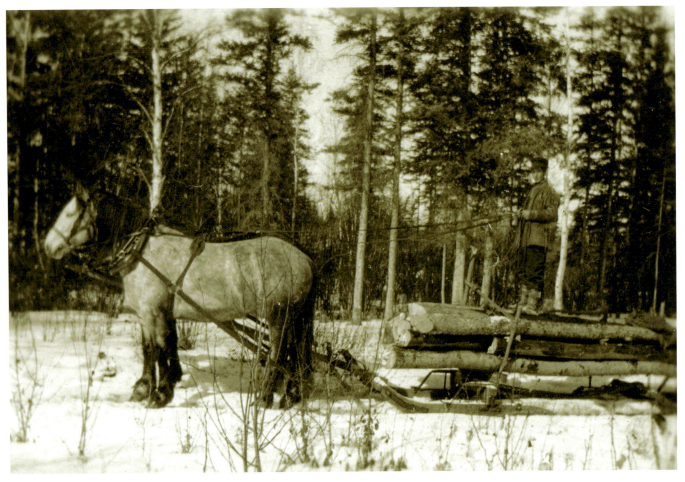

of sod. He obtained his logs from bluffs that were close to his home, and "he bought windows and lumber for doors, [and] tarpaper for the roof at a cost of about $20." He also pointed out that his neighbours helped him during the construction process. Another settler, George Hartwell, used logs from the bush to build his dwelling and barn, while Elizabeth Duncan's family home "was made of hewed logs with a thatched roof. The stable was made of sod with hay poles and sod roof."

Other settlers described living in dwellings that were somewhat different from the typical settler home. Lillian Miles's parents had built their "houses, barns, etc. out of mud, usually with thatched roofs," while Mrs. Robert Wilson remembered that her family had lived in a house that was built into the side of a hill. She recounted the problems with such a structure, as, one day, one of the horses

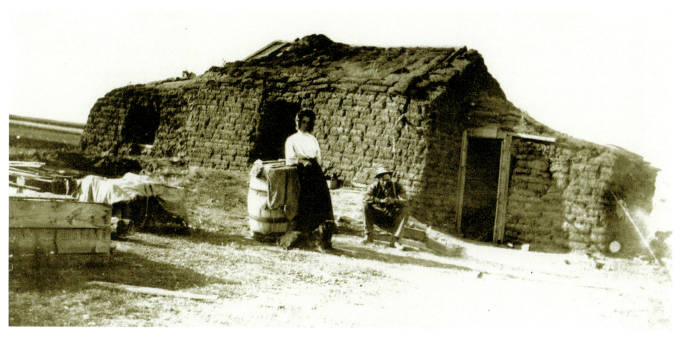

TOP LEFT: This house, owned by Mr. and Mrs. McNaughton, was made completely out of sod except for the framed door and windows. Note the extensions added on to the original soddie to make the home larger. Homesteaders tended to do this as their family grew with more children. ca. 1910. PAS S-B2144.

BOTTOM LEFT: A homesteading family in front of their log house with sod roof and tarpaper siding. ca. 1903. PAS R-A7226-2.

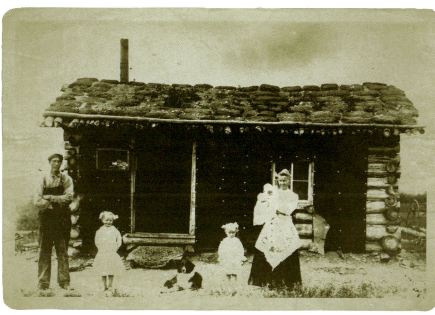

wandered down the hill and onto the roof of their home and fell through. Mrs. Wilson did not elaborate on how her family managed to remove the animal from their home, or what kind of damage was caused to the house or injury to the horse.

Other settlers who had extra funds on hand were able to build framed homes with purchased cut timber. Alfred Gibson built a twelve-foot-by-fourteen-foot home in 1904, as well as a fourteen-foot-by-twenty-foot barn. Both structures were built from lumber purchased from the Hind Lumber Company in Moosomin. Lena Purdy said her family's first house was a framed, fourteen-foot-by-twenty-foot, one-and-a-half storey dwelling. However, the other buildings on the farm were made with other types of construction materials. Their first stable was made of logs, with a second stable being built of poplar poles filled with straw and manure. The henhouse was made of sod bricks.

GETTING SETTLED

The Cost of Hardware and Building Supplies

The following were some of the products offered to settlers by Sears Roebuck in its 1902 catalogue:

- glass windows ($5.15–$9.70 each)
- wooden doors ($4.15–$12.15 each)
- hinges ($.08–$.18 per pair)
- gate hook and eyes ($.15–$.45)
- door latches ($.54–$.64 each)
- door locks ($.51–$1.04 each)
- smoothing planes ($1.90–$3.50 each)
- steel framing squares ($.20–$1.00 each)
- spirit level ($.35–$1.25)
- plumb bob ($.10–$.15)
- shingle hatchet ($.40–$.50)
- hammer ($.35–$1.25)
- carpenter's rule ($.08–$.45)
- a set of tools (saws, planes, hatchets, wrenches, knives, pincers, clamps, and chisels) ($15.00).*

* *Sears Roebuck Catalogue* (New York: Crowne Publishers, 1902).

SNAKES IN THE BED

Along with describing the exterior construction materials used in their homes and other farm buildings, many settlers also commented on how the interiors of their homes were finished and how important this was for family comfort. Whether they built with logs or with sod, many settlers put extra effort into smoothing the walls. For those with sod walls, a settler would take a spade or a hatchet and slice off any root or sod protrusions that stuck out from the walls. For those with log walls, gaps and spaces had to be filled or chinked with a mud mixture of dirt and water and allowed to dry. Afterward, additional work was done so a flat and smooth surface could be obtained, which could then be whitewashed, giving the interior an adobe-style look. Some settlers went further and covered their whitewashed walls with coloured pieces of cotton, newspaper, or white building paper, personal letters, or pages from catalogues or magazines. Mrs. Gust Gubberud's walls were covered with pages from the *Minneapolis Tribune*, a copy of which she brought with her when she travelled to Canada from the United States.

For those settlers who had built soddies but did not have the extra funds to finish the interior walls, they experienced some unique problems. Mrs. Day and Mary Cossar said their families had to contend with the nuisance of having a number of mice and mouse nests lodged within the sod walls. As such, they constantly had mice running through their house, over their beds, and hiding out in cupboards. While these women did not come up with a solution to their mouse infestation problem, another settler, Richard Day, came up with an idea that saw the end to all of the mice within his home:

> *I was bothered with mice in my sod shack and as there was no cats, I brought a couple of garter snakes up from the creek and put them in the sod wall. They cleaned up the mice. A neighbour by the name of Ben Shepherd put up with me one night after a hard*

OPPOSITE PAGE, CLOCKWISE FROM TOP LEFT: The home of the Marshall family was made of hewed logs and had a thatched roof. n.d. PAS R-A1528; It took some skill to make sure that a home would be structurally sound and would not collapse. These enterprising men have used a variety of building materials (logs, cut lumber and mud). However, one has to wonder how long the structure remained standing given the unevenness of the walls. n.d. Library and Archives Canada, C-027596; Frona Woodman's homestead, Davidson, Saskatchewan, 1904. His home was a simple framed dwelling using cut timber. PAS R-A20203; The Henry J. Brumberg homestead, 1909. Note that the house is decorated with oxen skulls. PAS S-B7573.

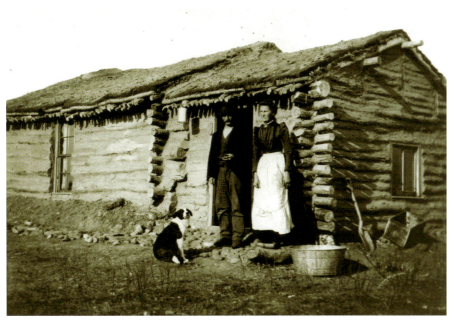
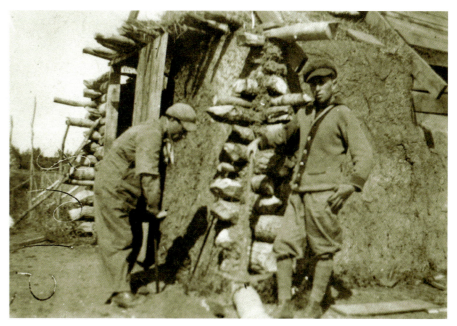
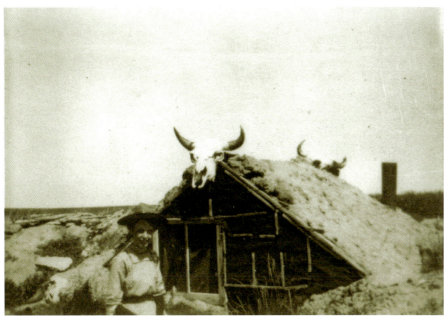
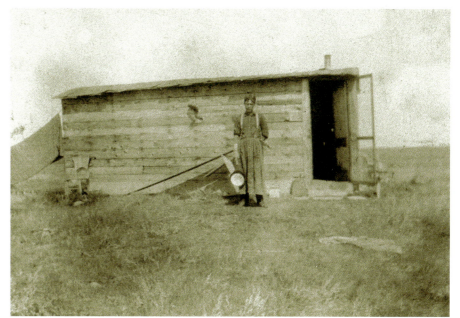

GETTING SETTLED 41

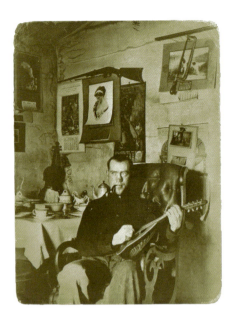

ABOVE LEFT: This bachelor, Charlie Sprig, decorated his walls with numerous calendars, musical instruments, and a rifle. n.d. PAS R-A26902.

ABOVE RIGHT: The Yurko Goronko log home with a cut timber roof built in 1910. Note the whitewashing around the exterior door and windows. Whitewashing was beneficial as it prevented mildew and served as a disinfectant and insect repellant. PAS R-A20804.

day on the trail. He was tired and soon climbed into the bunk, but got out quicker. "Gosh, there is snakes in the bed!" is what the man said.

Unfortunately, Richard did not elaborate on whether the neighbour decided to stay overnight, whether they were able to dislodge the snakes from the bed, or what the alternate sleeping arrangements might have been.

Along with mice problems, another settler, Hilda Rogers, reported that various types of animals, such as gophers, would try to burrow into her soddie, while other settlers described incessant bug infestations. Robert Cairns remembered his family's experience when they moved into their log home:

We moved in, the spring of 1903.... and the house was infested with bedbugs. We organized bedbug hunts—the bugs came out at night and crawled across the ceiling and walls. By putting a lighted kerosene lamp under them, they fell into the lamp and were killed. My father also painted all the cracks in the walls and ceiling with kerosene. We got rid of the bugs in one summer.

Other settlers detailed their experiences with unwanted snakes slithering through the sod, cutting back tree and grass roots that continued to grow into the house, and the ever-continuing problem of dust and loose dirt that fell from unfinished ceilings and walls.

Soddie dwellers experienced additional problems, particularly if they were not able to afford lining such as canvas, oilcloth, or wallpaper for the ceiling. While those with log homes tended to have roofs that were impenetrable to rain, thanks to the use of ship-lapped shingles and tarpaper, those who built soddies had to deal with roofs that were made out of layers of sod, which were not waterproof. As such, settlers and their families were challenged with coping with a deluge of mud and water whenever it rained, particularly if there was a continuous rainfall over many days. When this occurred, alternative methods of everyday living had to be adopted. Some settlers had to move their beds to the drier corners of the home, while others took to

sleeping under the kitchen table, where they were protected from the dripping rain. Buckets were also used to catch the drops of water, and blankets were held up over the stove, in an umbrella-like fashion, so clumps of mud or rain would not fall into their dinner while they were cooking. One settler, Ernest Ludlow, recalled the time when his "brother Jim had to seek shelter under a table covered with oil cloth (the only dry spot in the 10 x 12 shack with a sod roof) to mix his bread batter into dough."

For those who experienced wet weather over an extended period of time, they had to become accustomed to living in constant dampness. As set out by Delia Crawford in her memoirs, her family had to deal with fifty-two straight days of rain. During this time, they were confined to their soddie, walking through inches of rainwater on the floor, living in wet clothes, and sleeping in wet beds. Not only was it claustrophobic but it was hard on her family's morale and health. Conditions eventually improved when clearer skies prevailed and the sod roof began to dry. Even then, the smell emanating from the wet dirt, wet clothing, and damp furniture clung to the air within their home for days afterward.[1]

Settlers also commented on the flooring they used within their homes. For those who had trees nearby, they were able to use boards they had cut from logs. They either laid these boards flat side by side and planed and grooved them in a ship-lapped fashion so the boards fit more closely together, or they sliced the logs so the floor was covered with wooden circles. One settler tried to upgrade his family's living space by painting the wooden floor, while another had brought maple boards with him from Ontario to use as flooring in his new home. Other settlers who did not have the time, energy, or extra materials available to construct wooden floors for all of the rooms lived with dirt floors in some of the rooms and wooden floors in others, while others who lived in soddies lived with dirt floors in all rooms. In all cases, settlers and their families tended to make their living conditions as comfortable as possible by covering the floors with rag mats, carpets, or hooked rugs.[2]

ABOVE: Three generations of Croatian settlers at Kenaston, Saskatchewan, in 1910. Note the pride they had in their two horses (centre of photo). To many homesteaders, owning horses signalled that they were doing very well financially. Library and Archives Canada, c-089701.

GETTING SETTLED

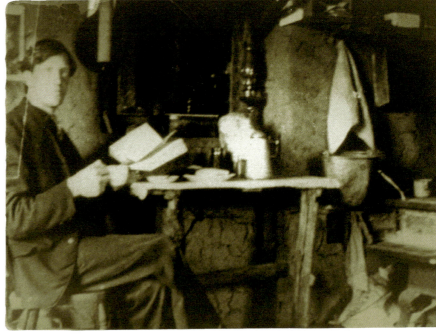

ABOVE LEFT: A woman making a rug on a frame outside of her log home in the Mistatim area. Decorative motifs were added during the weaving process. n.d. PAS R-A8543.

ABOVE RIGHT: John Phitzpatrick with his home-made furniture. n.d. PAS S-B1059.

MADE BY HAND

Once the log or sod home was completed, time and effort were taken by settlers to improve the interior of their living conditions with furniture and other home furnishings. Jacob Stratychuk had "beds, tables, chairs, benches and cupboards [that] were all made of poplar [trees]. Legs and boards were all made by hand, cut with a saw and planed with a hand planer." Much of James Cooper's furniture was also made of poplar trees. He owned "a stool made from a poplar log, a poplar bed, a big trunk, cook stove, and a table made of two boards hinged to the wall." Another settler, Hilda Rogers, whose family had moved from one small sod shack to a larger one on the prairie, was also reliant on poplar logs:

During the first summer, we placed six packing cases on each side of the shack, placed our beddings on each, curtain down the centre to divide it and those were our beds until the fall, in the 12 x 12. When the larger sod shack was built, my father made bed frames from poplar poles, peeled them and used small willows across to take the place of a bed spring. He also made a table in the same manner but bought some boards for a top. We were well supplied with materials to make things look home-like and comfortable.

Other settlers used the barrels and boxes that were filled with such staples as flour, sugar, and syrup or fruit they had purchased from their town store before heading out

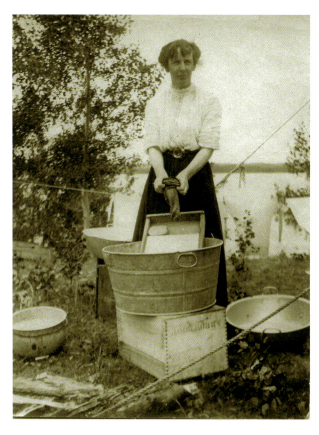

to their homestead. As described by Herbert Harrison, "In our first log house, our furniture was mostly store boxes and our first arm chair, I made out of an apple barrel cut down and filled with hay." Other settlers found other practical uses for their empty containers, particularly the boxes. The boxes could be nailed to the walls (if the home was framed with logs) and used as kitchen shelves or bookcases, while the trunks they brought with them during their move to the West could be used to store their clothes.

Other types of furniture or furnishings settlers owned included framed pictures of family members, rocking chairs, sewing machines, dressers, mirrors, homemade curtains for the windows, tablecloths, towels made from old linen shirts, patchwork quilts, prairie hay mattresses, and rugs made from old clothing. Pianos, iceboxes, and cooking pots, plates, bowls, and utensils were also noted, as was the flannel or canvas settlers used as room dividers. Many settlers also owned a cookstove for heating and cooking and purchased kerosene lamps for lighting in the evenings. Amanda Aikenhead owned a "homemade sofa, two wooden beds, a clock, table, chairs, cookstove, dresser, washstand and a homemade table," while Lottie Diggle had "lace curtains, carpet, a chair covered in red cashmere, cupboards, tables, benches, and cross-stitched and weaved pictures."

Some settlers also improvised by making bedsheets out of flour sacks, ticks out of old overalls, and quilts stuffed with raw wool and cattails. They also made rugs from all sorts of old clothing and created baby cribs out of tree trunks. Women also crocheted table covers and lace, and used wool for knitting socks, mittens, and sweaters.

FAR LEFT AND RIGHT: Tubs for washing clothes served a dual purpose. They were also used as outdoor bathtubs for children during the warmer months of the year and as indoor ones during the winters. Children took turns sharing the same bathwater, with the youngest having the bath first. Photo left: PAS S-A186 VIII 41; Photo right: Author's personal collection.

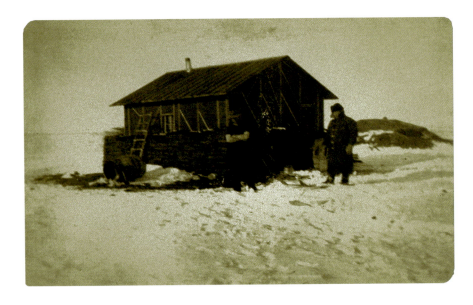

ABOVE: John and William McNaughton building a tarpaper shack, insulated on all sides with layers of sod. In the background is an ox barn which was part of a dugout (dug out of the side of a hill). 1905. PAS S-B2143.

A LOT OF HARD WORK

Rather than describing their home furnishings, other settlers recounted a variety of other interesting or memorable experiences about living in their log or sod homes. Francis Krischke and James Cooper remembered how they banked up the sides of their log houses with dirt, saw dust, or straw in order to insulate their homes from the extremely cold temperatures of the winter months. Mayfred Dunn's family nailed tarpaper onto the outside of their door and banked their house with cow and horse manure, while Edith Stilborne's family banked up their home with snow. Windbreaks were also used to protect the family home. Robert Widdess built his home so it was surrounded by a grove of oak trees, while William Evans built his home beside a natural bluff. Other settlers like James Barrie planted a shelterbelt of hundreds of young trees along their properties that would eventually mature into strong windbreaks, while others, like Benjamin Saloway, surrounded their homes with elm, ash, and caragana trees and shrubs.

Mrs. Gust Gubberud recounted one of many memorable experiences she and her family had in their sod home during the first winter they lived in it. As she told it, the sod roof began to seriously sag because of heavy snowfall. Before the roof actually caved in, the family quickly worked to rectify the problem. A brace was quickly installed in the middle of their fourteen-by-sixteen-foot home, so the ceiling did not collapse inward.

Other settlers described the problems they encountered during the building process. Building the soddie was particularly difficult, as "they were inexperienced and it often rained or they had bad weather during their building." Margaret McMannes described the multitude of mosquitoes that were constantly biting her family while they tried to build, while others reported it was difficult to control the oxen and cows, as they would often wander off if not attended to. Some remembered having to live in a tent while constructing their homes, while other settlers, like Kenneth Smith, focused on the amount of labour that was required when building a home. Stripping sod from the earth, creating walls with heavy sod bricks, building a proper roof, and dealing with the labour-intensive hardship of day-to-day living on the prairies, Kenneth simply stated that the entire gruelling and demanding process was "a lot of hard work."

Settler William Monaghan's most memorable experience was his close encounter with a dangerous animal that happened to find its way into his home. He explained, "Once when I went away after plastering the house, I left the door open for circulation. A bear came inside prospecting and wrenched open a suitcase." Along with bear problems, timber wolves also used to be a source of anxiety for the Bridle family. Emily Bridle wrote, "The timber wolves used to come around the house at night and it used to make us afraid to even breathe. When they howled, you would think there were hundreds of them."

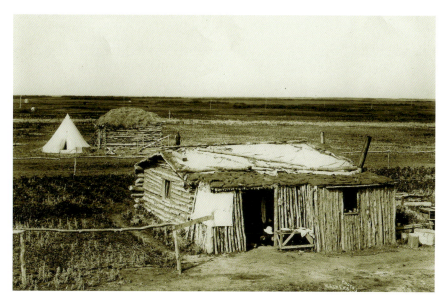

LEFT: A log house with a sod and straw–covered roof, 1904. This photo also shows the tent that the settlers lived in while building their home and a stable that they constructed as well. PAS R-B947.

RIGHT: Four bear cubs in a tree. Prior to fencing, it was not unusual to come across wildlife on the homestead. In some instances, meeting up with wildlife could be dangerous as some animals would attack if they felt threatened. Brown and black bears were common, as were cougars, coyotes, and wolves. Smaller wildlife included weasels, porcupines, skunks, and fox. n.d. PAS R-A5250-1.

MOTHER WAS KILLED

For others, weather conditions were at the foremost of their minds. Robert Cairns's family had problems in the spring when the snow started to melt. He wrote that the house

> was subject to flooding when the snow went in the spring. The water could not get away from the kitchen door, I should say, which was at ground level. So we just mopped up the water as it ran in and carried it out in pails. This only happened about one day in a year. Sometimes we bored holes in the wood floor and let the water soak away into the earth under the building.

Rather than having to deal with flooding, G. F. Gudmundson recounted a terrifying and tragic cyclone:

> The cyclone came with such a speedy onrush that even if there had been an adequate shelter available, none of us would have reached it in time. It had been a hot, sultry morning, with an ominous, oppressive feeling in the air. We noticed the massing of dark storm clouds in the west and expected an electrical storm.
>
> Then came the cyclone. It touched the ground about a mile to the west of us, at a distance from any buildings. It cut a swath through the wooded area, went over and down a hill, then raced on to our homestead on the bank of a coulee. My first sensation was of a great blast coupled with a terrifying darkness.... I thought that this was it. Then came a blackout. I came to and saw our nearest neighbour, Able Gislason, bending over the body of my mother, muttering and glancing around with a bewildered look. Rain was coming down like a cloudburst—this, I suppose, is what revived me.... then the sun shone again.

GETTING SETTLED

RIGHT: View of a fireguard being constructed and ploughed, 1913. Prairie fires were of great concern with respect to both property and lives. Many settlers hoped that a fireguard would protect them from the ravages of a fire. PAS R-A9770-4.

The house, a three bedroom dwelling, the barn, granaries, and all other buildings were torn to smithereens. The house was burning, probably set on fire from the cookstove. Wreckage was scattered like driftwood over the countryside. Even now we occasionally find splinters here and there, or a battered kitchen utensil miles away down the coulee bank. Our farm machinery, a binder, seed drill and other implements were carried away and twisted so badly, they could never be used again. Yet, a supply of sawed wood which my father had neatly piled about ten feet away from the house was undisturbed and the milk pails placed on the wood pile to dry in the sun were still in place.

My mother was killed, my sister was seriously injured, my brother had body lacerations and a multiple fractured leg and two other members of the family and a visiting guest had minor injuries.

Another settler, Mrs. Flora Fennell, also remembered a devastating cyclone that tore through her community:

August 14th, 1899, a hail storm and cyclone went through the country and took all the crops and killed hundreds of prairie chickens, uprooting trees and tearing down buildings. Mr. Smith's house had their roof taken off and their little girl was killed. Father's house, a two story log house and shingled roof was torn to the ground with father, mother and us three girls in it. The neighbours came and helped rebuild it.

Another threat that put many lives at risk on the western prairies was the prairie fire. Such fires could spread for miles and, in combination with strong prairie winds and dry grasses that burned quickly, overtake a homestead within minutes. Prairie fires could be started by lightning storms. John Peacock said, "The worst prairie fire I saw was set by a dry lightning storm. We had our buildings well fireguarded from the west as that was the direction of the prevailing winds but this fire swept up on us from the south east and we had to do some quick work to save our buildings." Other prairie fires could ignite by sparks thrown from farm machinery. Arthur Wheeler said, "Prairie fires were very bad in the early days as there was much old prairie grass and if a fire started, it swept for miles uninterrupted, burning haystacks and homes." Settler Harry Ford said prairie fires were severe and a common event given the sparks set off from trains as they rolled over the rails.

The devastation caused by prairie fires was recounted by a number of different homesteaders. Edith Stilborne wrote that "prairie fires took their toll every autumn," particularly in the early years of homesteading when the grasses were dry and very few fireguards had been created through the breaking of land. Amanda Aikenhead stated, "Prairie fires destroyed a lot of hay in 1896 and farmers had to make hay over again." Another settler said that during "the fall of 1885 there was a terrible prairie fire extending over a large part of the prairie between the Qu'Appelle

Valley and the C.P.R. We saved our buildings and stacks but felt the loss of the pasture, especially in '86 when it was very hot and dry."[3]

Other settlers reported more serious consequences when their homes were overtaken by prairie fires. James Tulloch wrote, "I had a fire that burned down my shack and one horse stall and a large amount of hay. As the nearest homesteader was about 2 miles away, I had to live in a tent until spring.... The worst prairie fire was in the fall of 1895. Many settlers were burnt out. They were forced to sell out their stock." Similarly, a prairie fire also burnt out Richmond Bayles: "All the fireguards we plowed were of no avail. It took weeks before we located all our stock." Sydney Chipperfield also commented on the prairie fire that affected his homestead in 1896. He wrote that it was "a disastrous prairie fire. We lost all grain, feed, stables. Eleven good pigs, harness etc."

William Rice had to deal with two prairie fires from different directions at the same time. Holding back the fires "took the effort of every available person." Even so, both fires burnt portions of his land. Norman McDonald's and Clarence Sentence's families also faced prairie fires and, in both cases, lost their homes. Their log houses burned down and they were forced to start again from the beginning and rebuild.

The Prairie Fire *By James Morton*

A night of fire! A night of fire!
No bells rang loud and far,
But skies were tagged and
 fringed with light,
And blood-red was each star.

It shone within the river's depth,
Whose streams like blood did run,
We saw the red moon in the sky
Look bigger than the sun.

The flashing windows
 roused from beds
The settlers far and near
The plows came rattling
 from the sheds
The horses shook their gear

The reddened stars in misty light
Half-hid in shrouds of grey
Saw ill-clad men toil half the night
To guard the wheat and hay

With rugged furrows fringed around
The settlers' homesteads stood
Like ships that can an earthly wash
Amidst a bellowing flood

Their homes made safe, they
 next drove forth
To where the long-ranked fire
Moved like a fierce invading host
With dread destruction dire.

Like straws against that fiery wave
Were puny hands of men
The blots they made within the flames
As quickly heated again

The fire rushed on, the panting men
Stood on the blackened sward
They watched their homes,
 and in their hearts
They prayed unto the Lord

The children slept within their beds
The anxious wives looked forth
And trembled like the
 quivering flames
That roared to west and north

The timid rabbit crouched for death
The deer went bounding by
The warm waft of the fiery breath
Came nigh—and still more nigh.

In sparking spots upon the plain
Like watch fires flaring high
A distant stack of hay or grain
Went blazing to the sky

The wind swept on the rolling smoke
And through the lessening night
We saw the distant forms of men
Beat moth-like at the light

The rugged fireguards
 stood like shores
Beat round by fiery foam
They turned the tide of terror back
And saved the settler's home.[*]

[*] *The Nor-West Farmer*, October 20, 1900, 829.

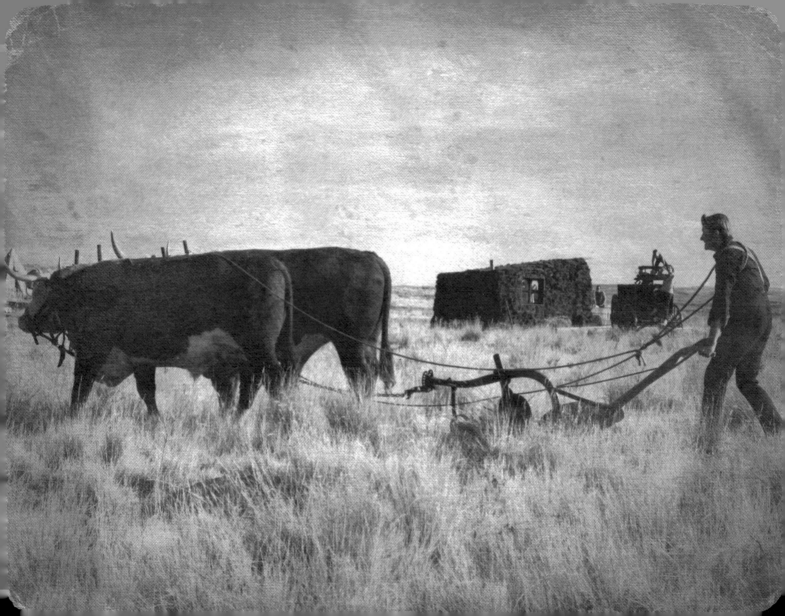

Chapter 3
Working the Fields

As mentioned earlier, the majority of settlers began their homesteading efforts by registering for land for a ten-dollar registration fee.[1] For many homesteaders, the registration fee was just one of many expenses that were initially incurred during the early part of their farming experience. If a settler and his family did not have any money saved for farm expenditures such as tools, equipment, seed, livestock, and poultry, or if they did not have any funds for clothing, bedding, boots, shoes, food, or any other necessities needed for daily prairie living, they were compelled to find the financial means in order to buy these goods.

To get a start on their homesteading operation, many settlers had to borrow money from family members, buy on credit from the local merchant, or obtain loans from financial institutions. Joseph Wilson ended up borrowing fifty dollars from his sister and "managed the balance of the homestead by working out in the winter." Arthur Tilford was more reliant on the credit extended to farmers by the local town merchants. He said, "The local merchants sold everything on time until we got our crop off." He also mentioned he had made a few extra dollars by working as a labourer on the bridge at Battleford. Like Arthur, Frank Baines also bought necessary items on time from the town merchants and made all of his payments as they came due.

James Tulloch initially tried to acquire a loan from a bank, but he was unsuccessful, as he could not provide security for the loan. He stated, "I remember the year 1900, I had to buy a binder as I had no means to pay cash and the banks would not lend unless good on security." Luckily for James, some business owners were more lenient in their dealings with homesteaders:

OPPOSITE PAGE: A settler breaking soil with oxen and hand plough. Note the poor posture he had to adopt in order for the plough to break the soil. His sod house is in the background. n.d. PAS S-B5686.

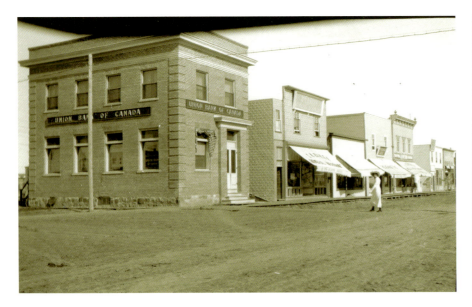
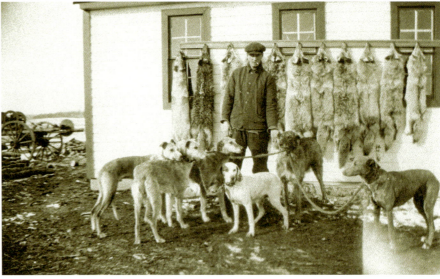

ABOVE LEFT: Union Bank of Canada in Kindersley, Saskatchewan. n.d. PAS R-A9376-9.

ABOVE RIGHT: Charles Dash in front of a rack of coyote pelts. He likely used his dogs to track and kill the coyotes. n.d. PAS R-A20938-1.

Levi Beck (in the Yorkton district) had a frost and wood binder. He was the agent for that Company. He let me have a binder, 6 foot, no down payment. Pay the interest on the value of the binder. The interest was 8 per cent, the value of the binder was $150 cash on two payments. I cut my own crop and two neighbours. I paid the interest that fall and paid for the binder the next fall.

Unlike James Tulloch, James Cooper was more successful in his efforts when dealing with a financial institution in order to secure a loan and acquire cash for farm necessities. He obtained an initial loan for $350 to $400 when he first started on his homestead and, later on, after he had received title to his land, he acquired a mortgage in 1911 for $300 for further improvements. Other settlers recounted how they had obtained mortgages after receiving title. George Bruce mortgaged his 160 acres in order to have some extra working capital available, while Albert Elderton mortgaged his land to purchase a team of horses. Arthur Wheeler mortgaged his land for $400 in 1911, while Harry Ford mortgaged his land at 6 per cent interest, which took years for him to pay back. Samuel Ellwood, who also obtained a mortgage, had to deal with a higher interest rate of 8 per cent. It took him six years to pay off his loan. Mrs. Jessie Cameron, instead of mentioning the interest rate, described the toll the debt took on her family. Her family borrowed money and "pretty near starved to death waiting for good crops. We always paid our debts first." Other settlers described how dire circumstances could become for those homesteaders who could not meet their payments, and how they ended up losing their land to their creditors. Lillian Miles said, "All the people in our district lost their land through mortgaging their land to purchase a community threshing machine (Minneapolis Moline). They had no crops for a

few years and could not make the payment and the company took their land in payment." Bertram Butterworth also recounted how so many of his neighbours lost their homesteads through financing problems:

> *We were always two steps ahead of starvation. In fact, 80% of the farmers around me lost their homesteads to the loan companies or lumber companies. High interest rates were the cause. Banks took 9% compounded every 3 months, loan companies 8% compounded and machine companies 8% till due; 10% after due compounded. Inside of 15 months from the day they took up their land, they lost it.*

Other settlers used a variety of sources to help with their financial situations when they first began their homesteading experiences. Amanda Aikenhead and her family sold cattle and pigs and tried to save money wherever possible. Many members of Frank Baines's family worked off the farm, while his mother stayed at home and washed clothes for the local bachelors. She bought her first heifer calf with her earnings. Lena Purdy said her mother also did washing for the bachelors, but, in addition, she mended "for some of them, baked bread for others, and always had open house for them. When we started, we had little to go on, and we sometimes made wild fruit into jam for sale. One year we sold a lot to the CPR for their construction camps. In 1892, we bought a few sheep and learned to spin, and sold double knit mitts, enough to help considerably."

While such ventures helped to enhance the Purdy family funds, other homesteaders had their own financial problems to overcome. Lena recounted the story of her husband, Russell, a bachelor who came to Saskatchewan with his brother in 1886:

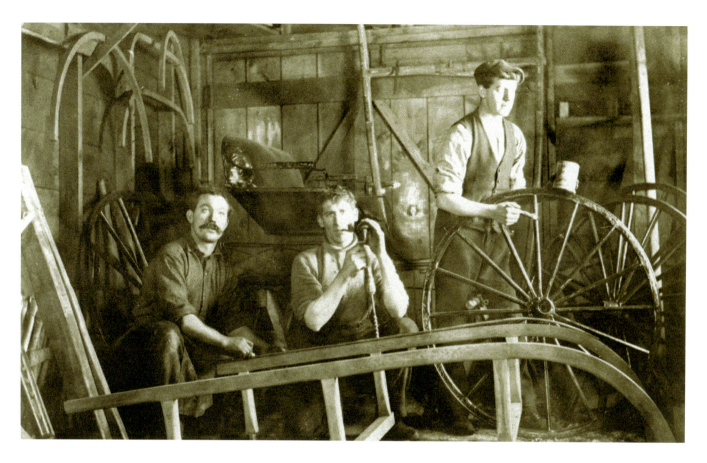

ABOVE: Jack Stewart, Sandy Beveridge and Andy Beveridge, Broadview, Saskatchewan. Some men worked for other farmers or worked in town as blacksmiths or in the livery stables. n.d. PAS R-A18790.

WORKING THE FIELDS

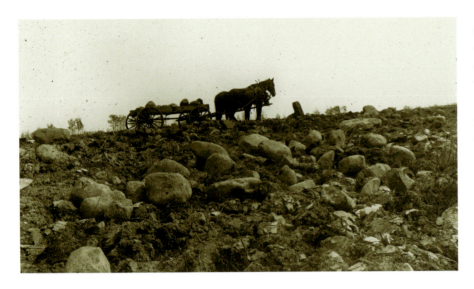

TOP LEFT: A wagonload of rocks pulled by a team of horses standing on a very rocky piece of land in 1910. Trying to clear this land to ready it for seeding would have entailed backbreaking work given the weight of the rocks and boulders. It would also have been a very time-consuming task. PAS R-B3031.

BOTTOM LEFT: George Sinclair, with daughter, Gladys, and son, Orville (sitting on plough), Rosetown District, 1908. PAS S-B6919.

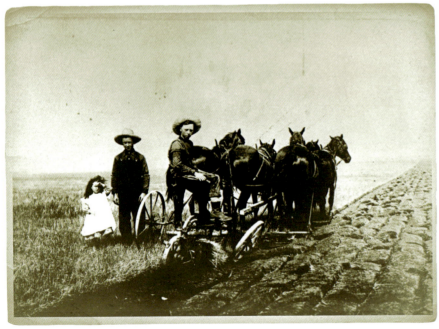

[In that year], the first severe drought struck and there was little crop. Russell Purdy went to Lethbridge where the government was building a jail and some other buildings and he got work as a carpenter there. To save all he could, he took his own bedding and as soon as a building was enclosed, he made a bed on shavings. He brought a nice bit of cash home in the spring and bought cattle.... Russell built a shack on his homestead and his brother built a small warm house on his homestead with a small cellar under it. From the first they made a garden and raised most ordinary vegetables and the bachelors baked good bread and even pies, picked and canned wild fruit. They let calves run with the cows in the summer but in the fall and winter they milked the cows and made the best of butter which they sold to private customers in Regina. They kept a few hens, and a sow or two, so had pork to cure for their own use.

After Lena met Russell and they had married, Lena described how they

made butter all the year, selling butter, eggs...to our regular customers in Regina. We supplied several of them with potatoes, too and after, sold them rhubarb. We always calculated to pay all household and living expenses with the cows, chickens, pigs, a young horse or two to sell every year, two or three beef cattle, fattened to sell between the winter fed cattle and the fall grass fed,

54 THE HOMESTEADERS

and the bits we sold from the garden, so our grain income could pay a man's wages and go for improvements.

Other homesteaders were more unique in their attempts to acquire funds. Rather than relying on selling vegetables or livestock, Richmond Bayles and his family "gathered limestone off the prairie, made a kiln and burnt same for 7 days and 7 nights, sold it for 25 cents a bushel." George Hickley tried to save every penny by working hard as a farm labourer during harvesting and threshing times. He also worked two fourteen-mile traplines between 1912 and 1914, which also brought in some extra cash when he sold the furs. George Almond also managed a trapline and wrote, "In the early years, we did a little trapping, chiefly muskrat, weasel and a few coyotes which would help with the budget."

Rather than relying on credit or loans, some settlers had put away some savings from previous work experiences before they decided to homestead. One settler's father had saved his earnings when he had worked with a survey party in 1882 and while he was employed as a skilled carpenter in Regina during the winter of 1882–1883. He used his savings to buy a "yoke of oxen, a John Deere breaking plow, wagon and harrows." However, he was not able to purchase everything he needed, given his funds were limited. As such, in 1883, "he bought a mower and rake partly on credit."[2] Samuel McWilliams had worked while he was in Ontario, at $25.00 per month during the spring of 1893, while Alfred Gibson had worked "as a hired man for the Dagleish Brothers in Moosomin for four years from 1900 to 1904," and also relied on a small inheritance he had received from England. Frank Wilson had "brought some money with him from England and had also earned some more by working for A. E. Young, who had a furniture store in Saskatoon," while Wasil Hancheroff had brought eight hundred rubles with him, which he had saved while working as a farmer in his mother country of Russia. John Cowell and his "brother worked together for the first three years. One worked the land while the other worked out." George Parks Marriott and his father pooled the money they had earned. He had "hired out for $125 in 1906 and $200 in 1907. [His] father earned similar princely sums."

ABOVE: Ploughing with oxen. n.d. PAS R-A8214.

WORKING THE FIELDS

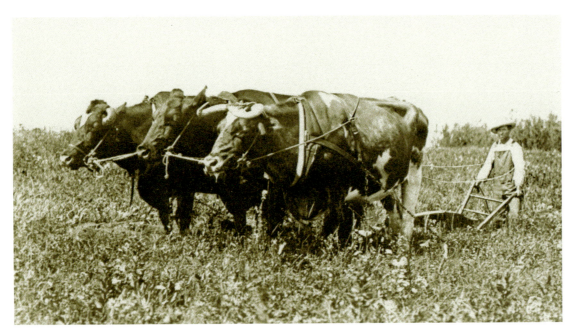

ABOVE: Peter Asmundson ploughing with his oxen, 1905. PAS R-A18382.

INTO THE FURROW

In order to break the centuries-old sod, or to turn over dirt and roots that had previously been covered with trees and brush, settlers relied on farm animals and their own labour power to accomplish the task. Most often oxen were used for breaking land. Given their strong muscle power, oxen could pull a plough and break through the roots without too much difficulty. According to Koozma Tarasoff, "For starting the farm, the oxen were quite efficient." Other settlers tended to rely on horses for fieldwork. Lottie Diggle's family preferred horses in the early years of homesteading, as her father had no patience with oxen.

The problem with oxen was they were very independent animals and had minds of their own. George Hickley wrote, "At times, they refused to pull. At anytime, if they wished to go to the stable, they went regardless of plough or persuasion of the driver." N. Scott Branscombe faced a similar problem with his oxen. One time, after feeding his oxen, "they put their tails over their back and ran away and you couldn't hold them and they would land you in a slough. The mud flew and everything else and I am telling you, there were no pet names going."

Frank Baines recounted how his oxen would not follow his direction for turning left or right: "Buck wouldn't gee and Bright wouldn't haw." Arthur Wheeler felt his ox Mac

was the stubbornest, most unpredictable creature on four legs. My partner and I thought we would do some training so took him...to snag logs out of the bush. We hooked him onto a tiny log, my partner holding the halter. Mac spotted the barn ½ mile away and [he took off]. My partner hung on, the cart went flying and so did Mac.

Joseph Wilson remembered how he was working with a walking plough when his oxen ran into a bee nest. He "had to let them go. They ran away and with their tails in the air and bees after them. Plow was smashed up when I got to them." Frank Wilson also reminisced about his oxen:

They were not very well broken so had quite a time getting them to pull a breaking plow. One would roll against the other and knock him out of the furrow, so after much trouble with him, I got a long narrow

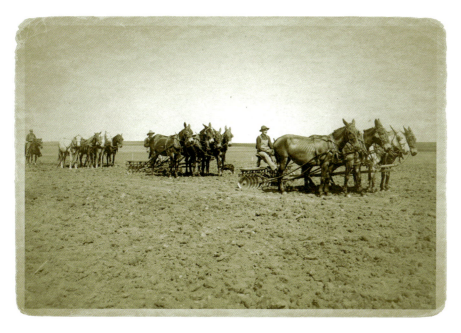
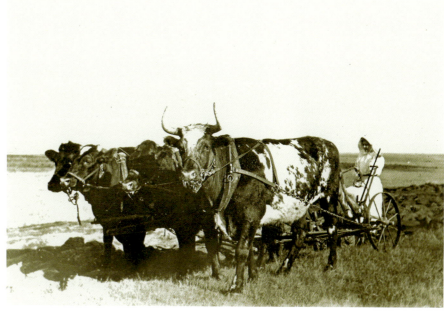

board and put nails in it and put it between them so when the middle one knocked into the furrow, one of the nails pricked him. When he first touched them, he did some fancy jumping but after a while they became real good at plowing.

Given the hard task of ploughing, Harvey Carson set up a rigid system over the course of the day that would ensure a good day's work without tiring out the oxen too much at one time. He wrote, "Them and I used to start breaking in the morning around 2:00, breakfast at 6 o'clock. Start again at 7:00 and unhitched at 10:30. Hooked up again around 2:30 and broke until 6:00 p.m. I never stopped for rain as there were no mosquitoes while it was raining." While Harvey was able to train his oxen to follow a daily routine, Joseph Wilson encountered an ox that outfoxed his master:

I had an ox. When I turned him loose, I put a bell on him to locate him when I was ready to work. Believe it or not, he would eat his fill and crawl into a bluff, lie down and keep the bell perfectly quiet so that I could not find him for hours when I wanted to work him again.

Like Harvey Carson, many settlers were determined to plough and ready their land for seeding as quickly as possible, given they were responsible for breaking and cropping thirty acres of land in three years as set out under the Dominion Lands Act regulations. Many homesteaders successfully accomplished this feat, as many of them reported breaking up to

ABOVE LEFT: Discing and harrowing on a Saskatchewan farm. n.d. Library and Archives Canada, PA-048343.

ABOVE RIGHT: Bernice Donaldson ploughing in the early 1900s. Typically, women worked within the home undertaking domestically related chores. They were also responsible for raising and caring for the children. However, given the importance of getting fields ready for seeding, women were often called upon to help out in the fields and labour alongside their husbands until the work was completed. PAS R-A6683.

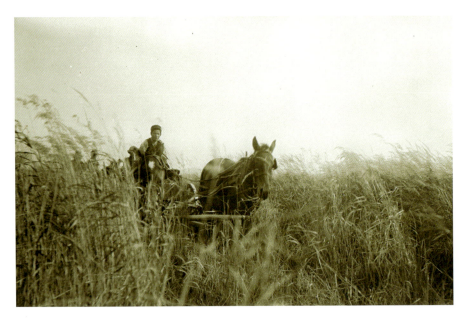

ABOVE: Riding through Red Top Grass (a common pasture grass) grown at Meadow Lake, Northern Saskatchewan. n.d. Library and Archives Canada, PA-044438.

twenty acres in their first year, with a few others breaking up to thirty acres. In their second and third years, results were much the same. Samuel Ellwood was fairly consistent in the number of acres he broke year after year. He said he broke eighteen acres in his first year on his homestead, followed by twelve acres in the second year and fifteen acres in the third, for a total of forty-five acres broken over a three-year period. Amanda Aikenhead's family had similar results. They broke ten acres the first year, followed by fifteen acres in both the second and third years, for a total of forty acres. Frank Kusch, however, was a bit more industrious with breaking his farmland: he broke ten acres in the first year but broke sixty acres in the second and seventy-five acres in the third, for a total of 145 acres.

Once the land had been ploughed and harrowed, the settler would have to decide on which breaking crop he would initially use on his land. The majority of settlers grew wheat, while others reported growing oats. Some seeded their land with flax, while fewer numbers used barley or potatoes. Lillian Miles and Robert Widdess both seeded their land with wheat, oats, and barley.

Settlers were also asked about the earliest date they had seeded their fields. While one settler tried his luck at seeding in February (an extremely cold winter month), the majority waited for warmer weather to commence. As such, the majority of settlers seeded their fields in March or April. Fewer seeded in May or June. Typically, settlers would try to plant as early as possible, as wheat such as Red Fyfe would not be ready for harvesting

RIGHT: Mr. Zacarson and his sons on their homestead in the Rolling Meadow District in 1907. Using this seeder pulled by horses would have been a step up from walking and seeding by hand. PAS R-A14214.

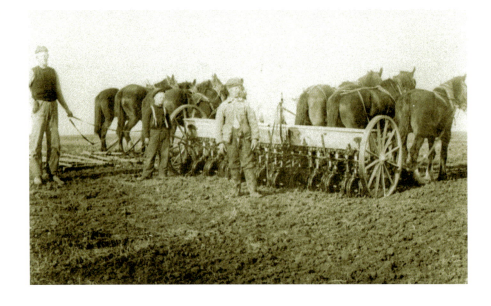

58 THE HOMESTEADERS

before the first frost appeared in the fall. As the years passed, and with the introduction of Marquis wheat, which produced at a far quicker rate than Red Fyfe, settlers were able to harvest and thresh their crops before the first frost occurred. As such, the harvesting of crops took part in mid- to late summer, with some settlers harvesting as late as September.

The seeding, harvesting, and threshing of grain was a labour-intensive process that first began by hand and then later on with the assistance of horses. As set out by Lottie Diggle, her "father sowed seed with a tin container hung by straps to his shoulders. It was shaped to his body and held about a bushel. He scattered the seed with both hands as he walked." Lillian Miles also remembered her family sowing seeds in this same fashion:

All seed in the earliest years that my folks arrived (1886) was sewn by hand. Harrows were made by driving railroad spikes through boards until we had about 5 or 6 rows on the boards. A team of horses would be hitched to the harrows. We made a drag by putting willows through the holes in a log and the brush end of the willow was left on to form a thick brush and this would be used after the harrows. Then a board was laid on the brush and stones put on the board to weigh it down and a man would stand on this board also to drive the team.

After a few months, when the wheat had turned from green to gold in colour, the plants were ready for harvesting. Men would use hand tools such as the scythe, sickle, or cradle. They would swing these tools and cut the stalks of the wheat plant. Once the wheat was cut, the stalks were gathered together by the armload into sheaves and then stood upright into stooks so the kernels of the plant would be kept off the ground.

After the stooking was done in a field, the settler would take a pitchfork and throw the stooks into the wagon. The wagonload of stooks would then be hauled to the barn for threshing. Once there, the sheaves would be taken from the wagon and beaten with a flail. This process separated the kernels of grain from the chaff. To ensure the kernels were completely

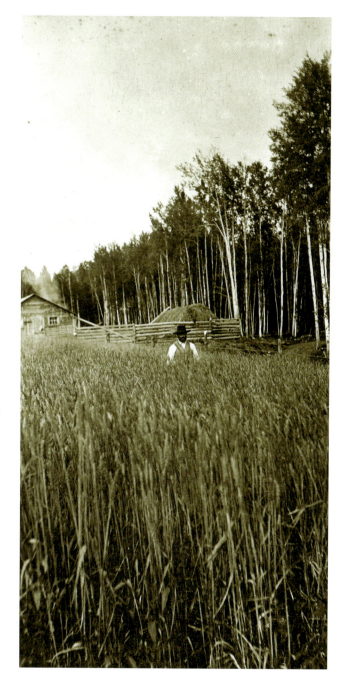

LEFT: A man standing in a wheat field at a Roman Catholic Mission in Saskatchewan, September 1908. PAS S-B8934.

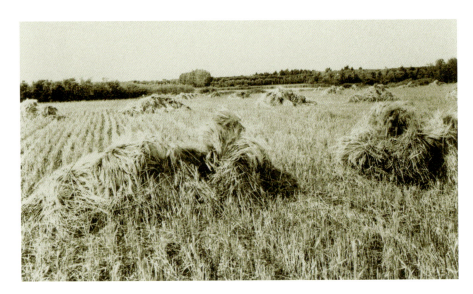

ABOVE: Stooked barley.
n.d. PAS R-A3740.

RIGHT: Stooked wheat, 1911.
PAS R-A23815-1.

clean from chaff, the settler and his family would winnow the wheat. Two people, standing opposite each other, would hang on to each corner of a large piece of canvas or material. The kernel/chaff mixture was dumped into the middle of the material and the two people would then bounce the material. The chaff would bounce out, which left clean kernels remaining. These kernels were then shovelled into sacks or loaded loose into wagons.

Lena Purdy recounted how her father "cut that first eight acres with a cradle which he had formed by hand, and then threshed it with a flail he made in the bottom of his wagon box. He kept some oat sheaves for feed, but threshed what he needed for seed. Soon the [neighbours] got a horse with power threshing machines and did custom threshing." Koozma Tarasoff also recounted harvesting and threshing on his homestead, but his family used their horses for threshing. He stated,

> We cut the grain by hand with a scythe. Then we raked it with hand rakes (wooden) and gathered it into a pile for transporting by a hay rack. Then we prepared a level ground for threshing (wet the ground with water mixed with clay and chaff; then the ground was rolled with wood rollers). Then horses and beaters were used to trample the grain. Wheat was cleaned by the wind and by screens.

Another settler, Lillian Miles, reported using horses as well for threshing but also highlighted the help of fellow settlers in the community:

> Our first threshing was done with horses tramping it out with their feet. The wheat was cut by hand with a sickle.

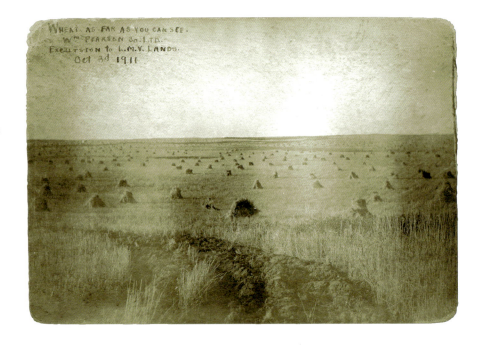

60 THE HOMESTEADERS

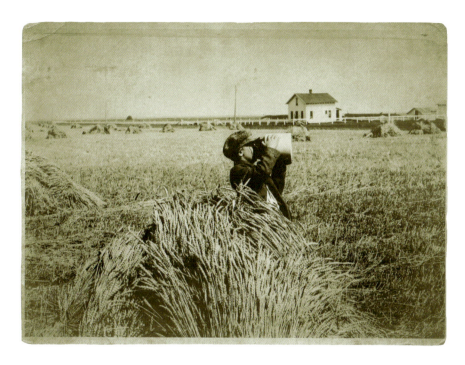

This was done for about two years. Then the whole community bought a binder and went from one farmer to another until everyone's harvest was in. While one was cutting, the others stooked the grain and it was put into stacks. Everyone worked methodically and in the best interests of all concerned.

Like Lillian Miles, Edith Stilborne elaborated on how people in the community helped each other: "Some early settlers came from Eastern Canada and bought binders with them. There were only a few, but they went the rounds, usually a man went and did the cutting for neighbours and others as the grain ripened."

TO HAUL GRAIN TO MARKET

In the late 1880s, Lillian Miles's family "used to haul grain to market with a team and wagon. We hauled it to the mill at Indian Head for making into flour and other products in the summer." She also mentioned they hauled grain during the winter months on a sleigh to Balgonie. Like Lillian and her family, John Peacock hauled his grain to town during the warm or cold months of the year. To him, it all depended on the shape of the roads. As he stated, "If we had good roads in the winter, we would haul some grain, likewise in the summer. When the roads were good, we would do some hauling." Another settler indicated her family preferred the winter for moving their grain, as other work needed to be done around the homestead in the fall. Like Lillian's family, they used horses and a sleigh to transport their product. Frank Baines also preferred the winter months, but he used a team of oxen, rather than horses, to pull his sleigh ten miles to Saltcoats.

LEFT: A harvest scene in Saskatchewan. n.d. Library and Archives Canada, PA-044484.

BELOW: Stacking wheat sheaves on the homestead in the Quill Plains area, Fall 1907. PAS S-B7585.

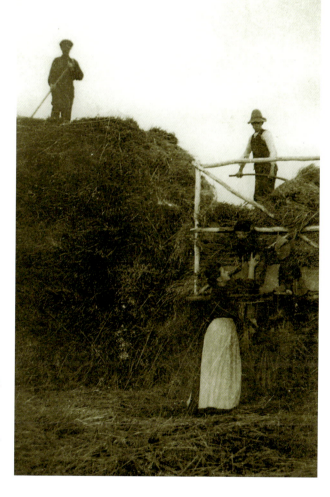

WORKING THE FIELDS

A Guinea Pig No Longer

Gavin Martens recalled a story his grandfather, Heinrich (Henry) J. Martens, told him when he had been a young fellow working on the grain thresher.

*He was 15 years old and along with other youths (approximately his age), they had been threshing for a very long day. All of the work was extremely labour intensive, especially in those days. Hand cutting wheat and other grain stalks, tying them into sheaves and then having to load them onto a wagon pulled by work horses, transporting them to a steam driven threshing machine and throwing them into the thresher with pitch forks. Due to the work conditions, most of the men had developed a rawness on their thighs (from perspiration and chaffing/dust between their thighs and pant leggings). Of course, he said, in those days not too many people were very knowledgeable in regards to medicine, especially young men on the threshing crew. One of the crew members suggested that the turpentine that they used for cleaning grease would be good to put on and relieve the irritation in the affected area. Due to the fact that Henry (Heinrich) was one of the younger ones it was suggested that he should be the first to try this. At first, he said, there was a tingling sensation, although after less than a minute, he was in excruciating pain. He had described this pain in the most colourful of language. Tears were welling in his eyes. He said that it immediately occurred to him that if he let on how painful it was to the others, he would deprive himself of watching them feel the same pain. With all his might summoned, he told them that the pain was alleviated and he felt great. At this point, several of the others applied the magical cure in the same manner. They all began to howl with pain and immediately applied water from the drink can to the affected areas. After this Henry (Heinrich) was no longer the threshing gang's young guinea pig.**

* Nolan Martens's family recollections, 2015. Permission to use this recollection is set out in an email dated September 25, 2015.

Edith Stilborne's family transported their grain to such places as Wolseley, Indian Head, or Qu'Appelle; however, each trip was a lengthy one, averaging about thirty-five miles. George Hickley also had a long way to travel—he hauled all of his grain in the winter by sleigh over forty miles (one way), an eighty-mile round trip.

For Jessie Cameron and her children, hauling grain to market was an important time. When her husband took their grain to town and received payment, he would buy items for his family. For instance, in the winter of 1910 he returned home with two housedresses for his wife. In the spring, he planned another trip where clothing would be purchased for their two young sons. When Amanda Aikenhead's husband went to town with his load of grain, he would return with provisions such as flour, bran, and shorts,[3] which would last them a fairly long time.

A number of settlers recalled the problems they had when they either drove their wagons full of grain to town or on the reverse trip with provisions back to the homestead. Eloise Anderson, who lived in the Yorkton district, recalled:

There was the high trail and the low trail (the latter now a part of the No. 10 highway). I came home from Yorkton with my father when he had a load on the wagon of bran, shorts and numerous other supplies. Of course, we got stuck and he had to remove his shoes and socks, roll up his pant legs, unload everything and carry all to high ground including myself. Then the horses were able to pull the wagon out and he reloaded.

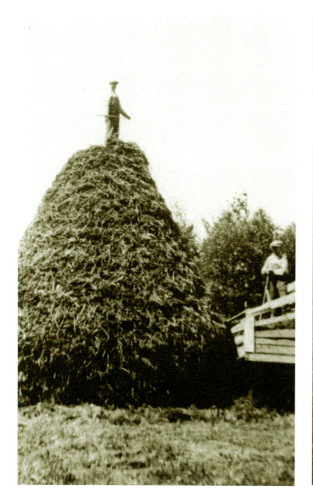 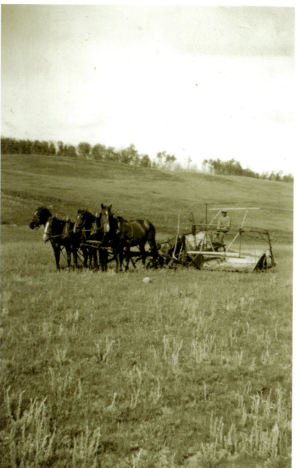 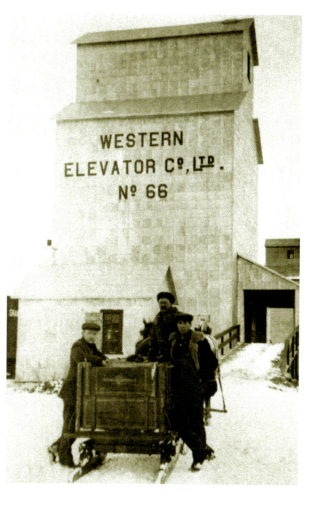

Eloise explained that getting stuck in mud or in dips on the roads were common affairs. They were so common, in fact, that it became a main topic of conversation among the settlers whenever they met up in town or on the road. Everyone always wanted to know where the other one got stuck, how long they were in this predicament, how they solved the problem, and how many times they were stuck along the route.

ABOVE LEFT: Andrew Albert stacking oat sheaves. n.d. PAS R-A14738.

ABOVE MIDDLE: John Smeretsky with his horses and binder on his farm near Theodore, Saskatchewan. n.d. PAS R-A10143-3.

ABOVE RIGHT: Andrew Alberton, Tom Statten, and Nick Carlson unloading at the grain elevator, 1911. PAS R-A14739.

Fences, Neighbours, and Roving Pigs

Settler William Gange set out in detail an experience he had with one of his neighbours and this neighbour's hungry pigs:

One year, I had my crop cut and stooked when a herd of pigs came in and knocked my stooks down. I knew where they came from. The man had acres of pigs. I went and saw him and he said he'd send his boys down and drive them home. They couldn't do it. I made a corral in the field and with the aid of a dozen of my neighbours, we captured about 80 and told the owner I'd sell them to collect damages. He went to the law and beat me. I did not have a legal fence that fall. I made it legal and put in a third wire. The following summer, they came down before the grain was cut. I went to the man again and took the minister with me and told him about it. He said he was sorry. He said he would drive them out. If they couldn't, [I said], we would shoot them out. We did. With my neighbours whose crops also suffered, we killed over 200 pigs. I had no more problems with pigs.

LESS NEIGHBOUR TROUBLE

Another task homesteaders hurried to complete was the fencing of their quarter section. Samuel Ellwood had fenced all of his land with barbed and woven wire and wooden posts. He said the primary purpose of fencing was to keep his "own stock at home and others out." By doing so, he had "less neighbour trouble." Samuel McWilliams also fenced his land for the same purpose, as did Richmond Bayles; however, instead of neighbour problems, Richmond had difficulty with roving bands of horses who would eat and trample his crops. Frank Baines fenced his property with barbed wire in 1910 to protect his crops from his own hungry livestock, while Lena Purdy's family fenced in some sheep they had purchased. Lillian Miles wrote that her family needed to protect their garden from their chickens, so they built a fence with closely woven willow branches.

Another settler, Jessie Cameron, rather than reporting on wayward animals or relationships with neighbours, focused on a different aspect of fencing. She felt fencing had more to do with property ownership. Settlers who would never have had a chance to own land in their mother country would have felt immense pride in possessing land in western Canada. By fencing their 160 acres, they were signalling to others that the land belonged to them.

I HAVE EXPERIENCED THEM ALL

Each and every settler had some sort of tale to tell about the hazards associated with homesteading life. At each turn, settlers were faced with a diverse assortment of problems, difficulties, dilemmas, and predicaments throughout the course of the year. Whether they were dealing with cutworms that destroyed gardens and crops, biting insects during the spring and summer months, or blizzards and freezing temperatures during the winter, each issue had to be dealt with in some fashion by the homesteader and his family. A great amount of perseverance was needed to overcome each situation, as well as ingenuity and, in some cases, humour, otherwise the circumstances could become so dire and disheartening that many settlers would have been willing to admit defeat and relinquish the homesteading life. Regardless of how each homesteader faced each individual problem, frustration levels tended to be high. As succinctly expressed by Albert Elderton,

I have experienced them all, with varying degrees

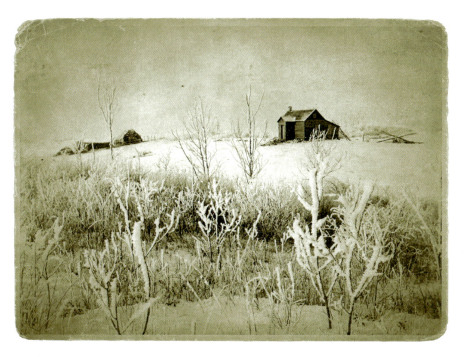

of severity and damage in each case.... We had lots of blizzards, and lots of drought, some hail even up to 100% damage and down to slight. Frost, wind and dust, more than you could shake a stick at. Cutworms, hoppers, skeeters, gophers, oodles and oodles, blast them!

While many settlers like Albert listed a number of problems with homesteading, some discussed, in greater detail, particular aspects of their individual experiences. Amanda Aikenhead elaborated on the devastating consequences associated with hailstorms: "In the year 1899. The worst hail storm ever known occurred in all the Melfort district. Cattle were killed and all the crops were battered to the ground. Farmers had to go near Prince Albert for feed for stock, gardens were battered to the ground, some came again. Carrots, beets, underground vegetables." Jessie Cameron also described her experiences with hail, saying, "We were completely hailed out. We watched the storm coming. It seemed to be from two directions south-west and north-west and the storm joined together a short distance from our land. I had 45 choice grey Plymouth Rock chickens, just about ready to use for meat, and they huddled on the ground, west of the barn and were all killed by the hailstorm." Alice Downey also described a hailstorm: "We had a terrible wind in 1910 on July 3rd. Hail that cut the crop down which was very poor to start with. And blew it all away. We just threshed some seed and had one wagon load of wheat to sell. That was our hardest year as our money was all gone to five dollars in the bank. Our animals nearly starved to death as we had so little feed."

While hail could cause considerable damage, early frost was also a curse on those who relied on their harvest for income. According

ABOVE LEFT: A. Miller's wooden shack in winter, 1905. Note the hoarfrost on the trees and shrubs. PAS R-B2760.

ABOVE RIGHT: Clearing a new homestead in northern Saskatchewan. Note the fencing around the buildings and haystack. n.d. Library and Archives Canada, PA-044437.

WORKING THE FIELDS

ABOVE: A large snowdrift following a blizzard. Such snowdrifts made many roads impassable during the winter months. It was also not unheard of for settlers to be trapped in their homes by snowdrifts. PAS R-A2796-5.

to Edith Stilborne, frost was the greatest hazard her family had ever experienced, as crops were entirely wiped out. Such was the situation with James Tulloch, who indicated his oat crop was completely destroyed in 1907. In addition, he exclaimed about how the early cold had left many of his pigs lame. Alfred Gibson discussed this same frost in his memoirs. He wrote,

The worst crop disaster was in the year 1907 when a heavy frost came when the wheat was in the milk stage in August. None of us realized how bad the damage was until cutting started. Some farmers then plowed fireguards around their fields and burned the crop. Others did the same after cutting. Some sold hay rack loads of wheat sheaves for fifty cents to those lucky enough to have cattle to feed.

Joseph Wilson remembered the severe frost he experienced in 1909. He wrote that he "had 200 acres frozen in 1909, I think it was. I had the threshing machine work one day and they hardly cleared expenses so I burned all the rest as I had no stock to feed it to."

When it came to blizzards during the winter months, many settlers commented on how dangerous they were and how quickly lives could be put into jeopardy. Edith Stilborne stated, "Blizzards would sometimes last for days in the winter and the snow would blow so we could not see to the barns. Ropes would be stretched from house to barn as a guide for those going to feed the cattle and do the milking." Elizabeth Duncan recounted how her family had to dig out the high drifts around their home that had formed during the storm, while Samuel McWilliams wrote, "I have seen a three days and night blizzard, deep snow after storm. The old stables completely covered over, looked just like a large snow drift." On a humorous note, Samuel also remembered a story about his father's experiences with blizzards in the West:

My father came west to Manitoba from Muskoka in 1879 after spending two years in the west experiencing blizzards and what not. He went back to Muskoka for a spell before returning west. While at home, he told a neighbour about the blizzards out west. He said it was not safe to go out to feed your stock, you might get caught in a blizzard. Johnny Johnson spoke up and said that they would not stop me. I would take my shot gun along. He thought these blizzards were wild animals.

During the winters of 1906 and 1907, Frank Wilson had also experienced some very bad blizzards and freezing temperatures. He and his brother had to travel to Eagle Hills for firewood but "could not bring back very much at a time as the snow was almost too deep for the horses." Harry Ford also commented on the winters of 1906 and 1907. He wrote, "Blizzards and heavy snow, the worst I remember.... No trains through from Humboldt to Saskatoon for six weeks." Eric Langgard remembered how perilous blizzards could be for wild fowl, especially when blizzards occurred outside of the winter months. He reported, "In 1910, we had 2 feet of snow on the 3rd of June. Thousands of small birds killed. Frozen to death. We found them lying on top of the snow."

Along with unsettling climatic conditions, homesteaders also had to deal with insect infestations. Some insects could destroy crops and gardens and harm animals, while others were irritants to those who came in contact with them. One of the primary annoyances on the prairies was the grasshopper. Grasshoppers would eat all the vegetation above ground, consequently wiping out gardens the homesteaders relied on for nourishment and crops for harvesting. More often than not, discussion surrounding these insects emphasized the techniques used to kill them off en masse. Mrs. Robert Wilson explained how

> *[the] grasshoppers were terrible and my husband went all over organizing gangs of farmers to mix and spread poison. At home, we tried spreading straw around the fields and burning it off early in the mornings. This got a lot. I kept my chickens in the far corner of the yard and early in the morning, I would let them out and then take a stick and beat the carraganas round the yard. The grasshoppers climbed into them over night and this made them hop down and the chickens ate them up. In this way, I saved a lot of my garden.*

Albert Elderton described how he controlled the grasshopper population on his homestead. He wrote, "Control for hoppers was the poisoned bait method (sawdust and bran), put in a hopper and distributed by the bait falling on to a sort of a fan or blade spreader revolving under the hopper. Some drove this contraption by a belt which took in power from the hub of a wheel on a wagon pulled by horses (the hopper and bait being in the wagon)." Charles Bray also referred to the grasshopper population on his homestead. He had to poison grasshoppers all over the farm one year in order to protect his plants.

Caterpillars were also a nuisance and ate many types of vegetation on the land. When caterpillar infestations occurred, settlers like Winnifred Taylor and her family controlled the insects by mixing one cup of coal oil in a large washtub with soapy wash water. They applied this mixture by splashing it along the outer rows of their crops and gardens with a kalsomine brush. They repeated this process each morning for seven days. Along with grasshoppers and caterpillars, another destructive insect was the cutworm. Cutworms tended to eat vegetation below the ground and near the surface. The cutworms were severe on N. Scott Branscombe's land, but he did not know what to do. However, Thomas Drever found a unique solution to the problem:

> *I remember one year there were a number of patches in one-quarter section eaten by cutworms and the following year, nearly all of the field was destroyed. As there were some seagulls around, I thought I would help feed them, so went out and harrowed the ground. The birds followed for a while, hundreds of them. This I did every day as long as the birds would feed, with the result that the following years there wasn't any sign of a cutworm.*

Other insects that bothered animals and homesteaders alike were sandflies, sawflies, and bulldog flies. Many settlers, such as Amanda Aikenhead, reported, "Sand flies attacked the cattle and horses." The flies were so numerous that Mrs. Robert Wilson's family

The Broken Thermometer

John Wilson told a story that illustrated the extreme cold during prairie winters.

When I first came to Saskatchewan, I heard quite a lot about how cold it got sometimes, so I got me a thermometer and kept some track of it. When writing back to the folks in Toronto, I would tell the tales such as the one where the water in the kettle was boiling in the bottom and frozen on top. Evidently, Dad thought my thermometer must be all wrong, so he sent me a real good one. On examining it, I found it only registered to 30 below (farenheit) [sic] so I sent it back, telling him it was only good for the summertime out here.

WORKING THE FIELDS

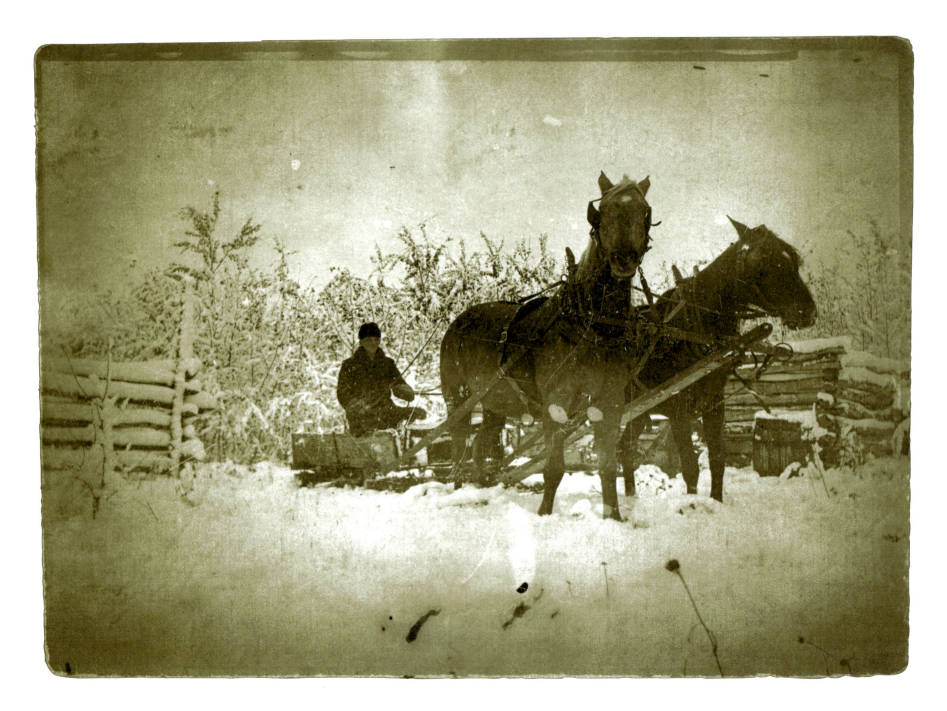

had to put pieces of sacking over the noses of their horses and cows in order to keep the flies off of them. Of fly infestations, Harry Ford wrote, "We had flies in the fall of one year that got in the eyes of the oxen until they could not see to travel." Rather than discuss the frustrating conditions associated with sandflies and sawflies, Lottie Diggle mentioned the more serious encounters she had with horseflies. She wrote, "There was a small black fly that caused the death of cattle in hot weather. Bulldogs—over half an inch long and grey black. [They] bit viciously as I well remember when I rode the horse in bare legs while scuttling the potatoes."

Along with dealing with biting flies, settlers also drew attention to the harshness of life with mosquitoes. Many settlers, particularly those who came from Europe, were unaware of the ferocity of the mosquito population on the western prairies and, as such, were completely unprepared for the miserable conditions they faced. In the early days of homesteading, the air would be thick with the large, grey, blood-sucking biters. As Joseph Wilson pointed out, "The mosquitoes…were so thick you could slap the oxen on their sides and kill thousands and have lots on your hand." Another settler, Howard Irvine, wrote, "In the early years, they were bad. I have seen them so bad, that towards evening, you couldn't see what colour a horse was." In a similar vein, Edith Stilborne wrote, "Mosquitoes were terrible. They caused the oxen to go frantic, so that [they] would bolt to a bluff or slough where they could brush or wash them off. We made big smudges and would unhitch the oxen and drive them to the smudge. The oxen would be literally covered so one could not tell their colour." Lottie Diggle also wrote about the mosquito problem: "Mosquitoes were in the millions of course with all the sloughs, alkali and soft water. Probably about two dozen sloughs on our section. Often animals had to stay all day at the smudge." Arthur Wheeler stated, "Mosquitoes were terrible especially in 1907 when water levels were high.... I remember one farmer breaking land with a pail holding a smudge on the plough handles. Some days it was impossible to work."

Even at night, there was no escape from the biting insects. N. Scott Branscombe wrote, "The mosquitoes were the only thing that you were sure of, were they ever big and the buzz of those things at night when you tried to sleep and the next morning, you looked as though you had measles." Albert Elderton railed against mosquitoes:

Skeeters we simply controlled by being slap happy and it took a lot of slaps in a bad year, I'm telling you. Oh sure, we made smudges for the poor animals to get a little relief. We also cursed Mephistopheles, Beezlebub and Old Nick for persecuting us with the blighters, but it didn't seem to help much.

Other pests, such as hawks, crows, coyotes, and gophers, visited the homestead and challenged the settlers by causing mischief or destruction. Jessie Cameron complained that "hawks many a time swooped down and got my chickens." Thomas Drever's family also had to be on the lookout for hawks to shoo them away, while Mrs. Robert Wilson's family dealt with hawks by shooting them. As for crows, she felt they "were a worse pest. My turkeys used to sneak away to set and the crows would get the eggs."

Some settlers discussed the harm caused by coyotes in the vicinity.

OPPOSITE PAGE: A man driving a very low sleigh being pulled by two horses. n.d. PAS R-A14336.

WORKING THE FIELDS 69

TOP: Sawflies in wheat. n.d. PAS R-A4189-1.

BOTTOM: Wheat that has been destroyed by insects. Note the lack of kernels. n.d. PAS R-A4189-3.

Jessie Cameron wrote, "Coyotes sneaked up in broad daylight and grabbed many a hen, rooster or turkey out of the barnyard." John Dickey and his family also contended with a pack of coyotes when "one year they cleaned up all our chickens...I put out some scarecrows which perhaps helped to keep them away. After we lost so many chickens that year, we changed to Leghorns as they could fly up into the trees and get away from the coyotes better than the heavier Plymouth Rocks." Rather than being concerned for their chickens, Koozma Tarasoff and his wife were more scared for their young boys, who were seven and nine years old. As he wrote, "My two sons would start plowing the land when I left for road work. My wife would sit at the end of the furrow watching to see that coyotes would not carry them off. She knew that they were afraid of coyotes."

While coyotes were an ongoing problem, another source of constant irritation on the prairies were the gophers and the garden and crop destruction they could cause if their populations were left uncontrolled. Edith Stilborne wrote, "Gophers took their share (or more) of the crops each year." Similarly, Richmond Bayles explained that with "gophers, it used to be a fight between us who should take the crop. The government supplied us with poison which we mixed with wheat and placed it in their holes." Albert Elderton not only relied on poison to kill the gophers on his land but also used traps. Lena Purdy's family also relied on traps—she and her sisters would literally catch hundreds of gophers in them. Jessie Cameron also had a problem with gophers:

Gophers were a bugbear. My husband bought me a 22 rifle to keep them out of the garden. Gardens meant so much to the homesteaders for winter vegetables. I had to learn to handle the 22 and would go out to the garden and see gophers scampering all over. They were quite safe in my presence. After I'd shoot, the gopher would stand up in the same place on his hind legs and with front paws chewing away at my garden stuff and just seem to say to me "Try again novice!". I longed for the day I could tumble them over and I kept practicing and was able, before long, to tumble over a good many of them to save my garden.

Mrs. Robert Wilson had help in tracking down gophers on her land. She wrote, "The gophers were poisoned, trapped and shot with a 22.... My dogs were always very helpful. One could even come and tell me to bring the gun if he had a gopher cornered." Other settlers used other tactics to kill the pests. "They were so tame," John Peacock wrote, "you could make a loop with an ordinary length of bag string, set it in a gopher hole and lay down an arm's length from the hole and have a gopher in five minutes." Another settler used a different tactic. Mike Bloodoff's family "used to drown many of them with water."

Settlers faced a variety of problems and frustrations, whether they were dealing with personal finances, the hard labour associated

with breaking, ploughing, seeding, and eventually harvesting crops, or dealing with climatic difficulties and insect infestations. They struggled on a daily basis, always alert for the next crisis and uncertain as to their long-term prospects. Saskatchewan settlers faced these problems head-on and continued to strive for the better future they envisioned for themselves and their families. In fact, some settlers felt fortunate as to their life circumstances. Frank Kusch wrote, "We had some damage from grasshoppers, cutworms, frost, gophers, but on the whole we were lucky to have moved to Saskatchewan." Edith Stilborne set out her thoughts on the various difficulties associated with homesteading:

> *All these things seemed to be taken in stride, as it were. Those who stayed accepted these things and did all they could to eradicate the menaces to comfort and success. Some became discouraged and gave up, went back East or to other parts, but many stayed and made the best of things as we did.*

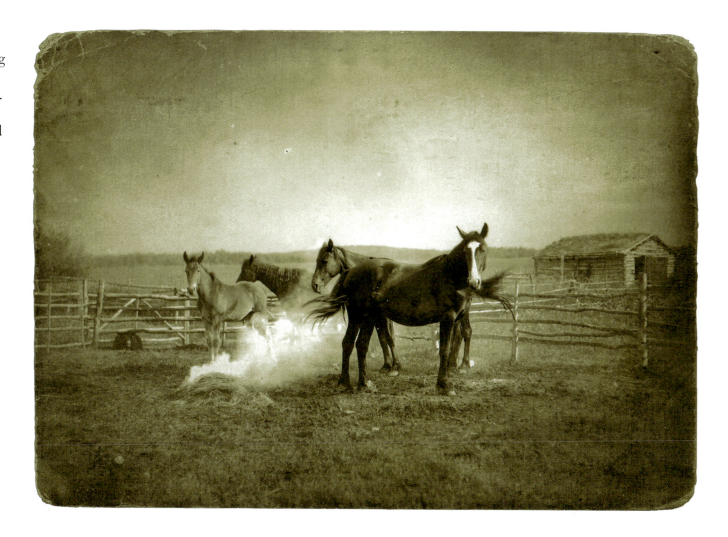

ABOVE: Three horses and colt on a farm standing beside a smudge in 1910. The best smudges used green wood (wood that had not been dried out). Lighting this wood on fire would produce a large amount of smoke which would clear the area of mosquitoes and other flying insects. PAS R-A6176.

WORKING THE FIELDS 71

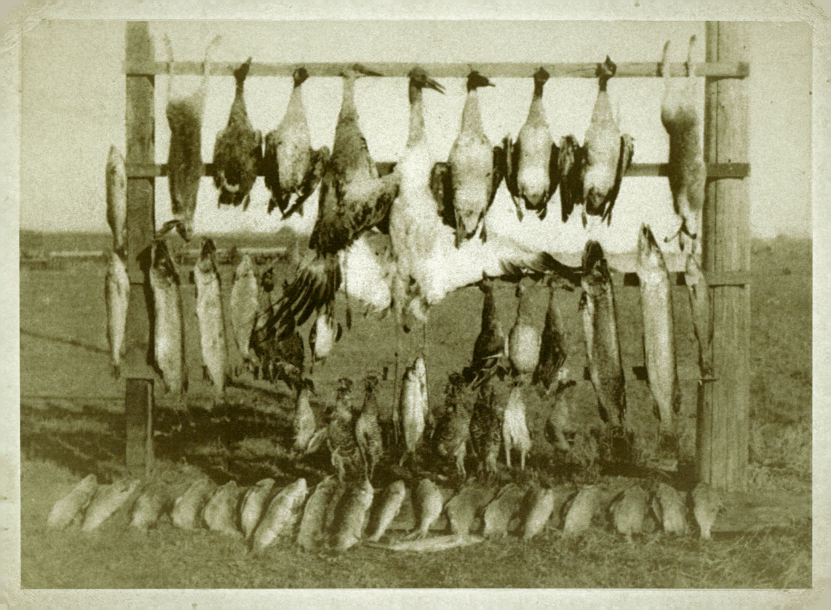

Chapter 4
Feeding the Family

In the settler household, there was one element of homesteading life that needed to be handled on a daily basis—acquiring enough food for the settler to feed himself and his family. In their initial years of homesteading, many settlers tended to rely on food they purchased in bulk from the local town store before they headed out to settle their land. Mrs. D. Gush, for example, recounted the story that when she was a child, her parents were startled to find their homestead was over sixty miles from the rail line and town store rather than the six miles they were expecting. Her family had been deceived about the distance, as they had relied upon a surveyor's map of the area, but, unfortunately, the rail lines and towns that had been drawn on the map had not yet been built and would not be built for another three years. Given the lengthy distance between the homestead and the town store, her parents were advised by the shopkeeper to buy enough groceries to last several months. To her mother's amazement, she "found herself ordering two hundred pounds of flour, a hundred pounds each of white and brown sugar, several twenty-pound pails of lard, pounds and pounds of raisins, dried apples, peaches and prunes." She was not able to diversify her family's diet, as no products were available outside of the basics, and, further, she discovered that what "was not to be found in the store, one had to learn to do without."[1]

Mrs. John Jameson, who realized she and her family would also be living miles away from the town store, purchased a number of goods, along with a six-month supply of basic groceries. She wrote,

OPPOSITE PAGE: One day's log of game (rabbits, geese, prairie chicken, and fish) in the Davidson district, 1912. PAS R-A20219.

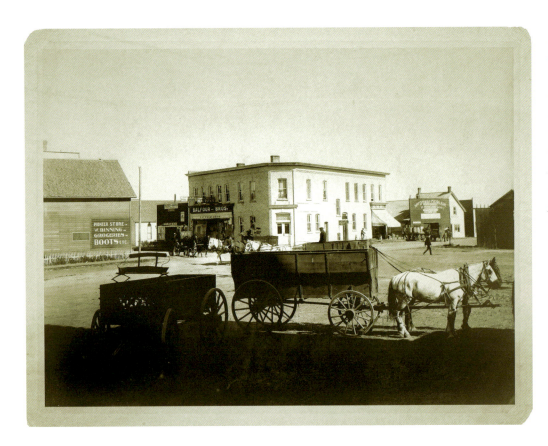

ABOVE: Lumsden, Saskatchewan, 1905. PAS R B-369.

[We] bought everything in bulk. Of course, our first year was the hardest for we could not tell exactly how much we needed. However, we started with 1,000 pounds of flour, 2—80 pound sacks of Rolled Oats, 10 pounds of black tea, 5 pounds coffee, 10 pounds cocoa, 25 pounds rice, 25 pounds beans, cases of dried apples, peaches, apricots, pears and prunes, cases of canned corn, tomatoes and salmon, 2 barrels salt, 20 gallons of coal oil, 8 cans of lye for soap making, 20 bars of soap (laundry), 20 cakes of toilet soap, 5 pounds currants, 10 pounds raisins, 3 pounds candied peel, 5 pounds coconut and other small items.

Mrs. Jameson and her family had predicted fairly accurately as to how much of each item they would need. However, she went on to say that within a few months (during the winter), they had run out of coal oil and sugar and had to make an unplanned trip to the store to obtain these goods.

Another settler, Mary Jordens, said her family bought flour, molasses, salt, oatmeal, cornmeal, raisins, currents, dried apples, and prunes before heading out to their homestead, while Kate Stirling bought "flour, sugar, dried fruit, light molasses called 'blackstrap' substitute for syrup, rolled oats, coffee [and] tea." Others, like

Improvising and Making Do

When particular ingredients could not be found at the local store, some pioneers learned to improvise. For example, Ada Christian's family would make their own starch when it was unavailable for purchase. They would do this by grating potatoes and putting them in water. They would let the potatoes settle and then change the water. This process was repeated until the water ran clear. The collected water was then set aside until the starch settled in the bottom of the bowl, and then the water was discarded, leaving the starch behind.

74 THE HOMESTEADERS

Fred Baines, purchased, along with basic staples, sowbelly, rice, pearl barley, baking powder, and baking soda. In addition, Fred mentioned he had to buy tea, as coffee was not available, and that he also purchased chewing and plug tobacco. David Maginnes bought "figs in the block," while Elsie Campbell purchased canned milk.

While some settlers were able to purchase a number of provisions that would last them several months, other families were forced to limit the amount of goods they bought. Amy Arn wrote in 1880 that her family purchased their groceries in Winnipeg but then had to carry their food supplies to their homestead in Saskatchewan. All of her family members walked the distance, each sharing their load, with her brother William carrying a bag of flour and her sister Margaret carrying two hens and a rooster.[2] Another young settler, Kathleen Lennox Smith, also commented on the problem of transporting goods and food 160 miles to their homestead in 1908. In her case, her parents purchased much more than Amy Arn's family, as they bought all of the equipment, work animals, supplies, and groceries they would need for their farming operation. Kathleen wrote,

We gathered together three big strong oxen, a pony, two wagons, a buggy, walking plow, disc, harrows, mower and rake, some oats and feed, potatoes for planting and garden seeds. One wagon had a hay rack on it and this was loaded with most of the machinery and drawn by the big black team of oxen. The other wagon, drawn by the pony and the extra oxen, was rigged up with canvas over hoops as a covered wagon. The buggy was fastened behind this wagon which was loaded with our potatoes, feed, groceries and clothing. It was necessary for Dad to make two trips to bring all of our equipment.

She continues by explaining that her mother stayed behind in town with the second load while her father, herself, and her five brothers and sisters made a ten-day trek to the homestead. Once there, they unloaded their goods and then their father left with the empty wagons. While he was gone, Kathleen noted their grocery supply was inadequate. She and her brothers and sisters had to exist on "a big pot of porridge with milk" they

Food and Cultural Heritage

Given that homesteading families could only buy what was available at the local stores or use what was growing in the wild, it is not surprising that many immigrants had to adapt to a basic staple diet. Many could not rely on recipes brought from their mother countries, as ingredients could not be obtained. Until homesteads were more developed (so homesteaders had additional funds in hand), gardens were grown, and a greater variety of goods became available at the local stores, many were unable to diversify their diets to any great degree. Dorothy Duncan wrote, "The rigors of homesteading and the lack of ingredients forced them to put aside their culinary traditions temporarily."[*]

However, as homesteading progressed and conditions changed over time, people were able to create meals based on their family heritage. For example, eventually, British immigrants could make oxtail soup once they obtained leeks and celery, while the Welsh could enjoy *crempog* (a type of pancake made with cream of tartar and honey). Those of Swedish descent could make *arter och flask* (pea soup with pork made with peppercorns, yellow peas, and bay leaves), Germans could make *sauerbraten* (pot roast with bay leaves, cloves, and red wine), and Ukrainians could make *apfeltaschen* (apples in pastry, made with apricot jam, apples, icing sugar, and cottage cheese).

* Dorothy Duncan, *Canadians at Table: Food, Fellowship, and Folklore: A Culinary History of Canada* (Toronto: Dundurn Press, 2006), 96.

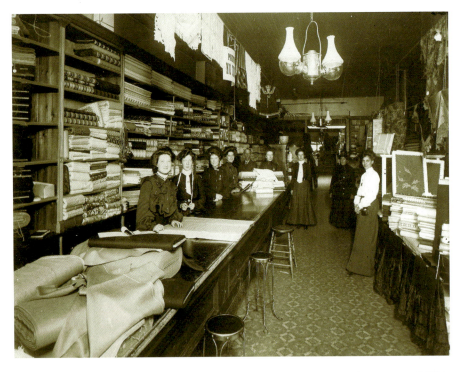

TOP LEFT: Household goods and dry goods department of the E.J. Brooks store in Indian Head, Saskatchewan, 1898. Many settlers held accounts in such stores until they sold their harvested crops in the fall to pay the bill. PAS R-B12800.

BOTTOM LEFT: Anton and Anna Burke and their two children sitting on a wagonload of goods going to their homestead, located eight miles from Watrous, Saskatchewan, 1909. PAS S-B8266.

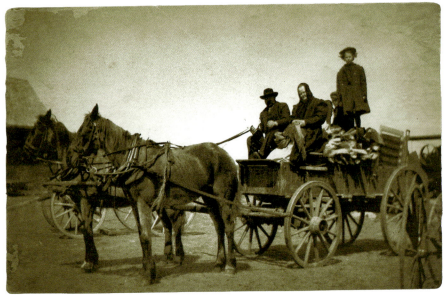

would eat for breakfast. "The only meat [they] had left was a side of home-cured pork," as well as some potatoes. The children decided to ration what was left and, after more than two weeks alone, they were more than happy to see the end of their hunger as their parents arrived home with a large supply of groceries, including bags of flour, sugar, and dried fruits.[3]

Other settlers, such as Frances Pierce Page, remembered similar situations where food was running short. Frances's grandfather and uncle, who were building a house on her grandfather's homestead land, one hundred miles from the local store, were existing on only two types of purchased food: bacon and beans. Her uncle had a sense of humour about their situation when he said they were able to vary their diet by having beans and bacon.[4]

Helen Regier's family also experienced many hardships when it came to obtaining purchased food. When store-bought food dwindled in the cupboard, and money was in short supply, the boys in her family would find ways to acquire the funds needed to buy groceries for the family. They would often go into the fields and hunt or trap gophers.[5] In particular, they were after gopher tails, as the federal government, through its gopher bounty policy, was offering money for every tail collected. This policy was needed as gophers could devour crops and gardens within a short period of time. Gopher holes were also hazardous for horses, when they would inadvertently step into a hole and break their legs. Given the destructive nature of the gopher, the government offered one cent for each gopher tail, the tail being needed as proof the gopher was killed.[6] When the boys were paid for their gopher bounty services, the family used the money to buy flour and other essential groceries.[7]

76 THE HOMESTEADERS

Jessie Beckton also offered an interesting account of her family's sparse meals. Even though her family, like many others, had to resort to buying only the essentials from the store, due to a lack of funds, one of the major problems they encountered as new and naive settlers was learning how to cook some of the staple products that were available. They bought beans and tried to soak them and boil them, but it was all to no avail as the beans stayed hard and inedible. They had the same experience with dried peas when they tried to make pea soup. No matter what they did to the peas, they ended up tasting gritty and burnt. In another instance, Jessie tried to bake bread, using flour they had bought at the store, for supper, but her loaves turned out to be less than desirable, as she did not know how to build a fire that would reach the right temperature in the wood stove to successfully bake the bread. As such, the bread was also inedible. Luckily, an acquaintance passing by offered to help Jessie with her bread-baking struggles. He soon found dried wood, heated up the stove, and baked the bread. While Jessie was happy with the outcome, she found out later that day, when she and her family had settled down to supper, that something was amiss. Her father was very angry and, when questioned, commented that he would "like to know who the fool was that chopped out the manger in the stable." The manger was a log of wood dovetailed into the building at the time of its raising. Jessie realized this was the piece of wood the acquaintance had used to bake her bread. She did not fess up to knowing anything about the destroyed manger until years later.[8]

Mrs. F. B. Reilly also described the meagre meals she ate as a child on a Saskatchewan homestead in 1884. She pointed out that her family had very little money to spend at that time and resorted to only buying the basics. She remembered her family's "principle article of food was what [her] mother called 'thickened milk' made by thickening milk with flour, adding salt, a little sugar and eaten with milk or cream." Even though Mrs. Reilly described their meals as monotonous, all of the members of her family tended to like the milk mixture and, in fact, thrived on it.[9]

Other settlers who could not afford to buy store-bought flour sought other ways to make their own. A number of them used a coffee grinder, a feed crusher, a meat chopper, or a large, horse-drawn crusher to grind the wheat kernels. Some settlers, like Sam McWilliams, handled the grinding task in a different way. When Sam was ten years old, his job was to pound the "wheat on a smooth flat rock with a hammer to make porridge for the family not once but many times." A few others, such as Susan Tucker, did not crush their wheat but rather just soaked it overnight or boiled it for a long period of time and then ate it with salt or sugar. Wellwood Rattray took a more basic approach. He did not bother to crush or cook the wheat; he just chewed it with his teeth.

When extra money became available, it could be spent on such

ABOVE: Saskatchewan gopher. PAS R-A16709.

TOP: An advertisement in *The Nor-West Farmer*, Aug. 6, 1900, p. 635.

BOTTOM: An advertisement in *The Nor-West Farmer*, Aug. 20, 1900, p. 679.

luxury goods as raisins or bars of chocolate. Given that such foods were a rare indulgence, Mrs. F. B. Reilly explained that permission needed to be obtained from a parent before such treats were eaten. Unfortunately, she had a desire to eat some raisins one day but did not gain consent from her mother before she ate them. As a result, she ended up being chastised for her transgression. She recounted,

Raisins were a great treat.... Mother kept them in a cupboard in the kitchen and occasionally when no one was looking I would take the odd handful and eat them in seclusion. One day I had a great urge for raisins and had taken several helpings, going outside to eat them uninterruptedly. My mother's suspicion was aroused and she followed me out. I turned to her with an innocent countenance and suggested that she had better go back into the house as she might get sunstroke without her sunbonnet.... Needless to say, she went back, but not for her sunbonnet.

In a second episode of pilfering rare food, Mrs. Reilly remembered the time when she and her sister found a bar of chocolate in the food supplies their father had brought home from town one day. They knew it was used in their mother's baking, but, Mrs. Reilly wrote,

[It was] very nice to eat. As it was quite a luxury we each took a few nibbles from the bar then wrapped it up well thinking that it would not be noticed. We thought the odour might be detected on the breath so we drank copious drafts of fresh buttermilk from the churn standing in the kitchen. We did not seem to realize that the chocolate on the outside of our faces might give us away so when we were accused of having eaten the chocolate we denied with lusty protestation. But circumstantial evidence gave us away and we received our painful and just reward.[10]

Other foods were deemed luxury items. As set out in a story by Mr. G. Frazer, who came to Saskatchewan in 1891, apples were an expensive and special treat. He recounted that while travelling through Saskatchewan he stopped for the night at a stopping house, where the proprietor offered supper to his guests. Mr. Frazer dined on pickled beef, cold boiled beans, tea, and stewed apples. He commented that anyone who "could put up stewed apples for supper or desert [sic] was considered to be well fixed."

Settlers also commented on the various types of beverages that were available for drinking while they were homesteading. Not surprisingly, many of them identified tea and coffee as their drinks of choice. From the stores, settlers were able to buy the Blue Ribbon brand of tea, Red Rose, or Lipton's, while those who purchased coffee typically bought coffee beans. These beans would be brought home from the town store, the settler would roast and grind them, and then they would use the ground coffee with boiled water to

Oatmeal Drink Recipe

Into a little cold water put a half a pound of sugar, a quarter of a pound of oatmeal, and a lemon cut in very thin slices. When the sugar is dissolved, add a gallon of boiling water and stir a few minutes. Drink when cooled.*

* "Oatmeal Drink Recipe," *The Nor-West Farmer*, July 20, 1901, 472.

make an agreeable hot drink. Along with tea and coffee, settlers also purchased Postum (made of ground grain and molasses), while others made their own homemade coffee by buying barley, oatmeal, wheat, or rye from the local gristmills and then roasting and grinding it. A few would buy molasses and then add it to ground barley or wheat to improve the taste, while one settler reported he would scorch the barley and add dried peppermint to give the mixture some flavour.

According to Mrs. George Johnson, such burnt-grain coffee was typically known as "sin and misery," since it was barely palatable. Another settler's coffee consisted of burning bread, crushing it, and then brewing it with boiled water.

In addition to coffee and tea, others preferred chocolate drinks made from bars of unsweetened chocolate, while a few other settlers tended to drink lemonade, made from fresh lemons when they were available for sale at the store. Mary Jordens would mix her spring water, which had a high alkali content, with ground ginger so it would be pleasant to drink, while another settler made dandelion wine and homemade root beer. One settler's family made drinks from Saskatoon berries, vinegar, and sugar, while another made a drink out of vinegar, sugar, and soda. Two settlers made homemade beer and others made homemade wines from chokecherries and wild cowslips, while another made tea from wild mint.

RIGHT: Lipton Tea poster, 1914. Author's personal collection.

FEEDING THE FAMILY 79

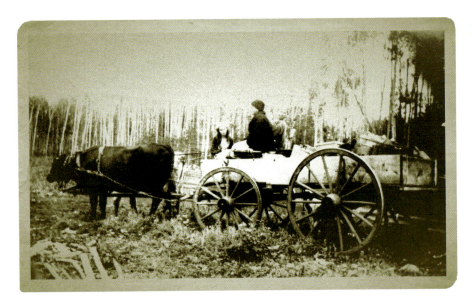

ABOVE: Mrs. Vaadeland, with her son, Peter, and her daughter, Clare, on their way to Big River. They were transporting their eggs in crates to the town store for trading purposes. n.d. PAS R-A17297.

Some settler families did not have the financial means to buy any products from the town store, not even tea or coffee beans. Instead, they developed alternative ways to acquire purchased food for their families. Settlers like Elsie Campbell and her family used the barter system. They would take a load of hay into town and exchange it for groceries. Andrew Salamon exchanged cut wood or pelts for necessities like flour, tea, sugar, and porridge, while Mrs. George Pepper would take her butter and eggs into the store to exchange for basic food. Mrs. R. Miles's family took in butter, eggs, and vegetables to the store and traded them for dried fruits and jam. Mrs. Ada Christian mentioned that her storekeeper let people "run a bill at the store," which kept getting longer each time they needed provisions. She noted that while this was beneficial for the pioneers, it was less so for the shopkeeper: "[It] was risky business for the storekeeper who carried [the bill] for several years." Typically, it was the shopkeeper who would lose out in the end.

Some families had difficulty in getting to town for supplies, particularly during the winter season. For instance, Mary Bishop's family could not go to town during the winter of 1886, as the temperature was minus fifty degrees Fahrenheit, they were fourteen miles from town, and the snow was five feet deep. Mrs. Lang's family faced a similar deprivation in 1904, and they had to resort to eating frozen potatoes and syrup for a week. Meanwhile, Mrs. N. H. Spencer wrote that with the trains and roads blocked in 1903–1904, and the stores completely sold out, her family "had to live on supplies right down to one pail of coal and one loaf of bread." The Archibald family ran so short on supplies one time that they were only left with sugar, tea, salt and pepper, and soap. Mrs. L. B. Pugh's family was reduced to a food supply of only beans and raisins because of bad weather conditions: "Beans were eaten at every meal and for so long, that that was all that was expected at the table." In a similar situation, Jessie Cameron recounted how she and her family only had rhubarb and eggs to eat:

The Effects of Home Brew

According to settler Sydney May, his "neighbour made home brew. He had finished a batch and then threw out the mash where the stock could get it. Well of all the antics they got into, drunk of course for eating the mash. One cow bloated and pigs were squealing, turning summersaults, jumping up and down, until the stuff was removed."

Homestead Cooking Tips #1

Mrs. Lena May Purdy and her husband were very creative. They made their own vinegar rather than buying it from the store. She stated,

One year my husband got an empty vinegar barrel. We half filled it with chokecherries, covered these with water, set up the barrel in the warm kitchen. It soon fermented like yeast, later turned into very fine flavored vinegar and for several years I made pickles. It made the pickles brown, but tasted the best of any vinegar I ever used.

It was hard to get fruit in the early summer months. No money on the homestead to get a variety of the foods we should have had. Nearly all homesteaders had a patch of rhubarb and in the newly broken land, rhubarb grew well and there was always lots of it!... Fried eggs were also an old standby on the homestead menu during the summer months. Money was too scarce to buy any kind of meat. So, it was eggs three times a day. They were fried, boiled, scrambled, omelets, etc. We were often sick and tired of them.

Ernest Ludlow also ran short of food and had no choice but to boil the "brown sugar bag to salvage the sweetening left in it," while Fred Baines recounted the time his mother cried because of the poor dinner she had to serve her family.

Other pioneers were so poverty-stricken that they and their children were forced to wear sugar or flour sacks for clothing. Jessie Cameron recounted how a neighbour lady wore a skirt made out of flour sacks, which she had sewn herself. On the front of the skirt was printed the company name "Purity," while the words "Five Roses" adorned the back. Andrew Salamon described the sack clothing some neighbour children wore:

Funds were very limited at times and [groceries] were purchased according to means. However, I might add some of the hardships some of my neighbours contended with. Two large families in particular with eight and nine children respectively. These families used 20 to 30 bags of flour yearly, and in order to make ends meet, they had to use the flour bags to clothe their children since they had no means of sewing or altering these bags. The bags

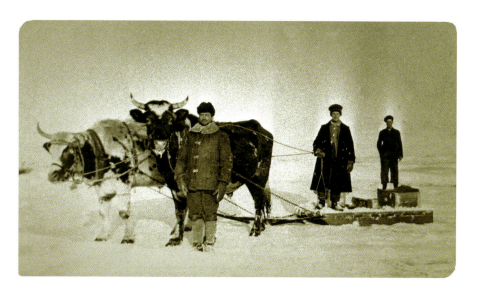

ABOVE: Win Kirnel, Lawrence Craig, and Frank Boyd heading into the town of Vanguard, Saskatchewan, to pick up supplies with oxen and a stoneboat during the winter of 1913–14. PAS R-A2726.

FEEDING THE FAMILY

Homestead Cooking Tips #2

If homesteaders were not able to acquire baking powder (which helps cakes, scones, or biscuits to rise) from the town store in the winter, then they could use dry snow from the yard. Dry snow, once crystallized, could be quickly mixed into the batter and then immediately placed into the oven for baking. As the mixture baked, the snow evaporated, leaving small pockets of air in the finished product. As a result, the cakes, scones, and biscuits were light and fluffy.*

* "Uses Snow in Cakes," *The Grain Grower's Guide*, May 7, 1913, 28.

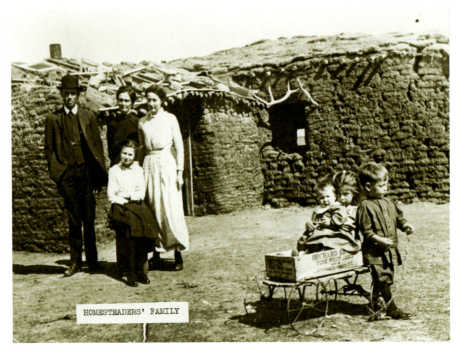

LEFT: A homesteader's family outside their sod house, Mankota, Saskatchewan, ca. 1900–1920. The children's wagon was made using a jam box from the town store. PAS S-B9280.

were cut out on each corner for sleeves, a hole in the centre for the neck and pulled over each child, some with the letters in front, others at the back.

Edith Stilborne's family also suffered due to a lack of funds and thus an inability to buy food from the town store. However, even though they had to experience less than desirable eating conditions, she did note a positive aspect to the experience, that is, the ability to create play toys out of animal bones. She wrote,

The stored potatoes would be frozen in the cellar almost past eating. If they were put in cold water, the frost would come out of them, leaving them eatable but not very palatable, they were sweet, and sad. Our meat would consist of fat bacon and game, chiefly rabbit in the winter. We would even be short of milk in the winter when the cows had to be dried off for a time. When we had milk, we used to have big baked rice puddings, made in a large milk pan. We were all very fond of the brown "Top" as it was called, so mother had to arrange that we had this in turns. Rabbit heads were a favourite too, we had to take turns to have those when we had rabbit. The jaw bones made very good imitation guns.

WILD FRUIT AND THE VALLEYS NEAR

Over time, some settlers were able to expand their farming operations by buying cows for milking and hens for laying eggs, both of which would help to supplement the family diet. For others who could not afford to purchase cows or hens, they had to find other ways of obtaining dairy goods and eggs or they did without. Elsie Campbell purchased milk or skim milk from neighbouring farmers. Unfortunately for Elsie, going to

the neighbours for milk could be a hazardous chore. She "walked 2 ½ miles to John Evans' farm with a can. Met a coyote face to face on way home. Good job he didn't know my red cloak was exactly like little Red Riding Hood's." Fred Baines and his family did not have any milk for their first two years on the homestead. Finally, in 1890, he was able to buy a quart a week for ten cents.

For those who were able to obtain milk from their own cows, they were able to separate the cream from the milk and churn it to make butter. Other settlers stated that along with making butter, they also prepared an assortment of cheeses. A number of settlers made whole milk or cheddar cheese, while others made curds, cottage cheese, or cream cheese.

With regard to poultry and eggs, many settlers had enough eggs for their family, as they kept a flock of five to twenty hens in their farmyard, while others bought eggs from their neighbours. Some settlers did not have access to any eggs at all, while others claimed that instead of being reliant solely on chicken eggs, they were able to expand their diet by searching and finding duck eggs for their meals.

ABOVE: Cows in corral, 1910. PAS R-A16557-3.

Regardless of the type of egg they ate, a number of settlers would preserve their eggs so they could eat them year-round. When asked how they undertook this preservation process, they gave a variety of answers. Ethel Sentance's family covered their eggs with lard, wrapped them in paper, and packed them in tins, while Wanda Upton greased the eggs and wrapped them in paper. Others, like John Evans and J. B. Payne, used salt brine, while Mrs. Nelson boiled her eggs and packed them in sawdust or oats. Mrs. James Kidd packed her eggs in a box of salt and then put them into their dirt cellar, while Mrs. John Jameson's neighbour would pack their eggs in wood ashes.

Many settlers would also try and plant a garden during the first year they were on their homestead, particularly if they arrived in the spring. This was an advantageous undertaking, as a garden would help to ensure that another food supply was available to the settler family. The most popular vegetables planted were potatoes, followed by carrots, beets, turnips, onions, and cabbage. Along with the vegetables

FEEDING THE FAMILY

ABOVE: A small child feeding chickens. Children started doing chores around the farmhouse and in the gardens and fields when they were four years. By the time they were fourteen years old, both boys and girls were doing an adult's share of daily labour. n.d. PAS R-A17263.

listed above, Mrs. John Jameson also planted lettuce, radishes, and peas, while Mrs. George Pepper also planted cucumbers.

Other settlers tried their hand at gathering wild berries to add variety to their diet. When she was a child, Mrs. Lena Purdy and her mother would search for wild fruit in nearby areas:

Mother and I were real experts at finding and picking wild fruit and the valleys near us provided a great quantity and variety. In 1889, we had a row of wild black currants in our garden and there was a grand crop of fruit of them and in the valley near. Mother and we girls picked 24 pails of beautiful currants and father took them to Regina and sold them for $2 a pail. The year the CPR was being completed, mother used dried apples and with raspberries and plenty of sugar and made many pails full of jam, selling it to the CPR for 25 cents a pound and the railway furnished the pails.

Not only were Lena Purdy and her mother able to add a number of different berries to their family meals but, given they had a surplus of fruit, they were able to take advantage of the opportunity to sell their harvest and increase their family income. Having additional funds meant they would be able to buy additional

Homestead Cooking Tips #3

CHICKEN GIZZARD AND HEART SOUP

A wonderful chicken soup made with gizzards and hearts. Add a couple of quarts of water to hearts and gizzards in a large pot. Add salt and simmer for a fair time. You can add sliced carrots and some onion to the soup, plus salt and pepper. Then add homemade noodles and cook until tender. Noodles—Egg and flour and salt. Mix to a fairly stiff dough. Roll out on floured board and then cut into strips. Or you may pull off pieces and add it to the soup. Very good and enjoy!*

PS: You may want to add stewed tomatoes to the soup just before serving.

* This 1907 recipe comes from my personal collection.

ABOVE: A homesteader feeding chickens and geese. n.d. PAS S-B461.

groceries or other essential items from the town stores when required.

Other settlers gathered fruit for their own benefit rather than selling it to others. Importance was placed on preserving the fruits so they could be consumed during the long winter season. As described by Mrs. John Jameson,

We canned wild gooseberries, saskatoons, raspberries, made preserves of strawberries, currants, and blueberries. Jelly and jam of cranberries. Preserved rhubarb out of our own garden. All the fruit we canned and otherwise preserved was wild fruit we picked around and in the vicinity of our home.

Aside from collecting wild berries, a few other settlers collected wild mushrooms to add to the family's diet. If they could collect enough, they could make flavoured sauces or soups. To keep mushrooms over the long term, settlers would preserve them by drying them.

The Kindness of Neighbours

Sorine Franks remembered how kind people were to one another and the friendships that developed among the settler community. She recounted the story of when her family was in need and had no money:

In the spring of the year, we did not have any money to get garden seeds and were talking of selling a nice heifer to get some money…but we had looked forward to getting a cow from her. Well, our neighbour, Mrs. Barton, came along one morning and put a dollar bill in my hand and said, "Get your garden seeds with that" and we did. It does a person good to think back to times like that and there were many like that in those days. Neighbours helped neighbours.

FEEDING THE FAMILY

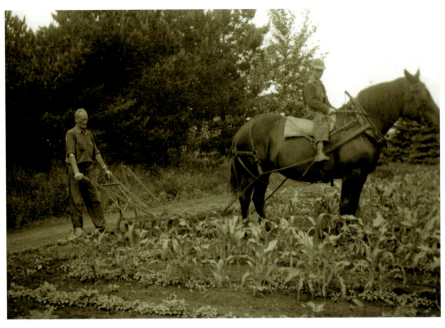
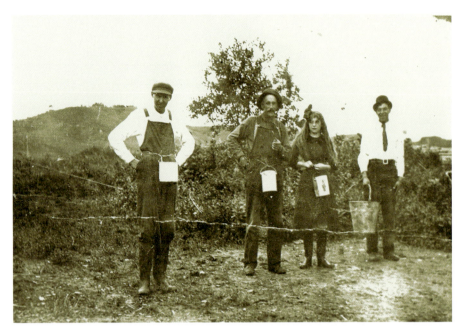

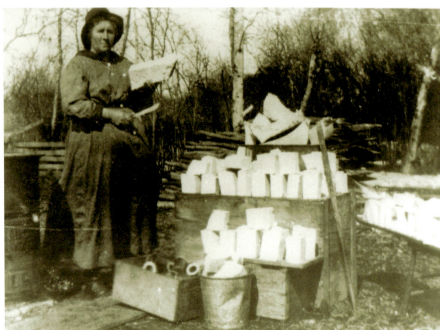

WE MADE WELL WITH RABBITS

Settlers complemented their diet with red and white meat products such as beef, pork, or wild game. With regard to domestic animals, they raised cows or pigs themselves for slaughter, or bought the animals from a neighbouring farmer for butchering in the fall or winter. Typically, butchering was done in the fall, as it was easier to keep meat fresher for a longer period of time compared to the warmer seasons when meat would spoil more quickly. For those who needed meat and had to butcher during the warmer months, they would quickly divide any excess they had among their neighbours and salt it before the meat spoiled.

Some settlers were involved in a more formal process to acquire meat by being a member of what was called a beef ring. Generally, there were approximately fifteen to twenty people involved in a ring, with one member supplying one steer every twenty weeks. Each butchered portion would be weighed (so each person would obtain the same amount as all of the others), then the meat would be put into flour sacks and hauled home.[11] In terms of other kinds of animals that were available for butchering, a few settlers kept a flock of sheep on their homestead. For example, Nelson Hall's family had a number of sheep, and sometimes they would slaughter one of these animals and then hang the eviscerated carcass in the well (to keep it cool) until they were ready to cook and eat a portion of it.

As for obtaining wild game, a large number of settlers hunted on or near their homestead. When asked what kind of wild game they hunted, many settlers said they snared rabbits. Sam McWilliams offered an interesting account of his rabbit-hunting exploits:

Dad purchased a roll or two of brass wire and made snares. He took me down to the river and he showed me how to set the snares in runways of the rabbits, both Jack and Bush rabbits. We went home and he made a sleigh and that was my joy to take that sleigh and gather the rabbits and

OPPOSITE PAGE, CLOCKWISE FROM TOP LEFT: Cultivating corn with a horse-drawn cultivator. This was done to control weeds by working up the rows in between the vegetables. n.d. PAS S-B4642; Gathering berries by the bucket. Depending on when the fruit was ready to be harvested, settlers and their families could gather raspberries, strawberries, blueberries, currants and Saskatoon berries. Every once in a while, they also collected mushrooms. However, one had to be knowledgeable about which mushrooms were edible and which ones were poisonous. n.d. PAS R-A7570; A woman collecting honey. n.d. PAS R-A18320; Some settlers kept bees and collected honey to add to their meals, 1907. PAS R-A2520.

Homestead Cooking Tips #4

If cranberries are dried and shriveled, the skins will be rough when cooked. The remedy is to soak the shriveled berries in cold water for several days before using.*

Butter may be preserved in quantities in the following way: Wrap the rolls of butter in a cloth and pack in a jar, pour over them a cold brine made of 6 quarts of water, 1 quart of salt, a teaspoonful of saltpeter, 2 tablespoons of sugar, all boiled together for five minutes. Keep in as cool a place as possible, and the butter will retain its original sweetness.†

Never make tea in a tin pot. The tannin, which is acid, attacks the tin and produces a poison.‡

* "Cooking Tips," *The Nor-West Farmer*, May 1898, 226.

† "Cooking Tips," *The Nor-West Farmer*, April 1898, 180.

‡ "Cooking Tips," *The Nor-West Farmer*, November 1885, 293.

FEEDING THE FAMILY

Summer Borscht (Zumma) Soup

2 quarts of soup stock made by boiling a ham bone for 1 hour

2 cups finely chopped beet greens, burdock leaves, or sorrel leaves

1/2 cup chopped onion greens

1/3 cup dill greens

3–4 medium potatoes, diced

salt and pepper to taste

1/2 cup sweet cream

1 cup thick sour milk (optional)

Mix together soup stock and vegetables. Boil until vegetables are done. Add the cream and sour milk and serve hot.*

* Nolan Martens's family recollections, 2015.

reset the snares. Some of those big jacks would break the snares and I would find one or more broken snares on them. Well the whole family ate rabbits until we would jump around at night. We made well with rabbits.

Andrew Salamon was also proud of his rabbit-catching abilities. When the family's provisions ran low, he would go hunting. He stated, "Rabbits were seen by the thousands in the forest. When our ammunition supply was limited, [I] would sit out along the rabbit trails, waiting for them to come along on a bright moonlit night. [I] killed quite a few with a club; other times with a snare." Wilhelmina Taphorn also commented on the number of rabbits that were available and how easy it was to catch them in 1907. She wrote, "The rabbits got around the haystacks by the dozens. If doors were left open they often ran into the house [and as a result] one of our main dishes was rabbit. There was fried rabbit, stewed rabbit, rabbit ground into hamburgers, and smoked rabbit, and rabbit everywhere, winter or summer." She also mentioned that deer were easy to capture, as the animals would run with the cattle in the pasture.[12]

Other settlers had partridge or grouse in their diet, while a few had moose, antelope, and wild turkeys. Some settlers, like Fred Baines's family, ate badger, but he was not too fond of it. As he stated, "The badger was an oily strong nauseating meat, it took a strong stomach to handle it." Other settlers ate porcupine and skunk. Regardless of the type of animal caught, it is likely settlers cooked these animals in much the same manner as they would chicken or rabbit. Once the animals had been cleaned (and the scent glands removed from the skunk), the meat would be cut up and put into a pot for cooking, along with some chopped carrots, onions, potatoes, and salt and pepper. Flour and water would be added to make a gravy.

While some settlers were able to hunt larger game, many of them were limited in their hunting efforts because of a lack of firearms and, therefore, they ate only what they could snare or catch. Fred Baines's family tended to only eat rabbits and badgers. They were unable to hunt deer, as they did not own any rifles. Although not stated, Fred's family may have owned a shotgun. However, shotguns lacked sufficient accuracy and range to shoot large game. Other settlers, like the Campbell family, hunted the smaller animals, but they seemed to prefer this kind of hunting as they could make money from the skins. Elsie Campbell's family "could have eaten the muskrats that they caught," but, rather, they "dressed the skins and sold them for eight cents each— beautiful skins." Depending on how many animals they caught, such an enterprise could have been very profitable. Making eight cents on each skin might have meant the Campbell family could have purchased some luxury food, or at the very least been able to buy all the basic groceries they needed.

In order to ensure their families had meat in their diets on a regular basis over

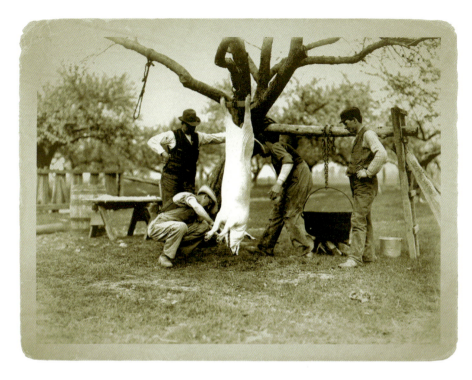

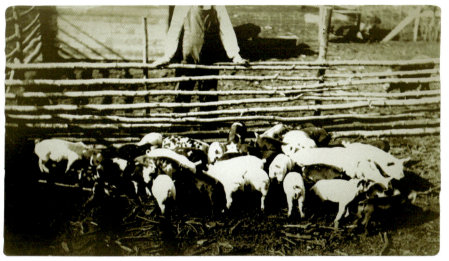

ABOVE LEFT: Slaughtering time. n.d. PAS R-B9803-1.

ABOVE RIGHT: A farmer with his pigs, 1910. PAS R-A16557-2.

the course of the year, many settlers preserved it using a variety of methods. Winnifred Taylor's family kept their beef frozen in winter, and they salted their pork and smoked sausage. Meanwhile, Milly Olmstead and Catherine Young canned their meat. Others such as Elizabeth Harrigan and Ellen Hubbard corned their beef, while Ethel Jameson's family fried their pork, packed it in a crock, poured fat over it, and then placed the crock into the cellar or dugout. Other settlers, such as Ruddy Howes, would cure their meat in brine and then nail a pole onto the roof of their home and hang the meat on the pole, while another settler, Rosanne Thompson, stated that her family would hang their cured meat in a well. William Hargarten would just stash the meat in a hole in the ground, while Ada Christian would take her brine-cured pork and pack it in oats. Alwyn Wilson and Mrs. William Orth sugar-cured their meat, while Mrs. Charles Archer and Eric Neal pickled or smoked it. Edith Stewart, in her memoirs, set out in great detail the butchering of a pig. She discussed how the carcass was scalded and the coarse hairs removed with sharp knives, how the entrails were taken out, and how the pig was bled (and the blood collected for blood sausage). The pork belly was cured in a brine, hams were smoked, and headcheese was made out of the jowls.[13] Drying meat was also a popular method, with settlers like Norman Irving and W. O. Fraser taking wild game like deer and making it into pemmican. Pemmican was an Indigenous recipe that entailed mixing dried (or cooked) meat with grease. Sometimes berries would be added

FEEDING THE FAMILY 89

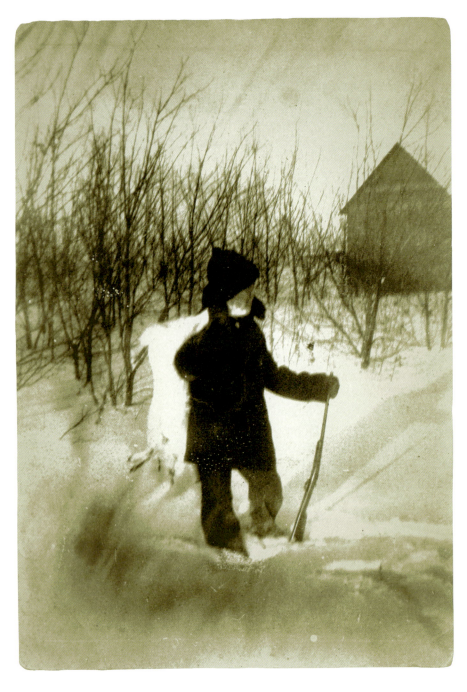

LEFT: Edward Stephanson, 6 years old, holding a rifle and the first rabbit he shot. n.d. PAS R-A18492.

for flavour. Using this method would ensure the meat would be preserved for a long period of time.

Rather than discussing the various types of meat that were available, Jessie Beckton related how simple it was to obtain fowl for their family dinners due to the large number of mallards in their area. She wrote that it was cruel to shoot them but that they had a large number of people to feed in their family and that the birds "made a welcome break in the winter menu of bacon and beans." Using a shotgun, her brothers could shoot down between six to eight birds at a time.[14]

In her biography, Augustine Koett wrote about how she and her sister caught fowl for their family's lunch:

> Helen, age six and I, age 5, caught blackbirds every day and Mother prepared them for lunch. (Blackbirds taste good fried.) There was a big box full of oats with a board over it. Helen and I would push the cover a little to the side so that the blackbirds would get in. Then Helen would crawl into the box while I held the opening shut with Mother's old cape. Whenever Helen caught a bird she handed it to me and I would give it to Mother.[15]

Rather than relying on hunting blackbirds or any other types of fowl, Aaron Biehn's family used a different strategy for obtaining food. They fished for their meals from nearby streams or lakes. One time Aaron went fishing with his father and, instead of using fishing poles, they used their wagon to catch fish. His father would back the wagon into a deep part of the stream, open the back, and then allow the fish to swim into it. A net at the back of the wagon prevented the fish from escaping. When their wagon was full, Aaron and his father would be done their fishing for the day.[16]

Many settlers indicated there was a variety of fish available for capture. Fish such as jackfish, whitefish, goldeye, trout, pickerel, and white suckers all became

90 THE HOMESTEADERS

part of many settlers' diets. Mrs. Hugh Travey's family ate fish three or four times a month. Sam McWilliams's family was able to enjoy fish over the long term due to the large amount they were able to catch at one time. He recalled that even though he and his father had intended to go duck hunting one day at Moose Jaw River, they ended up fishing instead. He wrote,

In one place the riverbed was narrow. Suckers trying to get upstream were so thick their fins were sticking up out of the water. They had to wait for those in front to get out of the way. Dad found a net made out of slender willows. Hid in the bushes. It was made on the style of the old wire fly net with a cone inside so fish could not get out again.... Woven together Dad placed it in the water where it was shallow and wide. He built a wall of stone on each side of the net out to the shore so the fish had to go into the net. The next morning it was packed full, 3 or 4 barrel fulls that were cleaned and salted for summer use.

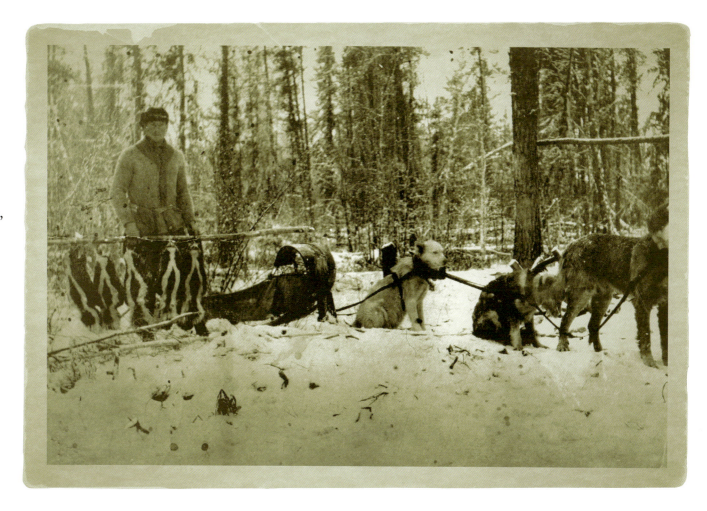

For those settlers who were not able to catch their own fish but had some additional funds in hand, they had the option of buying canned fish from the local store. David Maginnes's family bought canned salmon, herring, and sardines, while Edith Stilborne's family purchased a few more additional kinds of fish from the store, including mackerel, herring in tomato sauce, and bloater paste, the latter being mashed smoked herring that is spread on toast or sandwiches.

ABOVE: Peter Fuchs and his dog team and sled trapping skunk in the Beauval, Saskatchewan, area in 1914. PAS S-B1135.

Hauling Water from a Spring

The following is a story recounted by Mrs. Harvey Taylor.

When we homesteaded at Kindersley, we had to haul water from a spring 3 ½ miles away. You always met your neighbours at the Spring. One old chap with a team of oxen said he always got three barrels, one in each ox and one on the stoneboat. I used to go to help my brother. We had a tank. We used to fill our pockets with raisins and prunes to eat along the way. There was a steep coulee so you would never get up with a full barrel or tank. It was fun. We all helped each other get up the hill. Some people brought their cows along to get a drink. It was like an oasis in the desert. Many a story was told while waiting your turn at the Spring. It relieved some of the loneliness.

MOTHER USED TO MELT SNOW FOR THE COWS

Along with the basic groceries and provisions pioneers and their families needed, finding a water source was also a priority. Fortunately for some settlers, they had a stream on their property or had access to a nearby river, which meant they had an easily obtainable water source not only for themselves and their families but also for their livestock. For instance, Spencer Pearse and Mrs. E. Borwick had a water source right outside their house, while Kate Stirling obtained her water from a river that was two hundred yards away from her front door. George Ballantine also used water he hauled in barrels to his home from a river located about one-quarter of a mile away. Edith Stilborne's family retrieved most of their water from a creek. However, they would also collect water "from the roof using coal oil barrels as containers" during the rainy season.

Other settlers had a more difficult time of it as they discovered the only available water they had near their property was slough water. They reported using slough water for drinking, and for household and farmyard use. Two of those settlers, David Maginnes and Mary Anderson, had to collect slough water, as it was the only water available on or near their land. Given that slough water tended to be dirty and full of bugs, the water would need to be filtered before drinking. Typically, the filtering process included a handkerchief or an empty flour sack. Slough water was poured through the material and the filtered water was drunk. The cloth would retain bugs and mud and, once it dried, it could be shaken out and reused. Yet, even with this filtering process, the water was not purified and, as such, many people during the pioneer era contracted typhoid fever, which was brought on by drinking contaminated water.

Some settlers tried digging wells on their property. If they found a high alkali content in the water, they would have to give up the idea of obtaining water on their own land and instead travel on a regular basis to the nearest slough for water. Elsie Campbell and her family also tried digging numerous wells on their property, all of which were nonproductive. She wrote,

> *[We] had no water in 9 years though we dug 7 wells and drilled one. Had to haul 1 to 2 miles either from neighbours well or from slough.... I used to ride 4 horses abreast full gallop a mile in winter to water them. Mother used to melt snow for the cows.*

Others settlers were more successful at digging productive wells and, in fact, found it to be a somewhat easy undertaking. Andrew Salamon dug his own well on his homestead in 1907, while Mrs. R. Miles had a well in her own yard, twenty yards from the house. Arthur Wheeler had no problem finding water for drinking and cooking. In fact, in 1906, water was plentiful and he could get water from three sources: the well; the slough, which was always full; or the spring, which also ran throughout the winter.

How well the settlers drank or ate depended on a number

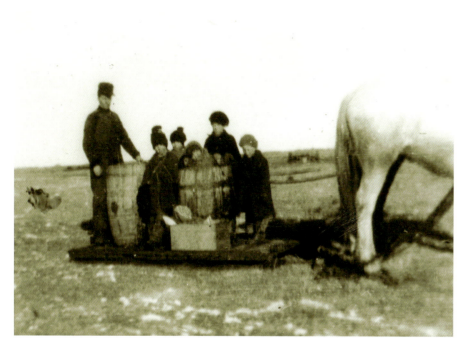

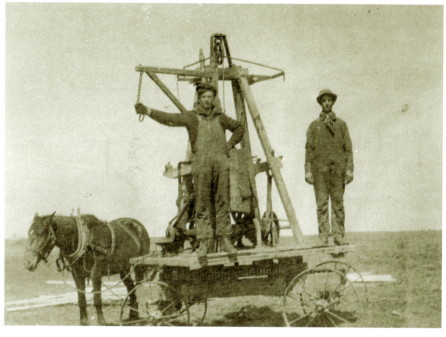

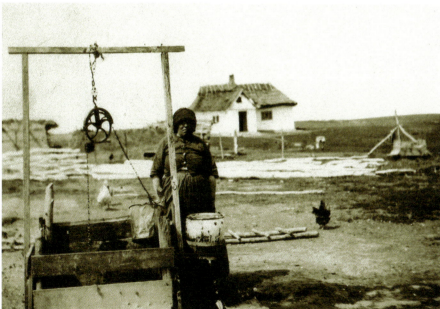

ABOVE: Drilling for water at Kenaston, Saskatchewan, ca. 1903–1910. Library and Archives Canada, C-030985.

TOP LEFT: James Hagarth and his family hauling water in barrels on a horse-drawn stoneboat. n.d. PAS R-A20135.

BOTTOM LEFT: A homesteader at her well. Note the distance between the well and the farmhouse. n.d. PAS S-B7350.

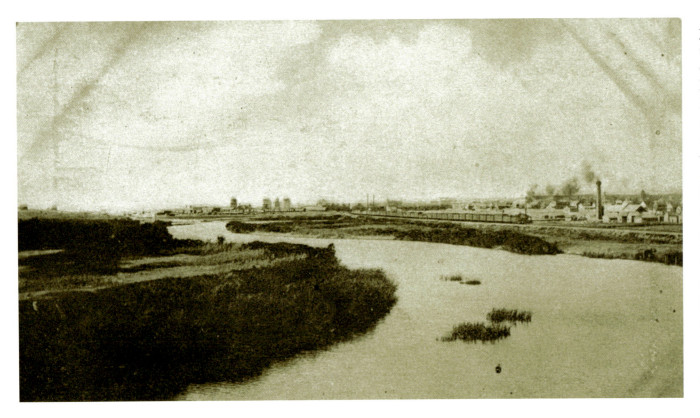

ABOVE: Moose Jaw River with the city of Moose Jaw, Saskatchewan in the background, early 1900s. As stated by Sam McWilliams above, the fish were so plentiful in this river that he and his father caught barrels of fish at one time. Being able to take home a substantial amount of fish ensured that the McWilliams family would have some diversity in their diet over the next few months. PAS R-A24641.

OPPOSITE PAGE: Elderly homesteaders, aged 98 and 95 years old. The wife was three years older than her husband. This couple took up homesteading when they were 85 and 82 years of age. n.d. Author's personal collection.

of conditions. If they began homesteading under optimal circumstances (i.e., registering for homestead land in the spring; having good land for farming, which included a freshwater stream; had enough funds to purchase all of the supplies they needed; were able to plant a garden; and were able to hunt wild game nearby), then it is likely they would survive their initial years. However, if they were not as fortunate and had to struggle to obtain food and water, then it is likely their chances of successfully homesteading would have been more challenging. Struggling through the hard times, and watching their children go hungry or having to clothe their children in flour or sugar sacks, would have been very stressful for those pioneers who lacked the monetary means to improve their situation. Working on empty stomachs day after day in the fields during harvesting, or having to ration the most meagre of meals during the winter months would have been distressing if not heartbreaking. If a family experienced more extreme circumstances and was close to starving, then life would have been filled with continuing misery and anguish until they were able to obtain some food. Determination and perseverance may have helped them in their quest to stay and work their homestead land, but the need for food and the ability to stave off hunger would have been a daily concern.

Daily Menus

Saskatchewan settler George Ballantine reported on a typical day's menu he and his family members consumed between 1880 and 1890. It is interesting to note that his family had a few more luxury items included in their meals as compared to other families.

Breakfast—Oatmeal porridge with brown sugar and milk. Toasted bread or scones and butter. Fried prairie chicken, applesauce, barley coffee with cream, milk for children.

Dinner—Mashed potatoes, and other vegetable, roast beef or other fresh meat or stewed prairie chicken with dumplings. Bread and butter, corn starch or bread pudding, tea, milk.

Supper—Bread and butter, fried fish, warmed up potatoes, homemade pickles, fresh or preserved fruit, cake or cookies. Tea, milk.

The Diggle family provided a second menu sample for the same time frame:

Breakfast—Fried potatoes, fried pork, light white bread, butter, tea, sometimes oatmeal porridge with cream.

Dinner—Roast duck, potatoes with jackets on, boiled carrots, bread pudding with raisins, eaten with cream, tea.

Supper—bean soup, boiled eggs, bread and butter, raspberry jam, tea.

Chapter 5
Health and Illness

Given the lifestyle of a typical prairie settler, it was not surprising to find there were a number of serious accidents that were reported during the homesteading years. Settlers detailed a wide range of misfortunes and mishaps that befell family members. For example, many indicated that at least one person in their family had broken or fractured an arm or a leg. Such injuries came about when family members were thrown from carriages or wagons due to a runaway horse or pair of oxen. Another settler recounted how her son had fallen off a load of straw, which resulted in a double fracture, while another settler was kicked by a horse and suffered a cracked leg bone. In the absence of professional care, self-help remedies had to suffice. One young child found his fractured leg being pinned back together with wooden screw nails, while a mother who had broken her wrist after a bad fall off a runaway team had to live with a weak and crooked wrist for the rest of her life, since it had never been set properly. Deadly results were not unexpected. Mrs. Esther Goldsmith remembered how a "five year old girl was run over by a stoneboat loaded with stones" and could not be saved using the basic care techniques that were common knowledge. Another settler, Mrs. Harry Teece, described how her young brother had been hurt by "slipping down off a rackload of grain between horses and wagon. As they had not learned the right way at that time to build racks, the wheel went over his body. He passed away a few hours later."

Settlers also reported on other serious injuries like amputations. One settler's husband had cut off his toe with an axe, while another lost all of his fingers in a chaffing mill. Another lost a finger while he was using a hatchet to cut and split wood. Home remedies did work on occasion, as with the settler who lost his finger

OPPOSITE PAGE: Dr. and Mrs. R. G. Scott in a horse-drawn buggy, 1902. PAS S-B1195.

HEALTH AND ILLNESS 97

A Painful Experience

Phyllis Cardwell recounted an accident her mother had while working in the kitchen.

The three of us older ones went to visit a neighbour one Sunday and while we were away Mother was washing the dishes and she put an empty syrup pail on the stove with a little water in it. She said she just set the lid on it but the steam must have tightened it because when she moved it to wash it, the lid flew up and she got scalded with the hot water and steam in her face. One of the smaller boys ran to the barn to get Dad. All Mother had in the house was Vaseline so that was what they used. When we got home, Mother was sitting by the stove with her winter coat on and we couldn't seen her eyes as her face was one big blister and she had the chills. I got her in bed with hot irons wrapped in a towel and tried to keep her warm. I looked after her and I am proud to say she did not have a scar on her face when it healed up.

and stuck the stub into a slice of fresh bread, which was sterile, and the stump healed well with no blood poisoning. Lottie Diggle knew of a father who had saved the finger of his young daughter when he "put a splint [on] each side and wrapped it up in its own blood." The finger "healed beautifully." Unfortunately, not all memories offered happy endings. Edith Stilborne provided a lengthy description of a threshing accident in 1889:

Billy Ringrose was a bachelor, no known relatives near. He was a feeder, so pushed the sheaves into the separator as bands were cut. Billy was stepping across the mechanism that received the sheaves. At that moment the power was turned on by starting the horses. It was frosty, the separator covered with rhimy frost. Billy slipped, fell with his leg in the machinery that carried the sheaves.... The driver stopped the horses, but it was too late. Billy's leg was caught in the machine. As he was lifted out, he cried "Oh my foot, my foot". But his leg was crushed and severed at the groin, leaving arteries pumping out the life blood.... Chris Cooke...and another young man tried to tie off some of the arteries, but Billy bled to death.

Along with machinery accidents, settlers and their family members also suffered from burns. Mrs. Maggie Whyte's brother had been "severely burned by steam from [a] tea kettle. He was covered with Vaseline and tied up in soft white cotton." Other burns were received from boiling fat on the stove or from falling against the wooden stove or heater. One child burnt his backside, another boy his hands, a baby girl burnt her palms and fingers, which all blistered, and another baby received burns when his highchair tipped over onto the stove. One of the worst disfiguring accidents reported involved a teenage boy repairing farm equipment who badly burned his face in an explosion while working with a blowtorch.

Conditions outside the home were no safer. One settler reported his family's house had been reduced to ashes and all of his family members had been burned during a prairie fire. Lillian Miles, who also lived through a prairie fire, suffered from having burnt hands and feet. She explained she "had to sit for quite some time with my feet in a bowl of raw eggs before they were bandaged."

With regard to other types of injuries, a number of settlers listed sprains as a problem, particularly sprained ankles from stepping into gopher holes. Injuries from horse kicks were also quite common, as were injuries related to farm tools and machinery. One settler noted her "father had an anvil fall on his foot in a blacksmith shop. The corner cut through [his] boot, sock and cut his foot and cracked the bone. He put salt and a bandage on, wore a soft shoe, and worked, and it healed." Edith Stilborne recounted how her

baby, born after we came to Canada, got some Gillett's Lye in her mouth burning her very badly, so she was unable to swallow. A doctor was consulted about that and although he did not see her he sent some lotion which was used with a dropper. We fed her on diluted cream, also given with a medicine dropper. Her recovery was almost magical.

Other settlers dealt with wounds from rusty nails. Mrs. J. F. Keyser wrote, "Two or three of us, when I was a child had stepped on boards with nails in and had run them into our feet. We had to soak the foot, or have a poultice on and keep the foot up." Another settler had an eye that had been pierced with barbed wire, probably while fencing. One was struck by lightning, one received a concussion from a blow to the head with a winch, one was struck in the temple with a tree branch, and another was kicked by a horse and had his jaw broken in three places. Another youngster had a cracked kneecap and torn ligaments, while others suffered falls from gangploughs and harrows, had roots fly back and hit them when they were trying to dislodge brush from the ground, or suffered from crushed fingers, bullet wounds (including shotgun wounds), hog bites, and cuts from chopping wood. Edwin Gardner recounted many more injuries suffered by his fellow settlers:

We have had a number of accidents in our district. First a pioneer shot himself while carrying a gun on a plough to scare blackbirds off his crop. A bachelor got killed in his pasture with his bull. A young man was drowned in a swimming hole. Another got shot by his chum and recently a man was killed when some machinery overturned on him.

Kenelm Luttman-Johnson also recalled a tragic accident that had occurred in his district:

There was a school house where the village of Hart now stands. On the east side was open country and on the west side a steep hill. The road over the hill was fair on the east side, but very steep and rough on the western slope. One afternoon, as the children came out of school, many of them living on the west side, some distance from the school, a man driving a hay rack gave a number of them a lift. Descending the west side, the team ran away, resulting in the rack being upset and a bad smash up. One little girl was killed. Her sister, also thrown from the rack, ran home and asked her mother, who was sick, what a dead person looked like. The mother answered her, aided by descriptive questions from the little girl. Then the little girl told her that sister was dead. Some of the other children were hurt too.

Some settlers recounted instances where family members had fallen through the roof of the family home. Lottie Diggle wrote that her "baby sister fell through the stove pipe hole, about nine feet onto the floor and was unconscious.

Skunked

Annie de Balinhard recounted her own suffering when she encountered a skunk on her homestead:

I once got skunked right in the mouth and eyes. I went to collect the eggs and grabbed the hen as I was supposed to, and it was a skunk. Oh boy, I will never forget that! I thought I would choke and go blind.

ABOVE: North West Mounted Police Officer Herbert G. Slape. NWMP officers would have enforced quarantine rules. n.d. PAS R-A2382.

Mother took her out in the air and she recovered consciousness." Other settlers reported on family members who had been exposed to freezing temperatures in the winter. Mrs. W. B. Carmichael wrote that her brother had fallen through the ice and his feet and part of his legs were frozen. The family found a gallon of coal oil, and the mother put the oil into a tub and had the boy soak his legs in it. His feet and legs were fine in a short period of time. Clara Hoffer remembered the time when one of her neighbours experienced serious frostbite on one of his fingers. The neighbour cut off his frozen finger with a kitchen knife to save himself from getting gangrene.

WE LOST A BOY OF NINE AND A GIRL OF TWO

Settlers suffered from a variety of illnesses during their time on the homestead. Minor ailments such as fevers, the flu, and head and chest colds were dealt with, as were more serious maladies such as tonsillitis, strep throat, jaundice, asthma, lumbago, pleurisy, inflammatory rheumatism, and quinsy. Infectious eye diseases were also a problem, with many suffering from pink eye, while others endured the irritation associated with trachoma. Settlers also tended to suffer from various communicable diseases in the late 1800s and early 1900s, such as tuberculosis, diphtheria, whooping cough, measles, mumps, chicken pox, smallpox, typhoid, and scarlet fever. Many diseases would rapidly transfer from one family to another and remain virulent. Jemima Dowling wrote,

In 1902, there was an epidemic of diphtheria around Prince Albert. Many children died. We lost a boy of 9 and a girl of 2 years and 9 months. For 6 weeks our doctor was on the go day and night, sleeping in a buggy or sleigh, as a driver drove him from house to house.

Settlers did not understand how to deal with particular diseases and had little knowledge of the remedies that would be most effective in combating a disease. As a result, some settlers relied on purchased medicines, but many others depended on their own intuition and self-help remedies. Even if they did seek to protect their families from disease through immunization, such possibilities were few and far between. The only immunization program known to homesteaders was the one for smallpox. However, this immunization process did not appear to be widely accepted, nor was it immediately available, and, as a result, the majority of the settlers and their families were not protected. As noted by Lottie Diggle, "[Immunization] was practically unheard of in the 80's and 90's." Consequently, very few settlers were inoculated against smallpox, with only one settler

stating he had been inoculated between 1882 and 1884, and a few others receiving the needle between 1889 and 1890. Two settlers received their inoculation for smallpox in England before coming to Canada, one received his in Ireland, another in Quebec before leaving the ship, one in Ontario before coming west in 1895, while yet another had been injected when living in North Dakota. Even if settlers had been inoculated, the needle itself was not without its consequences. Mrs. Maggie Whyte wrote,

When in my early teens Mother and Father spent a winter in Ontario. There was a small pox scare in our town and all were ordered to be inoculated. My arm was terrific owing to impure vaccine and a kind friend took me to her home till return of my parents. Father took me to another doctor, whom, I remember had to send east to Toronto for a cure.

Settlers also recalled diseases that had appeared in their districts and where quarantines had been enforced for scarlet fever, smallpox, measles, and typhoid fever. While many did not understand how they or their family members contracted the various diseases, some settlers offered theories as to how such diseases spread, particularly with regard to typhoid fever. Many settlers believed typhoid fever was caused by bad river water or bad well water. Some speculated that old wells were disease-ridden and needed to be cleaned out, that all drinking water should be boiled, that the well water was too low, that typhoid was from creek water, or that cattle infected the water. One settler offered the theory that a father who had come to a church picnic was a carrier of the disease and had brought his well water with him for use in the lemonade. As such, most of the picnickers became infected. A few other settlers felt typhoid was due to the milk supply being tainted in some way.[1]

Some settlers, rather than speculating on the causes of illness, detailed the quarantine procedures they followed. One settler's family had experienced both smallpox and scarlet fever, and the North West Mounted Police went from house to house and quarantined those who were ill. A red card or red poster was placed on the door, with the word "quarantine" written on it. All of the family members, regardless of whether they were sick or not, were isolated with the ill person. In other words, no one was allowed to leave the residence, while others from outside were not allowed in.

Lena May Purdy wrote that during a smallpox epidemic in 1910, the "N.W. mounted police were stationed in [the] yard to secure strict quarantine, [and] did [the] necessary purchasing for [the] family." Mrs. Harry Teece also wrote of her experiences with a typhoid fever quarantine:

The first quarantine I remember was about 1891 or 2. Yes one family who lived in very

A Misdiagnosis

James Gray recounted his father's desperate flight to find a doctor for James's older brother, who had taken ill. In this case, the doctor automatically assumed the boy was suffering from typhoid fever.

My oldest brother took sick. My father walked ten miles to a neighbour who had a horse and buggy. He borrowed them and drove to Battleford to try to get a doctor. However, the doctor would not come as there was a typhoid epidemic raging in the town at that time. The Doctor said it was very likely typhoid that my brother had and wrote out a death certificate to that effect. When my father returned, my brother was dead. Later, it was felt by all that he had died of appendicitis. There was no undertaker or even a cemetery so the family and the few neighbours held the funeral and he was buried on a hill on the farm.

HEALTH AND ILLNESS

LEFT: A boy and his baby brother. It was a family milestone when a child reached the age of two years, as the mortality rate among babies was quite high. Babies died for a variety of reasons. Some were stillborn, while others were born early and were weak and underweight. Some lost their mothers during childbirth, or they passed away themselves during the birthing process, while others could not survive the freezing temperatures within the farmhouse during the course of the long winters and became ill with influenza or pneumonia. Others contracted diseases such as smallpox, diphtheria, lockjaw, German or red measles, mumps, or typhoid. n.d. Author's personal collection.

unsanitary conditions. . . . In this case 4 members of this family were all alarmingly ill before steps were taken. Then a Dr was called in who pronounced it Typhoid Fever. Called a nurse. I believe it was either from Indian Head or Regina. I think from Regina. Also some neighbours to thoroughly clean up the premises. If I remember right, two of the family died.

Not only were steps taken to isolate settlers on their homestead but settlers themselves tried to isolate those who were sick from the rest of the family who were healthy. However, given space restrictions, such efforts were minimal in most cases. Most of the settlers placed the sick person in an isolated room in the house, whether it was a separate bedroom or a backroom. Typically only one person entered the sickroom, and they would change clothes as soon as they were finished. The clothes would then be boiled and washed. Dishes and utensils used by the ill were also boiled. In the cases where the family lived in a one-room shack or soddie, a disinfected sheet or blanket was hung up, dividing the room in two. Such sheets were soaked in carbolic acid, Lysol, or formalin, and every day the house would be aired, even if it dropped to thirty degrees below Fahrenheit outside.

Sometimes isolation within the home was impossible if the dwelling was too small. In these cases, settlers moved the sick family member to a granary, or the healthy family members moved to the granary while the

sick person stayed in the house. In other circumstances, all of the family members stayed in the home, each taking the chance they would not contract the disease themselves. For those families who did not realize the importance of isolation, they did not make any effort to separate themselves from the person afflicted.

ANY NEIGHBOUR WOULD GO AND HELP

Many of the settlers' children were born at home on the homestead. In fact, one settler mentioned that all nine of her children were born at home. Most often, another woman was present and helped the mother-to-be as she went through labour and delivery. Even though one would assume these female assistants were experienced in the process, this was not necessarily the case. Often, the woman in attendance would be the neighbour lady who was not a medical professional or even a midwife but was available and had offered to help in any way she could. As noted by one settler, there was "a young married woman who never saw a live birth before [but] did what the mother told her."[2] Married women, older ladies, and widowed women also tended to offer their assistance. Edith Stilborne wrote,

In our district there were two women who were always sent for to attend maternity cases. As far as I know they obtained their knowledge by experience. If these women were not available at the time any neighbour would go and help deliver the baby and care for both Mother and baby afterwards for a few days.

Other settlers had a family member close at hand and, thus, grandmothers, mothers, sisters, and daughters all became part of the process. However, in some cases, having a close family member nearby was not helpful. Lena May Purdy explained,

My mother attended many maternity cases. One was especially memorable. A neighbour began to have pains, but her husband brought her mother, an old English woman, then found she was afraid and did not know what to do, so came for Mother. When she arrived the baby had been born, a tiny premature girl. The baby was lying in the bed, uncovered, the grandmother sat crying, mother and infant were cold.

ABOVE RIGHT AND LEFT: Mothers with their babies, n.d. PAS R-A19308-1 and R-A19308-2.

ABOVE: Mr. and Mrs. Eli Morozoff (seated) with their new baby in 1905. PAS S-B9504.

OPPOSITE PAGE: Doctors and a nurse. n.d. PAS R-A16578.

Mother tied and cut the cord, covered the mother and set the grandmother to find warm irons or stovelids to warm the mother, put the baby into warm water and did what she could to make it cry. The baby revived.

For other settlers, a midwife was present during the birth. Lillian Miles's grandmother was a registered midwife. Therefore, "she did a great deal of the work in connection with caring for patients and people would drive for miles to fetch her to come to their homes." Still other settlers had a doctor in attendance, while in other cases husbands helped their wives through childbirth.

THEY SENT FOR THE DOCTOR

While one would presume medical professionals dealt with settlers' health concerns, this was not the case for many. Most injuries were treated at home, as medical assistance was not close at hand. Few doctors had entered the western region in comparison to the number of settlers who sought free homestead land. Census reports indicate that only twenty physicians and surgeons resided in Saskatchewan in 1885, and this had only increased to 379 physicians and surgeons practising in the province by 1911.[3] The population of Saskatchewan was 492,432 by 1911: a one to 1,300 ratio of doctors to residents. Nursing care was also uncommon among the homesteading population. According to 1911 census figures, there were fewer nurses working in the province than doctors. The 205 individuals who reported being nurses were not formally schooled and certified registered nurses.[4] Rather, they were nurses that had been trained through apprenticeship or supervised through work-practice learning by private organizations such as the Victorian Order of Nurses or religious orders such as the Grey Nuns.[5] Training programs were run out of small "cottage hospitals" (residences converted to care for ill patients), which were slowly being built in urban centres.[6]

In addition to the limited numbers of doctors, nurses, and hospitals, access issues also restricted the availability of medical care for pioneering families. As stated above, the few hospitals, doctors, nurses, and training centres that were to be found in the region tended to be located in the growing urban centres. Homesteads, however, were founded across the prairies, and movement over undeveloped roads and trails on horseback was inconvenient and slow. Given that many settlers lived ten to twenty miles from town (one way), while some lived as far away as thirty miles or more, the time involved with riding a horse to town, tracking down the doctor, and riding back was substantial. The trip was particularly difficult during the winter months.

As for the cost of obtaining medical help, doctors not only tended to charge a fee for their services but they also charged for travelling time, which many settlers could not afford. For

example, settlers indicated that a maternity call cost between $15 and $25, while a regular home call (for an illness or injury) ranged from two to five dollars. In terms of mileage costs, doctors generally charged one dollar per mile, while a few were more reasonable and charged only fifty cents per mile.

Many settlers reported that medical costs deterred them from consulting a doctor. Money was scarce among many homesteaders, and so they would call only when home remedies failed. In other words, calling for a doctor was a remedy of last resort when nothing else could be done. Unfortunately, waiting until this point did not often end on a positive note. As reported by Mrs. W. B. Carmichael,

> *I remember one young man who had [a] hernia. When the hernia bothered him, his father and brother would lay him across a table, pull down on [his] shoulders and legs and the hernia would slip back into place. One day this failed—so they sent for the doctor. But the boy died.*

If settlers found themselves in a situation where a doctor had to be called, many of them had to exchange farm products or services for treatment. These included such things as vegetables, pork, beef, dressed poultry, butter, eggs, hay, oats, sacks of flour, cheese, blankets, clothing, potatoes, firewood, a Shetland pony, calves, hogs, and turkeys. Services included the wives sewing for the doctor's wife, and manual labour by the husband or sons. In other cases, the situation was so dire the doctor insisted on cash payment before attending to the patient.

Even though it may seem reasonable for patients and their families to pay in goods and services rather than in cash, many settlers were experiencing extreme hardship and were relying on their own subsistence efforts to survive. Having to give away basic items such as clothing, prepared food, or animals being raised for consumption meant the family would have to do without. Parting with work animals might mean that work on the farm would have to be delayed, while family members providing manual labour to the doctor meant they were unable to work on their own farms for

HEALTH AND ILLNESS

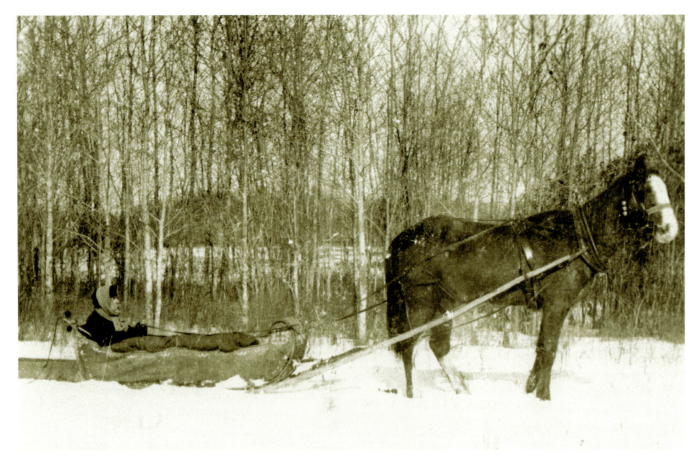

ABOVE: Dr. Gauthier of the Duck Lake District on a sleigh in the 1890s. Doctors used the most efficient transportation methods in order to make house calls: usually a horse and carriage during the warmer months of the year and a low-lying sleigh in the winter. PAS R-A6782.

that period of time. Given that many settlers lived on the edge of survival, a loss of any one or more of the above noted resources might devastate the family and lead to the failure of the family farm.

The lack of facilities and caregivers, the long distances and arduous travel conditions involved, and the cost of medical treatment meant that homesteaders were frequently required to rely on their own skills and knowledge. Self-help and home remedies that had been passed down in families from generation to generation were the sole, or at least the most important, aspects of medical care available to families unable to access, or afford, assistance.

PURIFY THE BLOOD, ENTIRELY REMOVE FLATULENCE

With regard to purchasing brand-name products, many settlers kept a bottle of Dr. Thomas' Eclectric Oil on hand. From the settlers' comments on this medicine, this product seemed to be a "cure-all," as it was used for everything from bruises and infections to earaches, colds, and sore throats. It was used both externally and internally. Elixirs like Perry Davis' Vegetable Painkiller were also used by settlers and their families. This medicine was used to cure upset stomachs, muscle pain, chills, exposure, and diarrhea. A wide variety of other patent medicines were also used by settlers: Scotts Emulsion and St. Jacob's Oil for coughs, colds, nasal problems, burns, and scalds; Ayer's Cherry Pectoral for whooping cough; quinine for fever and the flu; wintergreen for sore backs; Fowler's Strawberry Extract for diarrhea; Lydia Pinkham's Vegetable Compound for female disorders; Lewis' Beef, Iron and Wine for rotting teeth; Pitcher's Castoria for babies and children with constipation or upset stomachs; Minards Linament and Laudanum for pain; and Dodd's Kidney Pills.

Many people resorted to ordering these medicines from the Eaton's catalogue. The prices of medications would vary. For example, in 1901, quinine cost ten cents a bottle, Lydia Pinkham's Vegetable Compound was eighty-five cents, and Castor Oil was $1.75.[7] Not everyone purchased medicines. Some had discovered a different but effective remedy—purchasing alcoholic products such as whiskey and brandy to cure all of their ills.

As mentioned previously, given the economic stresses associated with acquiring medical attention, the distance involved in contacting a doctor, and the high cost of purchased medicines, many settlers relied on home remedies. These home remedies had been handed down for generations from great-grandmothers to grandmothers to mothers, all of who were typically reliant on wisdom from the old country. One settler's ties to home were so tight that her family continued to order herbs from Russia to help cure their aches and pains. However, as people became more familiar with the resources available on the prairies, new wisdom was developed. Some settlers obtained medical knowledge from their neighbours, from other women, or had picked it up by word of mouth. Others received medical information from a variety of sources, from reading material and advertisements found in the local newspaper, or listening to the local druggist or travelling salesman.

For most of the settlers who relied on home remedies, medicines tended to be made out of products they used on a daily basis or were those they could acquire on the farm. For example, for those who suffered from chest colds, chest rubs were common among the settlers as a cure. The base ingredient of these rubs was goose grease, but the curative element varied from camphor oil to bear oil, turpentine, olive oil, castor oil, or mustard. Once combined, these mixtures were applied to the neck and chest area. Sometimes goose grease was used alone and would be taken either internally or used externally. One settler would place goose grease into a wool sock that would then be tied around the neck of the patient. Mustard plasters were also used and applied to the chest, as were onion and mustard poultices and black poplar salve. One settler used either hot onion poultices or raw onions on the chest. One woman suggested that for babies, olive oil should be placed on the chest, along with a sprinkle of nutmeg, all of which should be covered with a piece of brown paper.

In terms of homemade medicines that were swallowed, settlers would either use a mixture of butter and brown sugar, onions and sugar, or honey, vinegar, butter, and lemon. Other suggestions included hot lemonade and ginger tea, while others relied on molasses, sulphur, and flax seed drinks. Chicken broth was also popular. Sometimes settlers tended to resort to more than one type of treatment at a time. One

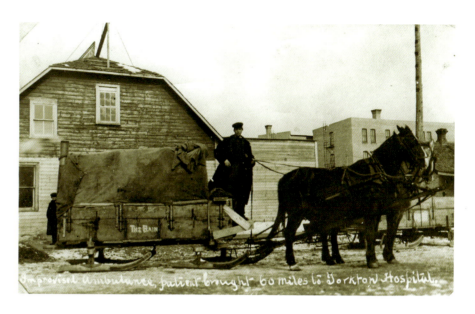

ABOVE: Some homesteaders would try to send their suffering family member to the nearest hospital. This photograph shows an example of an improvised ambulance sometimes used for a long-haul trip. This ambulance transported its patient 60 miles to Yorkton Hospital in 1905. PAS S-B3969.

HEALTH AND ILLNESS 107

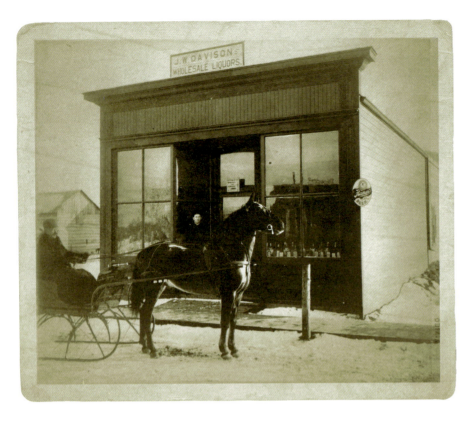

ABOVE: J. W. Davidson Wholesale Liquor Store, ca. 1905. Settlers sometimes used whiskey or brandy to cure their ills. PAS R-A4507.

suggested putting the patient's feet into a mixture of hot water and mustard, while at the same time offering them hot drinks such as ginger and water and placing a hot water bottle or hot iron in their bed. Another settler offered hot lemonade or tea to the patient, along with a hot mustard bath and mustard plasters for the chest.

If a family member was suffering from a sore throat, a piece of flannel was placed around the patient's neck that had been soaked in water. A dry sock would then be placed on top of the flannel. Another settler suggested that a newly worn woollen stocking should be placed around the neck, while others suggested drinking mixtures of coal oil and sugar, or vinegar and butter.

For those who had stomach upsets, it was suggested they drink a mixture of baking soda and water, or swallow a mix of salt water and raw eggs, while those who had diarrhea should swallow a mixture of brown flour and milk. If they were diagnosed with inflammation of the bowels, then they would drink coal oil or turpentine. Earaches could be cured by soaking some cotton batting in warm olive oil and then placing it in the ear.

If a family member was suffering from ringworm, then gunpowder would be mixed with enough saliva to make a paste-like substance that would then be applied to the infected area. Blood loss was countered by pouring flour onto the area when the bleeding was occurring, while those suffering from chicken pox could be relieved of the itch by using a mixture of baking soda and water.

For those who had sore limbs, a homemade liniment could be made using two ounces of turpentine, two ounces of olive oil, and one ounce of ammonia and applied to the limb. The settler who offered this suggestion stated this remedy was also good for sore throats and for use on animals. Making a poultice of bread and milk and setting it against the affected area could relieve toothache pain. If the pain continued or became more severe, then the tooth could be extracted with a pair of pliers.

Offering the patient a hot drink such as hot lemonade or tea could relieve the symptoms of measles, while those who suffered from pneumonia could be relieved of their symptoms by placing hot woollen compresses on their chests. It was also suggested that scalding water should be applied to the compress at five-minute intervals. Those who had tuberculosis should swallow cod liver oil and milk. In addition, those who had this ailment were to only eat yellow foods and be confined to a room with closed windows. For those who suffered abdominal pain, it was suggested that heat be applied to the affected area. One settler, however, came to realize this remedy was a mistake, as it caused inflammation of the bowels, ruptured appendices, and even death.

DRESSED IN HIS BEST SUNDAY CLOTHES

When a person passed away, whether it was due to injury, illness, disease, age, or any other circumstance, certain practices were upheld in the homesteader community. In terms of the length of the time between death and burial, most settlers buried their loved ones within two to three days. However, for others, it depended on the particular situation. According to one settler, Mrs. M. M. Whyte, typically family members were buried after two nights and a full day, but her family waited awhile if relatives were coming from a distance. Others, like Charles C. Bray, indicated that burial depended on the weather, and, if it were hot, then burials would happen quite quickly. Mrs. Downie also mentioned the effects of temperature. As she stated, in hot weather, burials would take place within two or three days. In severe, subzero temperatures, burial would occur in a week's time. In either case, time was needed for a carpenter or handyman to make a casket. Charles Archer also made the point that it would take longer in the winter for a burial, given that graves were harder to dig when the ground was frozen. Given their Jewish heritage, Mrs. Clara Hoffer and her family preferred to bury family members within one day or as soon as possible, regardless of the temperature.

Some settlers indicated that people would sit up and watch over the deceased during the evenings and nights. Various family members would take turns sitting with the body, whether it was placed in the front room of the house, in the barn, or in an empty granary, but friends were also welcome to assist with this task. While sitting, people were offered a cup of tea, while others were offered stronger alcoholic drinks.[8] Not all families observed the custom of sitting with the body. Mrs. Ethel Jameson's family put the deceased into "a cool room by themselves. Carefully shielded from prying eyes."

Other settlers put on a wake for the deceased. Charles Davis wrote, "Generally people of Irish descent held a wake for the dead. The corpse [he] saw was dressed in his best Sunday clothes. They stood him in the corner of the room and said what a wonderful man he had been. They drank to his safe crossing to St. Patrick…and danced with him,

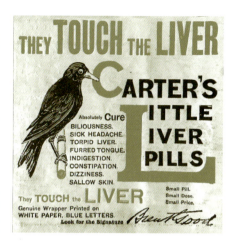
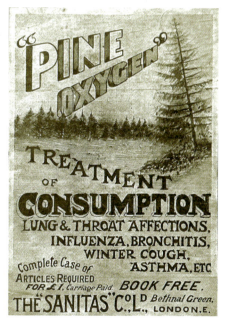
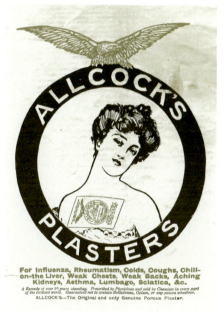

CLOCKWISE FROM TOP LEFT: Advertisements for medical remedies. All from *The Graphic*: March 17, 1906, p. iii; April 9, 1904, p. 506; March 17, 1906, p. 337; April 9, 1904, p. ii.

A Dying Wife's Goodbye Letter to Her Husband, Dated 1907

My dear husband,

I have written down the children's names and ages and if I am not spared, be very careful of it dear and don't lose it.

 I have not very much to leave them poor things except a mother's blessing. Flossie will have my coat and the two little girls the rings I have here. My feather bed and the little one, I would like two of the girls to have who needs them first. The little pin I had made from poor Willie's coin, perhaps Mother would like as I have nothing else to leave her. I have often talked to you of my wishes regarding the children. You think it hard of me to ask this of you dear, but you would only miss them for a short time as there would likely be others to take their place. If I am taken, I know they will all be in a hurry for you to marry for fear of trouble. I feel that I can trust you about that. Don't be in too great a hurry as I would like the children to be with you as long as possible and try to get a partner who will make you happier than I have done. I have faith in God that I am going to be spared, yet a little while and if I do, I mean to do better for the future.

 Do what I may, I can never repay you for all the love and care you have given me and it grieves me to think that all I am doing for you is putting a heavy bill on you to pay for me.

 Try and teach the children in a loving way to be obedient as they will not find life so hard when they come to face the cold world. Don't say anything harsh to any one of them that will hurt their feelings and I trust they will always be kind to you and thoughtful for your comfort. If I am able, I will write a letter to them today. If I am spared to get better, you need not give it to them.

 If you can manage it dear, try and take them to church and Sunday school. It has always been hard to have them ready but perhaps you will have more means after a little while. I will close now dear. Trusting in God that all will be for the best.

May God's blessing rest on you all.
 Your loving wife, Jamie.[*]

[*] This letter comes from my own personal collection. Jamie was in a hospital suffering from an undisclosed illness. She passed away shortly after writing this letter.

toasted him, and drank to him again." Mrs. D. A. Moorhouse described how common wakes were in Ontario, and how her family found out they were sometimes less than accepted by some people in the West. She wrote,

In Ontario, the wakes were a big affair, a real drinking party. My neighbours, the Isaacs had a new born baby die. My uncle George Baragar made its casket, and when it was finished, about 3 a.m., he walked the mile across to deliver it. Expecting to see lights on (as in Ontario), he was surprised to see the house dark. But to be as reverent as possible, he rapped on the door several times, then Mr. Isaacs yelled "Who is it?" He said, "George Baragar, I brought the casket over." Mr. Isaacs said "Just leave it outside the door." Everyone was in bed, and Uncle George got the shock of his life.

Whether a wake or a get-together was held after the service, food and drink were often offered to those who attended. Mrs. Annie de Balinhard said whiskey was often served, while Frank Kusch said people frequently ate sandwiches and drank coffee. Harry Martyn said coffee, tea, whiskey, and beer had been served at the funerals he attended, while Charles Sargent remembered a more elaborate affair. He wrote,

I recollect one Scotch Irish funeral when we were invited to what turned out to be a very hearty sit down supper after the

funeral and the widow (about 75 years) was the life of the party. As she put it "Isaac had a good life and lived close to fourscore years and he had to go sometime. The only thing to do was make the best of it."

The caskets were usually black in colour for adults, while white was reserved for children. When a funeral occurred for a child, children's hymns, such as "Safe in the Arms of Jesus," were sung. The service tended to be shorter for a child than for an adult, and the pallbearers tended to be boys. "If the child had attended school, then the little schoolmates in the summer time, would pick wild flowers and work them into wreathes, and intertwine them into a beautiful cross.... Often flower petals would be also cast as people proceeded from the cemetery gate to the graveside."[9]

In terms of the funeral service itself, sometimes settlers had a clergyman in the area, who would perform the service, but for others who lived in remote areas, it was difficult, if not impossible, to find an official to conduct the service. As set out by Frank Baines, "The first death occurred in 1884 when Neil McKay died and was buried without benefit of clergy by three settlers, Rayment, Atkey and myself." Frank Kusch's schoolteacher always performed the service, while Mrs. J. M. Telford reported that "a woman noted for her piety" was always chosen for this important task. Others, like Koozma Tarasoff, explained that there were no representatives from the church close by, so people in his location relied on friends or neighbours to conduct the service. In a similar vein, Sadie E. McCallum highlighted how neighbours were involved with funeral services:

Very early in our district, a homesteader became ill with cancer. He suffered very much, without alleviation, for quite a long time and died in the coldest spell of winter. Twenty five miles from a doctor or clergyman. There was no chance of having a minister or proper burial. The neighbours dug a grave on the farm and gathered for the burial. A neighbour recited the Lord's Prayer, and the body was lowered into the grave. ❋

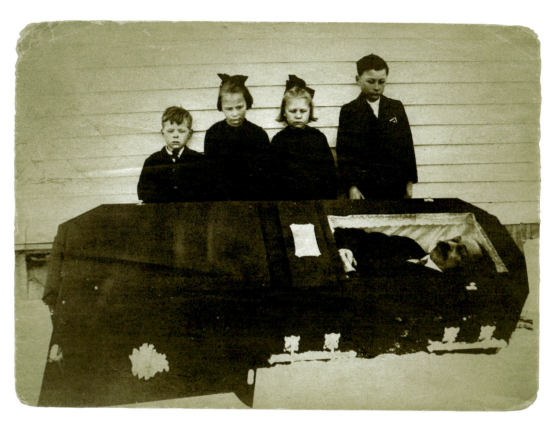

ABOVE: The funeral of Evers Klaus. n.d. PAS R-A23219.

HEALTH AND ILLNESS 111

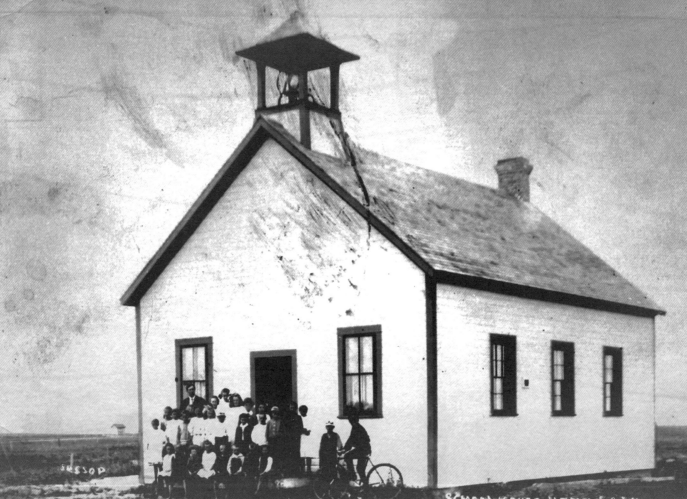

Chapter 6
The One-Room Schoolhouse

Under the Dominion Lands Act, two sections within each township were set aside as school lands.[1] When an area became populated with homesteaders and their families, one of the first community issues was to build a schoolhouse where the children could be taught their lessons. Even though the federal government provided the school land, assorted districts had problems with raising funds to build a formal school building. For example, according to Robert H. Wooff, he was not able to attend school when he, his brother, and parents arrived in Emmaville, Saskatchewan, in 1906, as the school was not built until 1909.[2] In the absence of a schoolhouse, various methods were employed to ensure children would have an appropriate dwelling where they could learn their studies, with some learning in private homes or at local farmhouses. Settler Charles Davis recounted,

> *A gent (gave free tuition) by the name of French. School was held in [his] log home. Children took lunches, coffee was supplied by the French's. This location was 5 miles north, 2 miles east of the present Parkdale School site. Pupils were taught during June to November 1908 and the early part of 1909.*

Other settlers attended school in one-room sod shacks or tents, some attended the local church for their school lessons, while others went to school at the teacher's residence. One settler and his schoolmates attended school in an old butcher shop, while another, James Entwistle, remembered going to school in a small lumber building that was later used as a barn. A few settlers, Susie Ferguson, Millie Olmstead, and George Tucker, all had to travel to another district if they wished to attend school, as there was no school in their area.

OPPOSITE PAGE: Schoolhouse at Venn, Saskatchewan, 1909. PAS S-B8260.

ABOVE: School-aged children, Eric, Sybil, and Mona Miller, and their pet dog and cat, 1903. PAS R-B1923.

As time went by, schools were built in the various townships. Many of them were constructed using lumber that was hauled from mills in towns like Moose Jaw, Regina, or Saskatoon. Other schoolhouses were made entirely of logs from trees felled from a nearby location, while others were built using a combination of lumber and stones. A few settlers said their school was made of bricks, while one remembered his school being made out of mud plaster.

School supplies on the prairies were also in short supply due to a lack of funds in the community. Some schools had a number of homemade desks, chairs, and blackboards, which were built by members of the school district, while other communities had a bit more money, which was spent on a number of different schoolroom necessities. With regard to schoolroom furniture, a variety of desks existed in the one-room schoolhouse. A number of settlers had single wooden desks in their school, while others had double desks. Charles Davis remembered the desks at his school:

The desks in the old school were a combination, an inkwell was set in the far right top of the desk. This top was slightly sloped towards [the] pupil and the sloping part was hinged allowing room for books, papers, and full paraphernalia, pens, pencils, rulers, squares, often more than school necessities such as marbles, sling shots, partly bitten apples, pea shooters and the like.

One settler reported that students at his school only had benches to sit on, while others sat at desks made out of planks or boards, along with homemade seats. Millie Olmstead's "teacher's desk and the pupil desks were made by a farmer in the district, who had been a carpenter. The desks were double, had a shelf beneath for books and were of different sizes."

As for classroom materials, many of the settlers reported having maps in the classroom. Maps of North America and the world were common, as were maps of Europe. The majority of students also had access to blackboards. Gladys Saloway's school had tarpaper blackboards: "After a little use they went a light grey. Rather difficult to see white chalk writing on them." Discussing other types of schoolroom materials, some settlers said they had globes, some reported having a library in their school, while others remembered students had to work with slates. Another settler stated she had an organ in her school, while yet another reported having a piano. Others reported having tables, a dictionary, a bell, chairs, cardboard flash cards, and inkwells. One settler, Ida Prafke, stated her school had "a crock for drinking water, though it seldom had any in it."

Settlers also commented on the availability of textbooks and other school supplies. In many cases, the school board did not buy textbooks for student use, nor did they buy scribblers or pencils. Rather, it was the responsibility of parents to buy these supplies. Typically, as reported by the children, their parents were able to order textbooks from the local general store in town, or they sent away for them from the Eaton's catalogue. However, many settlers found the cost of textbooks to be very expensive, as it cost up to $2.25 for

student textbooks in each subject. If a student took algebra, composition, science, history, and music, the cost would be as high as $11.25, not taking into account other supplies that needed to be purchased, such as slates, chalk, pencils, or ink.[3]

For many children, it was impossible to obtain a consistent education, given they were also needed to work on the homestead and help their families gain title. Homes needed to be built for family members; shelters needed to be created for animals; trees, rocks, stones, and weeds had to be cleared from the land before seeding; drinking water had to be hauled; hunting needed to be done so family members could be fed; and gardens needed to be sowed. In the fall, harvesting would take place. Given the need for family labour on the homestead just to ensure basic survival, some children were not able to attend school. Even if they did attend, they were absent from class at crucial times of the year, during seeding and harvesting seasons.

For those children who were able to attend school on a regular basis, teachers initially had the problem of trying to fit each student into an appropriate grade at the start of the school year. Given that some had home schooling or had been taught elsewhere before their families moved to Saskatchewan, teachers were sometimes at a loss as to where a student should be placed. Mistakes were common, as the expectation existed that older students had more of an educational background than younger ones. Yet older students may have been kept at home to work and, as a result, had no educational training. They then were placed in grades with children younger and smaller than themselves. Once the teacher had correctly arranged the students, the problem they then encountered was trying to teach eight grades in one room over the course of the day. More often than not, teachers would apportion their time into half-hour time slots for each grade, so that each would receive instruction. Other teachers reported overlapping some of the material between grades. For example, when giving a history lesson, the teacher might teach this information to both the students in Grade 7 and Grade 8 at the same time.

There were also other difficulties children had to contend with when they went to school. Some children had to travel two or more miles, with others noting they had to travel seven or more miles, to get to school. Very few were lucky enough to live close to the schoolhouse. For those who lived at a short distance, they were able to walk to school, while those who lived further away rode on horseback or used a horse and buggy. Settler Lawrence Kelly indicated that four children from one home rode four different horses, due to the fact they had to travel four miles over a "practically impassable rode [*sic*]." Charles Davis made an interesting point about the danger and difficulty of getting to school when he stated that children could easily become confused or lost on their way: "This was virgin

ABOVE: Five children sitting at desks inside Spring Lake School, Spring Lake, Saskatchewan. n.d. PAS R-A20942.

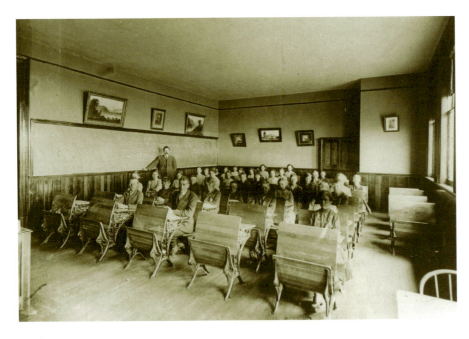

TOP LEFT: Interior of a classroom with students at their desks, 1911-12. PAS R-B10684.

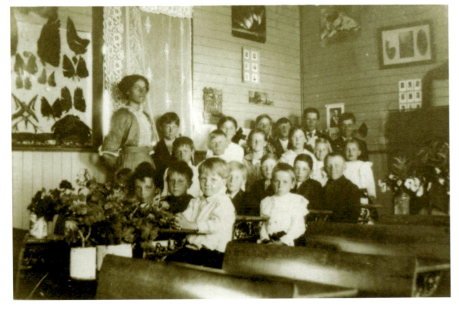

BOTTOM LEFT: A teacher and her school children. n.d. PAS S-A354.

park or bushland with main trails running north and south but miles apart. Local trails had to be staked or blazed and children were not good pathfinders."

While travelling a lengthy distance could be a problem, inclement weather could also hamper a child's ability to get to or from school. Charles Davis offered a detailed account of a storm that hit his school one afternoon, preventing the return of students to their homes:

> It came up from the N.W., an angry tempestuous looking sky about 2 p.m. The lightning was almost continuous and the peals of thunder vibrated the earth, then it was dark intensely so, with intervals of blinding flashes. The rain fell like sheets of water, even on the knolls, in a matter of seconds water lay inches deep before it could roll to lower levels.... The clock had struck the hour of four, no lessening occurred, the low levels became lakes, the small ravines became raging torrents.... By 5 p.m. all was calm.

Such storms also occurred prior to school starting and parents would not allow their children to go to school.[4]

In the winter months, settler children walked or used skis or snowshoes to get to school, while others drove a team of horses and a sleigh. Lewis Anderson mentioned that he and his siblings hitched up their toboggan to their horse. They would wrap themselves up in blankets, wear woollen underwear, and use hot stones in the sleigh or toboggan to keep warm. While these children were able to make it to school during the winter, other settlers, like Lawrence Kelly, wrote, "[It] was felt at the time that it was too cold to have the children travelling so far," so the children were not able to attend.

TOP RIGHT: Holmsdale School, Saskatchewan, 1908. PAS S-B7621.

BOTTOM RIGHT: A teaching certificate for Winnifred Goodwin and a contract for her first teaching assignment. PAS S-A160, Winnifred Theresa Bibbing.

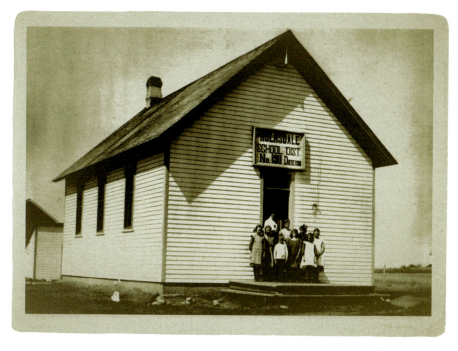

ONE YEAR IN THE WILD WEST WAS AS MUCH AS THEY COULD STAND

Communities tried to hire teachers based on the locale's preferences, but due to the lack of teachers and the cost associated with their hiring, such preferences were generally set aside. For example, when it came to the preferred gender of the teacher, many settlers wanted a male teacher, as they felt men could handle the bigger boys in class better than women. As for nationality, most settlers wanted a teacher with an English (Empire Loyalist) background. However, districts like St. Antoine, St. Brieux, and Marcelin preferred a French teacher, while the Humboldt area residents, which included a Mennonite block, preferred a Mennonite instructor. With regard to religious preference, the majority of settlers wished their teacher to be Protestant. Charles Davis wrote,

A teacher of the Protestant faith was an unwritten but practically binding condition, because there was only one family of Roman Catholics in the area and they were not zealous worshippers. Nearly all the settlements were emigrants from the British Isles, the remainder were eastern born Canadian, or settlers from the United States.

In terms of age, some communities wanted an experienced teacher, that is, someone who knew how to teach the various grades, who could handle any school-related problem that arose and be scholastically skilled and capable. They did not want a teacher that was too young, as they felt too many problems could arise over the school term, particularly if the teacher was younger than the oldest students in the classroom.

While these particular characteristics were desired,

THE ONE-ROOM SCHOOLHOUSE

ABOVE: Martha Cline and Luba Parsons, first and second teachers of Oxford Plains School. n.d. PAS R-A14743.

the fact was that teachers were scarce, and so the community generally accepted whoever applied, regardless of preferences.[5] Mrs. Lyle Wyman pointed out that their community had little luck in obtaining a teacher, but this was not due to lack of trying. Rather, "being so far from [the] railroad and sometimes only one mail day a week, a teacher had often accepted another school before our reply reached them."

For those communities who were successful in attracting a teacher to their locale, they found very few teachers stayed at their school for more than two or three years. Some only stayed a year. Settler James Entwistle offered a reason for why teachers did not extend their stay: "Most of our teachers were from the east and I guess one year in the wild west was as much as they could stand." Other settlers reasoned that many female teachers ended up marrying someone from the district and then quit their teaching position to become wives and mothers.

During their stay in the community, living arrangements were provided for the teachers, and sometimes transportation services to and from the school were offered. According to the majority of the settlers, their teachers obtained a regular boarding place (including room and board and sometimes laundry services), while others lived with a family at a local farmhouse. James Entwistle judged boarding arrangements to be very limited. His teacher boarded at "the only house in the district…with a spare room." In other cases, a teacher discovered "she was going to share the only bed in the house with the wife, daughter and baby while the husband slept nearby on the floor,"[6] while another reported staying with a family who lived in a home that was partitioned into two sections. One side was for the family members, while the other side was used as a stable for the animals. As the teacher stated, "One could sometimes hear the cattle across the partition and could sometimes feel them lurching against the partition."[7]

Some teachers boarded around from place to place, while others lived in their own home or had a homestead. In general, teachers did not board for free. Rather, they were charged for their room and board. On average, boarding costs tended to be between two dollars and ten dollars per month, while others paid a higher rate between eleven and twenty dollars per month, depending on whether food and clothes washing were included in the price.[8]

As for transportation services to and from the school, the majority of teachers walked to school, or, as John McChesney put it, walked "on her own legs." When Mrs. James Larmour was a teacher, she walked two and a half miles to the school. At one point, she had to take off her shoes and stockings and wade through ice-cold water. There was another problem to deal with in warm weather: mosquitoes. She stated, "[The] number of mosquitoes was almost

118 THE HOMESTEADERS

unbelievable. [When] we got down to the creek bottom they were almost like a wall, so we girls would put our top skirt over our heads and run through."⁹ Another teacher, Gertrude Telfodd, had to walk two miles to the school in the fall of 1911. However, she mentioned to the owner of her boarding house that she had company along the way. Five grey collie dogs always accompanied her back and forth from the boarding house to the school, and she inquired as to who owned them. In response, she said, "He laughed heartily and said 'They're not collie dogs, they're coyotes, but they won't hurt you.'" The dogs continued to keep Gertrude company, but, despite assurances, she was always frightened by them.

Other settlers mentioned their teachers rode horseback, or drove a horse and buggy, a horse and buckboard, or an oxen and wagon. Some teachers rode to school with their students, while one settler said his teacher rode a bicycle. In terms of the miles of travelling, the teachers tended to live closer to the school than their students. Most of them lived less than two miles from the school, while a few others lived further away. Charles Davis said his teacher travelled seven miles and never raised a fuss. Despite "hail, rain, overcast or fair, undaunted, [the teacher] was even tempered, as even as two parallel lines."

THOSE WHO HAD NO WATER, SPIT ON THE SLATE

The primary purpose of schooling was to learn basic educational material. Most often, people refer to this process as learning the three *R*s: reading, writing, and arithmetic. Given the importance of these subjects, settlers were asked if these three areas made up most of their school program. A full 100 per cent indicated that all three subjects were taught, but there was a variety of other subjects and issues that were included in the curriculum. Some settlers learned the three *R*s along with history, while others reported learning history, geography, music, and art. Other settlers were taught agriculture; health, including lessons on temperance and manners; bookkeeping; social studies; physical education; art; science; and home economics, including knitting and crocheting. In addition to the three *R*s, another settler (and most likely more than one) learned the meaning behind the use of the hickory stick in the classroom.

The language of instruction in the school system was to be English, as the federal and provincial governments sought assimilation of the immigrant children as quickly as possible. It was the governments' perspective that problems could arise if there was no conformity among the new prairie

A Winter Experience

As recounted by Ida Prafke, problems could occur during one of the coldest days of the year when some children and their teacher were trying to make it to school from the homestead:

In January of the year 1912, we had four children attending school and the teacher boarding at our place. We lived 2 ¼ miles from school. One morning, they started for school as usual with a team of oxen and a homemade sleigh. The two boys were seven years old and my oldest daughter fourteen who was driving. When a mile from school, the sleigh broke down, so she put the two boys on the backs of the oxen and the other three walked. They all got very cold. When they arrived at school, they had to make a fire but couldn't get warm. There were no other children there that day. About 2 o'clock in the afternoon, one of the trustees and a neighbour came along and said it was 56 below zero. They brought the three youngest children home and my daughter and the teacher walked home bringing the oxen. They all were nearly frozen.

ABOVE: Arthur J. McCulloch and James T. M. Anderson, ca. 1908. McCulloch taught at Stowes School from 1908 to 1910, and Anderson taught at Gravel Plains School in 1908. After his career in education, Anderson entered political life and became the fifth Premier of Saskatchewan (1929–1934). PAS R-A12057.

residents. Given that hundreds of thousands of immigrants were coming from various countries, all with their own belief systems in place in terms of culture, politics, religion, and education, both levels of government concluded these people should all adapt to Canadian (British-influenced) customs. While they recognized it would take some time for adults who settled on the western prairies to conform, the governments' opinion was that it was the children who could be easily socialized into accepting Canadian (British) ways.[10] They firmly held that the best strategy to assimilate these young people was through a school system that emphasized Canadian/British culture and the English language.[11] As a result, it was not surprising to find that the majority of settlers indicated that only English was taught in their school. Along with English instruction, some were also taught French, while others learned German, Latin, Norwegian, and Ukrainian.

While many English-speaking teachers probably hoped their students could speak English, as it would make instruction less complicated, a fair number of students in the one-room schoolhouse did not know the language. In fact, in some cases, the majority of the class could not speak English. Some students could only speak French in some schools, while at other schools the children could only speak German or Russian. One settler mentioned there were a lot of Swedish-speaking students in his classroom.

Because of this cultural diversity, some teachers designed activities to help improve English language skills among the immigrant children, although such activities tended to be limited. It turned out that most of the immigrant children picked up their English-speaking skills from fellow English-speaking students rather than from the teacher. Of course, if a majority of students in the schoolhouse did not speak English, then there would be a different outcome. For example, due to the large number of foreign students in his classroom, Alan Reidpath said those who were English-speaking started to pick up foreign words from the various immigrant children and started to create their own language. The teachers had quite a time trying to bring all of the students to the common denominator of English.

Other teachers tried providing interactive instruction to foreign students by pointing at objects and naming them in English. John Theissen remembered a situation between his teacher and an immigrant child. The teacher pointed to the bell on her desk and asked the student to ring the bell. The student, who did not know English very well, came up to her desk and "with his finger drew a ring around the bell." John McChesney recounted another time, when he went to school and "a new man teacher arrived. On this occasion, the teacher started in

with a young Norwegian youngster never at school till that morning. The mode was some sounds made by the teacher, in a very short time this youngster was repeating. This was a miracle to me." Two other settlers remembered children learning English by reciting verses, practising the sounds of the letters of the alphabet, and reading elementary-level books.

For those students who already knew the English language, teachers designed various activities to help improve the speaking and writing styles of their students. Some settlers had teachers who stated and expressed words aloud, emphasizing pronunciation and accent, and they asked students to perform recitations, monologues, poetry, and plays, as well as encouraged debate and asked for answers to complete a sentence. Charles Davis elaborated on his experiences:

> *Distinct utterances and pronunciation was something insisted upon in the early days by the teacher. Teeth and mouth had to be open and tongue relaxed. Intonation in reciting, fluency in speaking sentences, then short speeches would be practiced over and over.... There was an amusing incident when a young fellow with a slight impediment in his speech couldn't quite master reciting—"Under the spreading chestnut tree, the vil vil vil." "Villain!" came a loud whisper from a nearby lad. [The student said to the teacher], "I think I co co could sing it bet better." "Go ahead" said the teacher, and that lad amazed the whole classroom of pupils. He sang it beautifully, and got great applause.*

Another settler child, Gladys Saloway, also recounted how the teacher at her school tried to encourage the students to speak properly. She stated, "We read a paragraph aloud every day. Mostly very badly. Grades 7 to 8 did not. One teacher let us read several pages from our history books.... We loved it." Teachers would also correct errors overheard in conversation in class or on the playground during lunch or recess.[12] In particular, the teachers had quite a problem trying to abolish the word "ain't" from the children's vocabulary.[13]

It was also reported by one settler child that their teacher had an innovative way to motivate students to learn the English language properly. She had "Good English Contests" in class and would provide prizes to the winners.

In terms of improving the writing style of the students, the teachers handed out homework exercises, asked students to write compositions about holidays, or asked them to complete fill-in-the-blank sentences. Incorrect ways versus the correct way to write a sentence were written on the blackboard and students

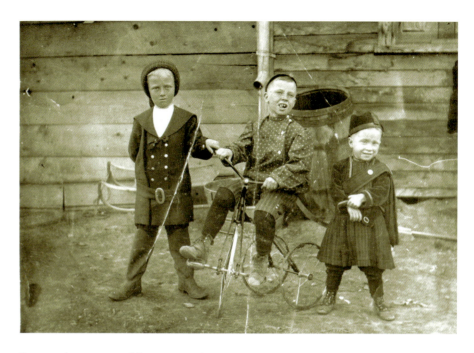

ABOVE: Lashburn, Saskatchewan, settlers Ernest Hellawell, Chester McNaughton, and Norman McNaughton. n.d. PAS R-A18933.

THE ONE-ROOM SCHOOLHOUSE 121

Popular Recitations

When Marion Anderson was in school, the boys and girls had preferences with regard to the literature they had to memorize. The boys enjoyed the poem, "There's a Good Time Coming Boys," while the girls liked the short story, "The Lost Doll." The teacher also had all of the students recite Henry Wadsworth Longfellow's epic poem, *The Song of Hiawatha*, and everyone had a "wonderful time with it." In fact, the children enjoyed it so much that their parents also read it when the children took it home. All were so appreciative that, at Christmas time, the parents and children gave the teacher a special gift—a leather-bound volume of Longfellow's poems.

were expected to write short essays, all of which were marked and explanations given as to why something was wrong. One teacher had the students create invitations that invited family and friends to school functions, such as short concerts given on Friday afternoons. François Gauthier explained that his fellow students learned their lessons by writing on their slates and copying from copybooks and readers. Given the limited space on a slate, the student had to "[w]ash the slate with water and write again. Those who had no water, spit on the slate and [used their] sleeve to wipe it off." Gladys Saloway, Mrs. M. J. Seeman, and John Woodward were more critical of the writing process. Gladys and her fellow students were expected to write every Friday afternoon. Gladys wrote, "I think most of the pupils thought it a headache. Some could not read their own writing." Mrs. Seeman recounted, "Grammar was my bugbear. I hated the subject." John offered a somewhat different perspective and questioned the quality of the English instruction in his classroom: "Considerable effort was made by some of the teachers to improve the speaking and writing of the pupils...however some of our teachers, especially those of South European extraction were not any too conversant with grammatical English themselves."

When it came to learning math, in general, settler children tended to be happy with the way the subject was taught. As mentioned by James Entwistle, "Everyday problems were quite popular. How many eggs at so much, pounds of meat or bushels of grain?" Another settler offered a similar story: "Pupils were taught combination and separation of numbers, afterwards adding, subtracting, multiplication, and division. Also practical problems coming up in everyday life such as—change from a dollar bill after purchasing $.60 [in] goods. In how many ways could you receive this change?"[14] Richard Loyns's teacher was also practical in terms of teaching mathematics to the students in that she would have "the pupils measure platforms, window panes, [and] boxes," and anything else that was handy in the classroom. However, a couple of settler children reported being less than enthused about their math experiences. Edward Watson recounted how his teacher dealt with inconsistencies between his own calculations on a math question and the answers given in the textbook. Edward stated, "[The teacher] would fly into quite a rage if asked [by a student] to do a question in arithmetic and then would say the answer in the book was wrong." He would then tell the class to leave the question. Everyday math problems were never taught at Lewis Anderson's school, so he went through a couple of grades not understanding mathematical symbols, particularly the one for division. Whenever he saw the division symbol, he would subtract. To correct his mistake, the "teacher proceeded to pound [the correct way] into me."

Along with learning basic subjects, many teachers also provided religious observance or instruction, typically at the beginning of the school day. Most of the settler children

reported having to recite the Lord's Prayer every day, while a few others sang a variety of hymns. Other settler children had to recite Bible readings. At Esther Bailey's school, they had the "Lord's Prayer in the morning, Grace before lunch, Thanks after, Now the Day is Over at night." While not religious in nature, but in keeping with Canadian/British loyalty and tradition, many students remembered having to sing "God Save the King" and "The Maple Leaf Forever."

Physical education, particularly organized play, whether during recess, lunch breaks, or during school time, was an important aspect of the educational curriculum. It was believed that having children mix and mingle in a game situation would aid with a child's social development. Children would learn to cooperate with others, take their turn, accept defeat without discouragement, develop a sense of will and endurance, learn to take risks, and try to realize goals, all within a friendly and safe environment. Given the advantages students could acquire through such endeavours, it was not a surprise to find that many students in the one-room schoolhouse took part in such activities.

Former settler children were asked what types of play they had experienced, in both the warmer and colder months of the year. In the warmer months, the majority played baseball and football. The school equipment needed for these games was acquired through numerous ways. The school board provided some balls and bats, while others reported that a collection for funds was taken up by the students.[15] Other settler children, like Gladys Saloway, had to rely on homemade equipment: "We had an old sock, stuffed with grass and a stone that was the ball, and a piece of wood, that was the bat. We

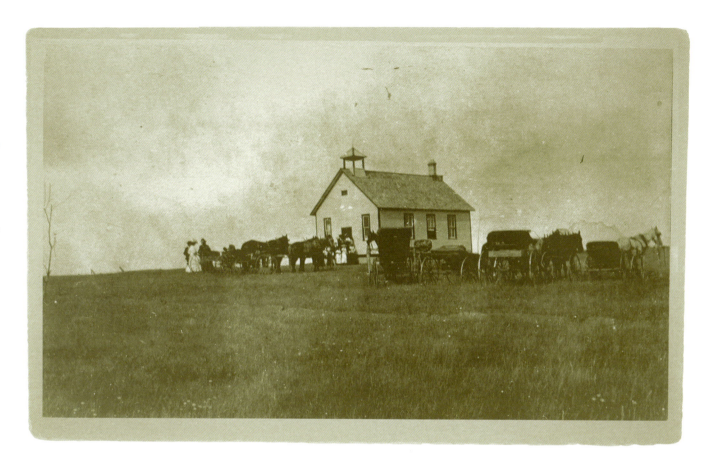

ABOVE: Glenford District School No. 2216; erected in 1908. PAS R-A12045.

ABOVE LEFT: A speller filled with word lessons for higher primary grades. Emphasis was placed not only on correct spelling but cursive writing as well. Source: Alonzo Reed, *Word Lessons: A Complete Speller* (New York: Effingham, Maynard & Co., 1890).

ABOVE RIGHT: Teachers were able to access books on games that could be used on the playground or in the school. One commonly used book was *Games for the Playground, Home, School and Gymnasium* by Jessie H. Bancroft (New York: MacMillan, 1913), which gave details as to how the games should be played and how many children could be involved; musical scores were included if the game required singing. For the singing game "Mulberry Bush" (above), the children would stand in a circle, join hands, and all move to the right or left as the song was sung. Whenever the words, "So early in the morning," were sung, the children would unclasp hands and spin quickly around and then rejoin hands and continue.

also had an old football filled with rags." Mrs. Hugh Cossar and her schoolmates played with a ball made out of yarn.

Other settler children enjoyed playing ante over. For this game, there were two teams of players, one on each side of the schoolhouse. The member of one team would yell "Ante over!" and throw the ball over the school. "Whoever caught it would run around to the other side and throw the ball in an attempt to hit a member of the other team. The person hit would then have to join the opposing team"[16] Pom pom pullaway was another favourite game, as were foot races or playing tag. Children also enjoyed hopscotch, blind man's bluff, prisoner's base, London Bridge, run sheep run, fox and geese, last couple out, pussy wants a corner, leapfrog, high jumping, one-legged races, and hide-and-seek. For those children who did not like structured games, they liked chasing and catching gophers and swimming in the local slough or creek.

In terms of the games played during the colder months of the year, many of them were enjoyed indoors. Settler children played x's and o's, various word games, guessing games, and puzzles. Sometimes the teacher or a student would read a story, with all of the students gathered around the stove for warmth, while at other times they played the game called button, button, who's got the button, as well as tic-tac-toe, checkers, dancing, singing games, pretending to be the teacher, drawing on slates or on the blackboard, and "Farmer in the Dell." When venturing outside, classes took part in sleigh rides or built snow forts for snowball fights. Settler Marion Anderson mentioned that "sides would be chosen; snowballs would be the weapons. Anyone hit by the opposite side dropped out."

There was another aspect of the student school experience that influenced student behaviour, and that was the discipline used by the teacher when he or she attempted to maintain control in the classroom. As reported by settler children, various techniques were employed to obtain a proper, well-functioning classroom environment, where students were expected to have their homework assignments done on time and bad conduct was held in check. The most common form of punishment was the leather strap. However, in one case, a strapping

did not go as planned. As Mrs. George Tucker wrote, "One family forbid the teacher to use [the] strap on [their] child. Teacher did so and oldest girl (about 14) snatched [the] strap away and hit teacher on [the] arm. School Board meeting called. Teacher resigned."

Other teachers made students stand in the corner of the room (for ten minutes up to half a day). Variations of "corner" punishments included kneeling, standing on peas, and wearing a dunce cap. Some teachers relied on handing out detentions for misbehaviour, which lasted fifteen minutes or more after school. However, parents were not too fond of this punishment, since they needed their children home after school to work on the farm. A few settlers said their teacher used a willow switch or hickory stick to hit them with. One settler elaborated on his experience by noting his teacher would get the misbehaving student to go outside and cut a switch from a nearby tree. It would then be brought to the teacher, who then whipped the pupil's backside. Maggie Whyte remembered a fellow student who was disciplined: "While in line going into school one boy pushed the one in front of him out of line. The innocent one got the cane on his hands till welts rose. Trustees came to school about it, forbade the use of the stick and provided a wide strap."[17] In this case, it seems the implement used for correction was more of a concern to the school trustees than the ethical issue of disciplining the wrong student.

Another settler, Evelyn Slater McLeod, recounted the story of when she was a small girl in school. The teacher gave her time to learn a spelling lesson and then asked her if she had learned it. She shook her head no. The teacher then "went to his desk and from a drawer took out the 'permissible strap' and struck [her] twice on the palm." Her cousin then came to her rescue and advised the teacher this was the first day she had ever been in school. In a second incident, Evelyn recounted the actions of a female teacher who became so irate at a boy in her class that she forgot to use the strap and instead hit the boy a number of times on the face with a wire-edged ruler. His face was severely cut up. The teacher was later dismissed from her post.[18] Other forms of punishment used in the classrooms included teachers hitting students with a pointer on their hands and knees, boxing or pulling their ears, shaking and slapping students, or hitting them with a buckle.

Some of the parents objected to the use of corporal punishment by the teachers. Generally, when this occurred, parents would have a discussion with the teacher, or the issue was taken up with the local school board. Mrs. Lyle Wyman recounted one particular incident:

At one time pupils had emptied dirt into [the] well of a family where the school got their drinking water but not one admitted it. Teacher deprived them of getting water until parents objected. Trustees met to discuss it and asked teacher to allow them to continue getting water at the well. The families were not in favor of depriving pupils of water.

> *"One family forbid the teacher to use the strap on their child. Teacher did so and oldest girl snatched the strap away and hit teacher on the arm. School Board meeting called. Teacher resigned."*

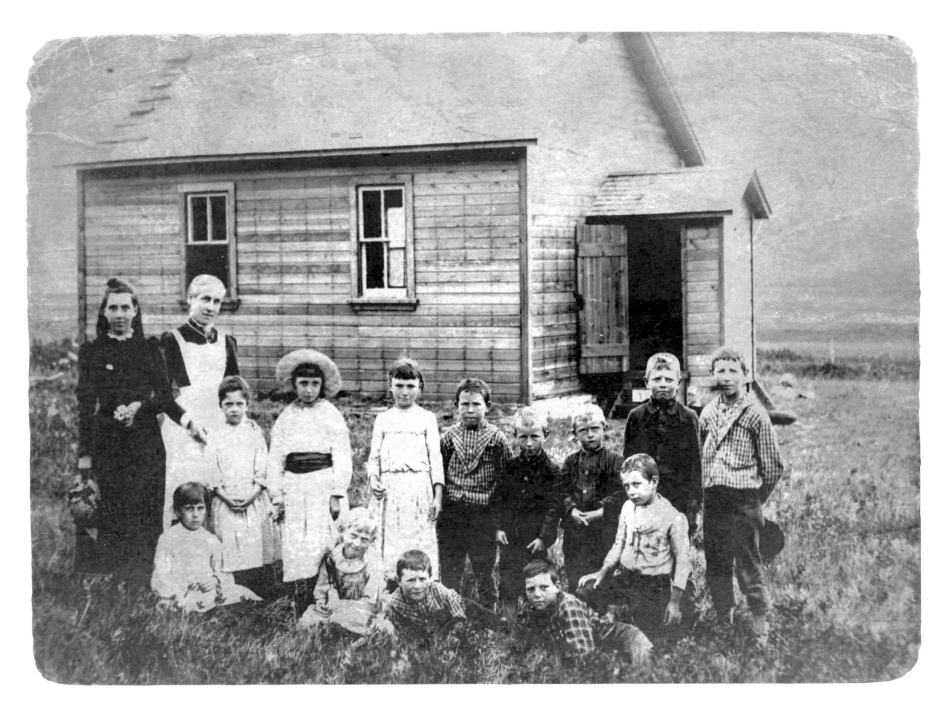

Other settler children reported experiencing less physical forms of punishment, such as the teacher threatening students to either behave or go home, giving students a good tongue-lashing, using sarcasm and mean looks, keeping students in at recess, making a student apologize to the class, separating the misbehaving student's desk away from the others, or sending the student outside to stack wood. Charles Davis noticed there was a difference in the way boys and girls were punished. At his school, boys were expected to fill the woodshed, while girls had to dust and sweep the school and clean the school ground of paper. For others, they were required to memorize lines, work out a difficult multiplication question, or a note would be sent home for parents to read. In other cases, students were expected to write repetitive lines, from one hundred up to five hundred lines at a time. At times, this type of punishment was not effective. R. Ernest Ludlow commented on his son's experience as a student:

> *[Often] students were expected to write some sentence pertaining to the offence—100 times—It became mechanical and meant little to correcting the condition. Willie's grammar was at fault. He persisted in saying "I have went…" He was to write—"I have gone…"—200 times. When he finished and teacher <u>had went,</u> Willie placed his work on teacher's desk with a note—"All done and I have <u>went</u> home."*

Even though corporal punishment was in use in some schoolhouses and the learning process was a tedious one for some, the majority of former students indicated they enjoyed going to school and were quite fond of it. Some were anxious for an education, while others, who were from a non-English background, were eager to learn English. Others liked the social aspects of attending school, as they liked meeting people their same age and appreciated the good times and games on the playground, while some enjoyed school, as they really liked their teacher. One settler child mentioned that she wept if they had to miss school, as she cared about it a great deal. For those students who were less enchanted with the school experience, some explained they preferred to farm, or play, rather than learn schoolwork.

Being a student in a one-room schoolhouse on the prairies during the pioneer era was a unique experience for many. Experienced teachers were rare, funds were low, and educational materials were sparse. However, the knowledge they obtained from their teachers, in terms of how they were taught and the ability they acquired to be able to socialize with children from other cultures, were valuable lessons that served the settler children well in the future.

Attending school in makeshift accommodations in bachelors' shacks, tents, or old butcher shops was problematic, as was travelling to and from school, particularly if students had many miles to cover or if weather conditions were poor. Being kept at home for days, weeks, or months to help out with seeding and harvesting and other farm or domestic-related chores also made continuous learning impossible. For foreign students, the problems with learning were heightened by the fact that many of them did not know how to speak English and, as such, they were initially unable to communicate with their teachers and with their fellow students. English became the language of choice in the school system, and all of the students were expected to adapt to the cultural aspects of their new country.

Even though students sometimes experienced hardship during their school years—travelling to school, doing without the necessary educational materials, and coping with corporal punishment—many settlers really liked going to school. In essence, they had created their own social community through their fondness for their one-room schoolhouse. They loved playing with children their own age, learning new games, and just generally enjoyed the experience. The one-room schoolhouse, with its slates, tarpaper blackboards, and homemade desks and benches, offers a meaningful, significant, and important understanding into pioneer life in the province of Saskatchewan.

OPPOSITE PAGE: Teacher and schoolchildren in the schoolyard at Ellisboro School No. 228. n.d. PAS R-A12193.

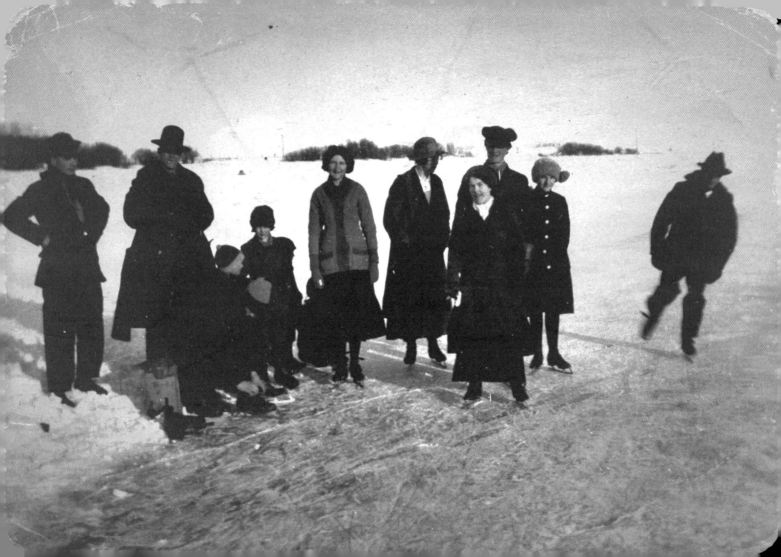

Chapter 7
Fun and Festivities

Even though settlers and their families toiled endlessly on developing their homesteads by taking care of their crops and farm animals, building homes for themselves and shelters for the animals, fencing their property, and planting gardens and hunting in order to provide enough food for their families to survive on, there were occasions when time was taken out for some sort of recreational activity. Many people pursued a variety of hobbies, some of which were very traditional in nature, such as embroidery, knitting and crocheting, or collecting stamps. Others began collecting Indigenous artifacts they found on the land, while others were more artistically inclined and liked to paint pictures or create artistic pieces of work. For instance, both Mrs. H. J. Seeman and Mrs. John C. Knaus enjoyed doing needlework, hooking and braiding rugs, and patching quilts and quilting during their spare time. Mrs. Knaus also liked collecting poems. Settler Margaret Smith painted with both watercolours and oils, did some writing, and also liked to crochet, knit, and embroider.

Wellwood Rattray was quite fond of his collection of old stamps and had a letter in his possession with a stamp from Scotland dating back to 1853. Frank Baines collected arrowheads, stone hammers, knives, and stone axes he found on his quarter section. He stated this collection "started during the 1890s by finding some pieces when working the land." Another settler, Godfrey Persson, had two "Indian war clubs" that he found in a field. He put handles on them and had them hanging on a wall in his home. Eva Mitchell also commented on the large assortment of arrowheads she had been able to collect.

Along with collecting Indigenous artifacts, Frank Baines also enjoyed hunting and had a collection of bird and small animal skins for mounting. Likewise, another settler reported that when she was a young girl, she caught and "skinned a good

OPPOSITE PAGE: Skating party on a lake near Hague, Saskatchewan, in 1912. PAS S-B7356.

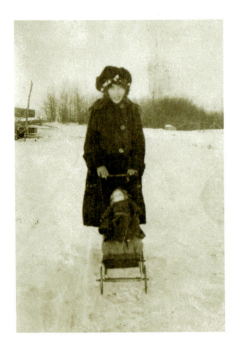

ABOVE LEFT: Some children had toys that they played with to pass the time. In this picture, Toba Cohen of Lipton, Saskatchewan, shows off her doll and carriage, 1916. Library and Archives Canada, c-027462.

ABOVE RIGHT: Some settlers built swings made from logs and rope for their children to play on. n.d. Author's personal collection.

many animals and tanned the skins."[1] Instead of acquiring animal skins, other settlers, like M. J. Downie and Minnie Taphorn, liked collecting stones and shells they found on the land. In particular, M. J. Downie liked the many garnets she found, while Minnie was taken with the number of "beautiful rocks" she located. As for the shells, both were quizzical as to their origins but felt they were remnants of the ice age.

Settler Esther Goldsmith's favourite hobby was gardening. She wrote, "[I enjoy] gardening of all kinds. I planted and took care of most all of the trees on our farm. [That was] a lot of work on the bald prairie." Another settler also reported that she and her daughter used to enjoy working in the garden together.

Mrs. Lillian Miles and her family preferred hobbies that were more artistic in nature. As revealed in their account, they were quite creative with the materials available to them:

We used to make beads out of colored paper (usually colored pages from the catalogue) and string them on a string. We also made beads out of the silver willow tree seeds. We boiled the seeds until they were soft, removed the skins, and used the little nut inside. We would string these nuts on a thread—let them dry out— and then varnished them.

It was likely these strings of colourful and shiny beads were used to decorate the family home by stringing them along the walls or across the room or hanging them in the windows.

Marion Anderson's hobby of collecting signatures was quite different from the other hobbies noted above. She wrote,

May 21, 1887 is the date of the beginning of my autograph collection in a book in my possession yet. Names are from Moosomin, Ravine Bank, Wawota, Welwyn and Fleming. It was the fashion of the day to collect these. I also liked collecting items of interest regarding places I have lived, also of interesting people.

Lawrence Kelly also kept a collection of writings. However, instead of collecting signatures, he kept a daily journal. It would

include such things as receipts and payments, attendance at meetings, anything of local interest, and a statement regarding the weather each day.

FATHER WOULD READ ALOUD TO US

Along with having hobbies, many families would often spend a quiet evening in their home reading, whether they read by themselves or had stories read aloud to them by other family members. Books were important to people, as many settlers brought books with them from their mother countries. Whether they were novels, or tales about some faraway place, or stories relating to actual events, or the family Bible, families had their favourites, which they did not wish to part with when leaving their homes for Saskatchewan. For example, Godfrey Persson's family brought along Swedish schoolbooks, which included a history of Sweden, while Mrs. Ellen Hubbard's family brought Scottish books with them, along with boxes of religious books. Marion Anderson reported that her family brought along a "large leather bound family bible with lots of pictures in it. It contained too, a record of our family's birth and death dates. A Gaelic Bible." Another settler, Mrs. H. J. Kenyon, stated,

> Coming from England we couldn't bring many but I remember we had a complete set of Dicken's works, an eight volume set of Kitto's Bible studies, books of music, hymn books, and of course, Bibles. A few girl's books such as Home Influence and Mother's Recompence by Grace Aquilar.

William Gange also brought a number of books with him, such as the works of Tennyson, Shakespeare, Coleridge, Milton, and Whittier. He also had Dickens's *Pickwick Papers*, *David Copperfield*, and *Dombey and Son*, as well as Edna Lyall's books, *Donovan*, *We Two*, and *In the Golden Days*. Elizabeth Duncan reported bringing *Robinson Crusoe* by Dafoe, *Uncle Tom's Cabin* by Harriet Beecher Stowe, *Pilgrim's Progress* by John Bunyan, and books by James Fenimore Cooper, while Mrs. Hugh Cossar remembered owning books by Julia Reid and Hans Christian Andersen and that someone had given her a copy of *Wee Willie Winkie* by William Miller. Minnie Taphorn reported having only two books in her possession, *Black Beauty* and *Christie's Old Organ*, while Sydney Chipperfield's parents had brought over thirty books with them when they immigrated to Canada. They included "two or three Bibles, *Pilgrim's Progress*, *Uncle Tom's Cabin*, and a number of English storybooks, some suitable for children, some for older people." Settler Eloise Anderson remembered her family relied on the basics: a doctor's book, a recipe book, and the family Bible.

Exchanging books with neighbours became a common pastime for settlers and their

ABOVE: If money was available, settlers would don their finest clothes and have their picture taken. This picture is of a mother and daughter. n.d. Author's personal collection.

FUN AND FESTIVITIES

Ordering Books from the Eaton's 1901 Catalogue

The T. Eaton Company offered an assortment of books people could purchase. Bibles, hymn and prayer books, books of poetry, novels, boy's and girl's books, as well as popular books, were all available. A selection of these books, along with their prices, is set out below.

TITLE	COST
Family Bibles (covered with padded sides and round corners, gold edges, marriage certificates, family records, illustrations, and coloured maps	$3.25
Pulpit Bibles	$8.25
Prayer Books	$0.25 to $1.25
Tennyson's *Poems*	$1.25
E. W. Wilcox's *Poems*	$0.35
Robert Browning's *Poetical Works*, 12 vols.	$7.50
The Chimes Series: Stories for Girls	$0.45
Dick Cheveley by Kingston	$0.50
Abandoned by Verne	$0.50
The Secret of the Island by Verne	$0.50
The Pansy Books	$0.35 each
Through the Looking Glass by Carroll	$0.20
Don Quixote by Cervantes	$0.25
Oliver Twist by Dickens	$0.25
Treasure Island by Stevenson	$0.19
Waverley by Thackeray	$0.25[*]

[*] Eaton Company Limited Catalogue, 166.

families. In fact, as stated by Mrs. Ellen Hubbard, her family borrowed or lent books quite often to others. Edith Stilborne said the practice was so common that books were exchanged as long as the binding held together. William Gange was proud to report his poetry books were always in high demand.

It was not a surprise that exchanging books was a popular custom, as books were expensive to purchase. In fact, a number of settlers could not afford to buy books once they had arrived in Saskatchewan. Mrs. H. J. Kenyon's family was not able to buy any for a number of years, as "money was needed for more necessary things like food and clothes." In a similar vein, Fred Baines did not order any books, as "cash was very scarce." However, for those who did have some extra funds on hand, they ordered their books from the Eaton's catalogue. As Gladys Saloway wrote, "We bought books, always as many as we could spare money for." Jessie Cameron ordered a book at one time, a cookbook for $1.00. However, her husband expressed his opinion that her purchase had been too extravagant.

Oftentimes, instead of buying books, settlers would buy subscriptions to weekly newspapers. These materials would keep settlers up to date on local matters, provide information on crops and animal husbandry, and the short stories that were included would provide entertainment for all family members. Particular newspapers, such as the *Nor-West Farmer* and the *Grain Grower's Guide*, were quite popular and were mentioned a number of times by settlers. Other newspapers included the *Family Herald* (Montreal), the *Star Weekly* (Toronto), the *Winnipeg Free Press*, the *Regina Standard*, and the *Prince Albert Advocate*.

Families would turn to reading either newspapers or books in the evenings when the daily chores were done. Mrs. H. J. Kenyon wrote,

> When we first came to Canada, my three brothers worked out for farmers. My father, mother and myself lived in a little log house loaned to us till we could build. During the winter evenings, while Mother and

I would be sewing or knitting, Father would read aloud to us. I can remember him reading Martin Chuzzlewit *and* Pickwick Papers *by Dickens. We would put in many hours this way which would otherwise have been lonesome or boring.*

Other settlers did not have time to read any sort of reading material, whether it was in a book or a newspaper. As stated by Lewis Fletcher, "I worked till I was tired, cooked my meals to eat, then slept." He repeated this process day after day. Mrs. Jean Hill also recounted how her days were too full to do any reading: "I had a family of four boys and my husband. I had to milk cows. I had enough to keep me busy." Sidney Steward's family was also too busy most of the time to read, particularly during the warmer months of the year. However, he said, "The long, stormy winter days sometimes got you down, but we could always turn to our books."

Writing Poetry

Another common pastime for many settlers was to write poetry. Many wrote for their own enjoyment and to pass the time, while others wrote about their feelings and life on the prairies. One such settler was Robert Chase, who wrote a number of poems about his life on the homestead. In one such poem, he wished to curb his loneliness by obtaining a wife:

A BACHELOR'S LAMENT

I'm only a bachelor, a poor single man
With no one to love and caress,
On a miserable homestead I live in a shack
Which is all the home I possess
There is no one to care if I go out at night
Nor welcome me home with a kiss
A miserable, sordid, contemptible life
Devoid of all pleasure is this
Each morn I awake and get up with a sigh
Of remorse for my desolate life
And I think Ah Elysium, wondrous sweet
What a joy in having a wife!
The food I prepare is unfit for the swine
I wonder that I can subsist
Did ever a more wretched person than I
In this miserable country exist?
I'm tempted at times to go down to the creek
And finding a suitable spot,
Jump in with an anchor attached to my neck
And end my most miserable lot
With no one to weep for me when I am gone
No tombstone to point out the place,
The turbulent waters would ceaselessly flow
Above the remains of Bob Chase.

At the end of the poem, Robert explained that he had only felt this way temporarily, as he "got over it" quickly enough. He never did mention whether he ever got married or not.

Another poem, also written by Robert Chase, had a more humorous side to it.

ELSIE

When haunting chains of recollection bind me
And pleasingly the harp of fancy plays
Full many years of strife I leave behind me
To stray amid the scenes of far off days.
And ever, as in dreams I wander over
The glad terrain my youthful steps knew
There comes to me the scent of new mown clover
A leafy lane, a garden gate, and you.

Among the stars of memory still gleaming,
Which light my pathway to those far off days
One poignant thought comes ever to my dreaming
I never quite could understand your ways.
It may have been some sorrow that possessed you,
When holding back from me that brimming pail.
I only knew your answer when I pressed you,
Was just to chew your cud and switch up your tail.

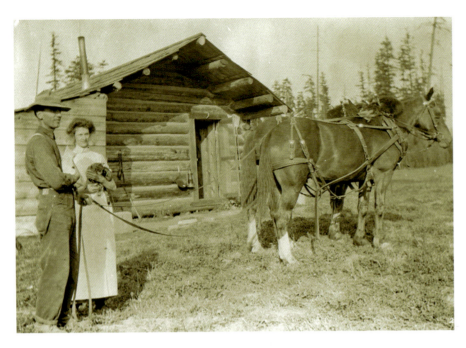

ABOVE: A homesteader and his wife (holding a pet cat) on their new homestead in 1912. Library and Archives Canada, PA-017378.

SINGING THE OLD FOLK SONGS AND HYMNS

Along with reading materials, settlers held musical ability in high regard, with many of them reporting they could play a musical instrument or that they were happy to sing various songs with other family members for entertainment. According to Lillian Miles, "Everyone seemed to be very fond of music—instrumental and singing and these played a very large part in the entertainment [of the West]. Each time we got together, we would have some musical entertainment, singing the old folk songs and hymns in particular."

In terms of the type of musical instruments settlers owned, Fannie Dunlop stated her mother had brought an organ with her to Saskatchewan, while her uncle brought a guitar. Her neighbours owned a flute, a cornet, a clarinet, and a piccolo. Robert Sanderson's family owned an organ, and his father "sat and sang old songs for an hour or more each evening." In fact, his father knew so many songs that he could sing a different song for each day of the year. Mrs. Hugh Cossar's grandparents had brought an organ west and her uncle had a violin, while her neighbours owned a tin whistle, an autoharp, and a mouth organ. Many of Margaret McLellan's neighbours owned either a banjo or an accordion, and most of the music they played tended to be dance music. In fact, when they played, everyone danced and enjoyed it. Norman McDonald brought a set of bagpipes with him when he immigrated to Saskatchewan, and he played Gaelic and Scotch/English songs, while Sydney Chipperfield's father brought a concertina with him from England. Marion Anderson wrote that one of her neighbours, a Mrs. Hewgill, owned a melodion, while another neighbour, Mr. McQueen, won an organ in a contest from the *Winnipeg Free Press*.

Common songs that were played included western songs and cowboy laments, such as "Home on the Range," church and school hymns, such as "Nearer My God to Thee" and "Rock of Ages," and Stephen Foster songs, such as "Oh! Susanna," "Camptown Races," "Old Folks at Home," "Old Black Joe," and "Jeannie with the Light Brown Hair." Other popular songs were "White Wings," "Nelly Grey," "When You and I Were Young Maggie," "After the Ball," "Tenting on the Old Campground," "Silver Threads among the Gold," "Waltz Me around Again Willie," and "Two Little Girls in Blue." Settlers who came from particular countries like Switzerland, Germany, Scotland, and Ireland, mentioned they also sang folk songs from their homelands. For example, Joseph Mohl and his family, who came from Germany, often sang the song *"Die Lorelei."*

Although playing music and singing were common hobbies, there were some settlers who did not own any musical instruments when they first settled on their

homesteads. Winnifred Adler's father had owned a piano but had sold it in North Battleford before making the final trek to the homestead. He felt it was too heavy to haul the last one hundred miles. Lawrence Kelly learned how to play the piano in England but was not able to buy one for over twelve years. However, he was able to satisfy his musical cravings, as he "passed a house where there was an organ in the winter of 1911. The house was abandoned and [he] would go in and play until his fingers were too cold." Esther Goldsmith's family could not afford any musical instruments, and, as a result, given that all of her family members liked to sing, sang without any instruments at all. Eloise Anderson, who desired to play a musical instrument but could not afford one, was quite creative when trying to determine how to purchase one. She wrote how she undertook this mission and ended up owning a piano when she was only sixteen years old. She had won a prize "for writing an essay and with this prize, [she] bought a heifer calf. It was from her progeny that she got the $90 for a nice piano."

A MAN AND HIS DOG ARE NEVER LONELY

Another source of entertainment were the pets the settlers brought with them or acquired while living on their homestead. More often than not, settlers would recount, with great fondness, the pet or pets that lived with them. Whether they remembered some of the humorous antics of their animals, particular qualities each animal had, the circumstances as to how they acquired the animal, or how the animals helped with chores around the farm, it is obvious pets were important to settlers. Not only were they companions but they were also helpers and had the ability to relieve the loneliest of times.

Charles Sargent talked about how he and his family and his neighbours all had different kinds of pets to keep them company:

Cats galore! Persians, Tortoiseshells, Tabbies! Reginald, a big tabbie was a mouse hunter. Another cat presented us with five kittens.... They were very interested in gardening and would follow me up and down the rows when I was mulching or hoeing and [they would] spring on my shoulder if I kneeled down to single out plants.... [I remember] my second daughter going to the barn with 23 cats and kittens trailing behind her. We have a few crows that would come back to the windbreak year after year each spring and one we called our pet crow. He sat on the pole and when we went down to the well and called out good morning, he answered caw caw. And will keep on cawing as long as

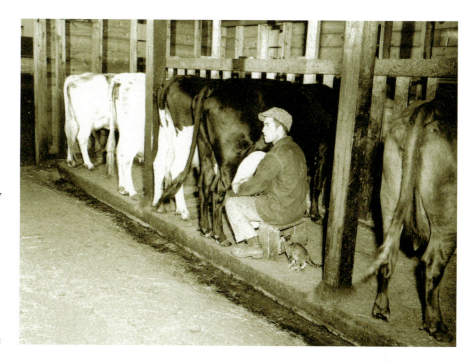

ABOVE: A settler and his barn cat, who is hoping for a drink of milk. n.d. PAS R-A5462-1.

FUN AND FESTIVITIES

Losing a Pet

Settlers recounted situations where they faced the heartbreak of losing a pet. Such loss was set out in this poem, where a kitten went missing.

Kitty, my kitty, my dear little kitty
I've hunted the house all around
I've looked in the cradle
 and under the table,
But no where could kitty be found.

I went to the stable
 as long as was able,
I looked at the old wooden spout
I went to the woodpile
 and stayed there a good while
But never would kitty come out.

I called my dog Rover
 to hunt the fields over
To find my poor kitty for me
No dog could be kinder,
 but he could not find her.
Oh, where can my poor kitty be?*

* This poem comes from my personal collection. The author of this poem is unknown, as is the date. Alternate versions of this poem are available online (see http://ceadserv1.nku.edu/longa//family/clines/kitty.html).

we talk to him. Mrs. Ed Fagan who had a lovely Scotch garden on her farm used to feed the small birds in her windbreak and they got so friendly, they would come and perch on her shoulder. One neighbor had a tame antelope and another some tame skunks. We have had tame partridges and one year the boys had hoot owls, another year some young hawks. The younger one used to carry a garter snake around in his pocket. My youngest daughter once had four tame geese. A friend gave her the eggs which she set under a hen and she used to carry them around to get them in at night as they would not let anyone else near them.... My second son had a pet toad one year and about a dozen tame bullfrogs.

Harriet Stueck's family also made pets out of all sorts of animals. She stated, "We had many pets, wild and tame. Jennie, our muskrat being one. In fact, we made pets out of everything we could, even a garter snake." Misella Otterson's family had dogs and cats, as well as pet chickens, while Mrs. Maud Goldsmith had a pair of canaries she named Jennie and Jim. She also tamed a crow and named him Rasters.

One settler, Percy Thomson, related the story of a man in his local town who owned a rather unusual pet:

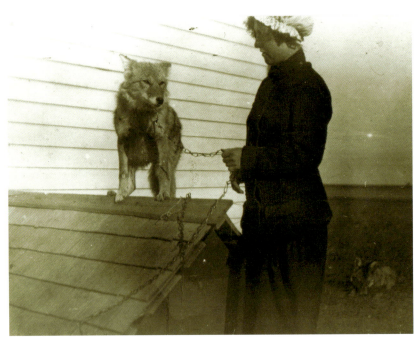

ABOVE: Bessie Ford and her pet coyote, four miles east of Milestone, 1912. PAS R-A23857.

There was a man named Warner had a store in the district and he had a pet moose which he thought a great deal of, but one day it was missing and he could not get any track of it and concluded that it must have been killed. A few miles from the lake lived a family with a large number of small children and they were often very

136 THE HOMESTEADERS

hard pressed for food. Once when they were completely out of flour and other provisions, the mother was out working in the yard when she saw a moose which she recognized as Warner's pet, so she got some feed and coaxed it into their barn. Then she went and told Warner that she had found his moose. He was very much pleased to get it back again and when he learned that they were so hard up, he gave them flour and all the provisions they needed and they never had to go hungry again.

Charles Davis also recounted a story about a lost animal. However, his story was quite different from Percy Thomson's. He said that in January 1907, a Husky dog, "Jock, came to me, a bag of bones…he was a pitiful mess, scarred and cowed. He had been beaten mercilessly. I could see open welts across his back. I took food to him at regular times and he would cringe if I went within 20 feet of him. I gradually lessened the feeding distance from the shack." As time went by, and the dog learned to trust Charles, he reported that Jock became a *friend indeed, guided me to feed stock and would help bring wood for the stove. He shared my troubles, and helped with difficulties to his last breath. All dogs ask is your kindly friendship. A man and his dog are never lonely and he'll point you out things with his steady gaze, you'd never seen otherwise, oftentimes averting danger. Once Jock saved my life in the worst blizzard I ever experienced.*

Other settlers reported having dogs that helped out on the homestead. Harvey Carson had a short-haired female collie who was able to herd and keep the cattle on his land without a fence. Mrs. Maud Goldsmith's family always had a dog and cat, and they were a big help around the farm. The dog was very protective and would bark to alert his owners if something was amiss or someone was approaching their home, while the cat was useful at keeping the mouse population under control.

ALL ATREMBLE WHEN I SAW A WOMAN

Another type of recreational activity settlers greatly appreciated was visiting other folks who lived in the community or having people come by and visit them. Lillian Miles wrote, "People were always pleased to see each other and never worried about anything as formal as an invitation." Not only did friends relieve the boredom and loneliness of living on a homestead and provide a break from homestead chores but they also gave people

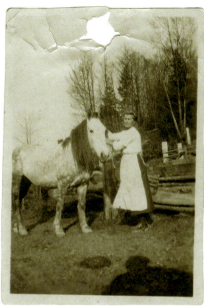

ABOVE LEFT: Family members posing for a photograph on the family horse. n.d. Author's personal collection.

ABOVE RIGHT: A settler with her pet horse. n.d. Author's personal collection.

FUN AND FESTIVITIES

An Unfortunate Accident

Settler Frank Kusch recounted the story of his uncle's pet deer:

One day, his uncle received visitors, Arthur and his brother who were newly arrived from England. Uncle had a large ranch and kept the little deer in a wire fence quite high. All the deer had little bells on their necks. The boys made up their minds to go hunting. They started off one morning and walked several miles and all at once, they saw a bunch of deer, so they shot them all and when they climbed over the fence, they found they had shot all of their Uncle's tame deer. . . . p.s. Uncle nearly shot the boys later.

an opportunity to chat and hear the latest news, find out about newcomers in the area, learn about crop prices and new machinery, swap ideas about making furniture, wagons, or sleds, and just generally have a good time telling jokes and laughing. People who were headed into town for provisions would sometimes visit various settlers on their return trip. Often, they would bring the mail with them from the post office, which was helpful, particularly if people lived five miles or more from town. It saved them a trip from having to go to town themselves.

Visiting typically took place in late afternoons and evenings on Saturdays or afternoons on Sundays (after church). While people would come by during late afternoons on weekdays, this time of the week was far less common than visiting on the weekends. For those who visited in the afternoons, the settler and his wife would offer their guests tea or coffee or lemonade, if fresh lemons were available from the local store. For those visitors who brought their children with them, they were typically offered a glass of milk along with some cookies. Others, like Marion Anderson, offered visitors anything that was available, such as "buttered buns or bannock, jam or jelly. Eggs, milk, vegetables, meat and wild fruit." Settler Godfrey Persson indicated that it was an old Swedish custom to offer "some coffee and cookies or just plain bread and butter," while James Tulloch stated that if the settlers were from northern Europe, then you would probably be offered coffee. If they were from England, Australia, or New Zealand, then they would serve tea. If, however, the settlers were from Scotland, then, he says,

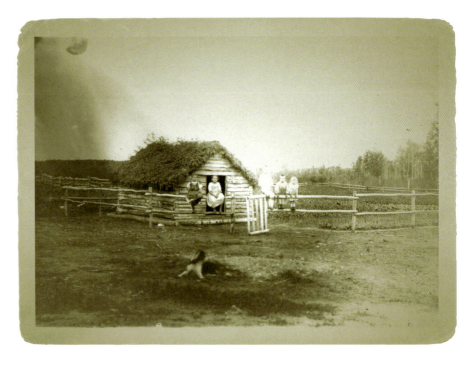

ABOVE: Denys Bergot's first home in St. Brieux, Saskatchewan, in 1904. The family's pet dog is playing in the yard in front of the children. PAS R-B8896.

you would be offered whiskey. Unfortunately, there were some settlers who could not afford some of the basics like tea leaves, coffee, or whiskey. In these instances, when people came to visit them, they would politely offer them a cup of "Lily White tea," which referred to a cup of hot water.[2]

If the visit was extended, and reached into mealtime, visitors were always expected to stay and share the evening meal. M. J. Downie recounted how he offered

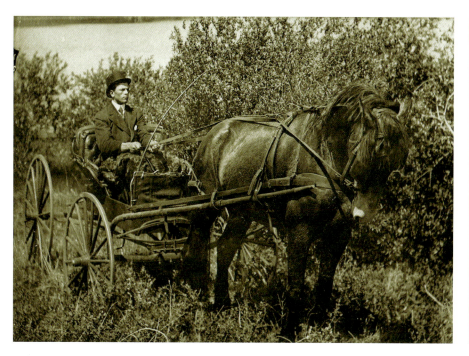

ABOVE: Joe Zeman going visiting (courting) in his buggy, Kenaston, Saskatchewan, 1905. Library and Archives Canada, c-030797.

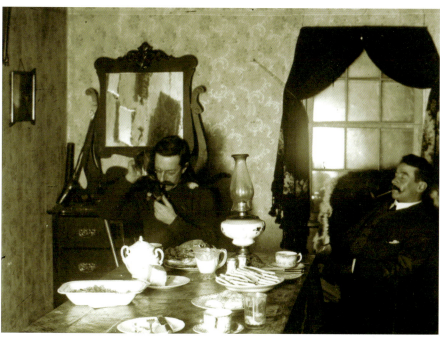

ABOVE: Homesteader Aubrey Rook in 1903 enjoying afternoon tea with a friend. PAS R-A4662.

his visitors potatoes, bread, and meat, with prunes for dessert, while Joseph Mohl placed some homemade pastry, cold meat, and bread on his table. Settlers would offer their visitors whatever they had on hand. If they had snared rabbits, or fished, or had meat from their stock, then that would be prepared, cooked, and served, along with any available beverages. If they could only provide a scone and syrup, as experienced by Margaret McLellan when she went visiting, then that was acceptable as well. The meals may have been sparse from time to time; however, the enjoyment of chatting with neighbours was of primary importance and the issue of whether there was a variety or quantity of food offered was of little concern.

People visited at all times of the year. According to Margaret McLellan, her family would go visiting in the summer with a wagon and team, and, during the winter, they would use a sleigh. If they were to be away from their home for a few hours, people would make sure enough feed was left for their animals. If there were chores that needed to be done, such as milking cows at a particular time, then one member of the family would stay home to take care of things while the rest of the family went visiting. Sometimes, it might be an older son or daughter who stayed behind or, perhaps, the wife would stay if there were no older children around to attend to the chores. When Lora LoRose's family went visiting, her mother usually stayed behind.

Women, however, did not always stay home. John McChesney's mother would get lonesome from time to time. Eventually, she would hitch up the oxen and go visit another woman who lived down the way. Lena May Purdy exclaimed about how exciting it was when another woman came to visit her. As she stated, she

FUN AND FESTIVITIES

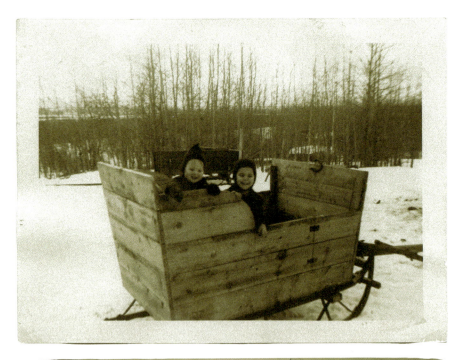

TOP LEFT: Two children in a sleigh. In the winter, this sleigh would be used when going to visit the neighbours. n.d. Author's personal collection.

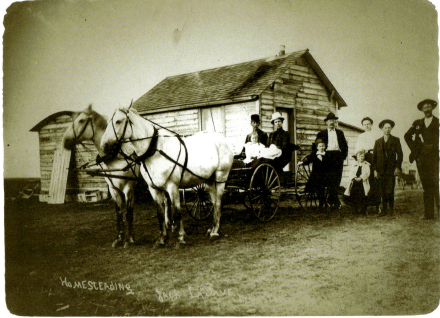

BOTTOM LEFT: Going visiting by horse and carriage, Kenaston, Saskatchewan, 1910. PAS R-B4502.

was always happy to have visitors, "especially a woman.... I have felt myself go all atremble when I saw a woman coming." Mrs. Arthur Kelly also expressed her happiness with having a woman's company, as she wrote that at one time she remembered "not seeing the face of another woman for three months." Having a woman to talk to not only provided companionship but allowed women to discuss issues and problems they were having within the family, trade recipes and sewing patterns, and obtain household hints for cleaning.

When people were not at home, visitors were welcome to enter, as doors were not locked. They could help themselves to a drink of water or milk, a cup of tea or coffee, and eat a light snack, such as a bun with butter or jam, before continuing on with their trip. One settler, Alfred Mann, who wished to know who had visited him, kept a scribbler and a pencil on his kitchen table. When people stopped by, they were able to write their names on the scribbler and tell their stories of recent events so Alfred was kept up to date.

A LOT OF PEOPLE FROWNED ON CARD PLAYING

Sometimes when people got together for an evening, they would turn to playing an assortment of games after the evening meal was done. According to Esther Goldsmith, some people played board games like checkers, dominoes, or crokinole, while others preferred more active games like charades and musical chairs. Others liked guessing games like one called animal, vegetable, or mineral. In this game, "two groups formed circles and each group tried to find the answer fast to an object chosen."[3] Other settlers favoured card games, such as pedro (a trick-taking card game), gin rummy, whist, cribbage, 500,

euchre, blackjack, and poker. Where gambling was involved in people's homes, the amount of money tended to be small. Charles Sargent recalled, "[One night] 15 cents changed hands; one man lost five cents and another ten cents. One other night when $12 was won, everybody was delighted as [this man] nearly always lost." The amount of money lost could be much higher if the players were in town at the local pool hall. Charles remembered that "on one occasion, title to a quarter section changed hands and losses up to $500 were not uncommon."

Not all people were happy with the notion of card playing or gambling. Minnie Taphorn wrote, "It was up to the person. If he wanted to play cards, he could. If he did not want to play, it was alright. Nothing was said if they did not want to play." Some people were reluctant to play cards for a variety of reasons. Mrs. H. J. Seeman explained that some people, who had previously lived under monarchist rule in their mother countries, were offended if the cards had pictures of the king or queen on the backs of them and would refuse to play. They preferred to play with cards that had pictures of wheat, oats, cats, or dogs instead. Sidney May said some older people were so against the idea of card playing that these "older folks would burn any cards taken into their homes. If the young folks wanted to play, they had to go to other places or play when the old folks were away, which wasn't often." Others had religious reasons for being against card playing. Edith Stilborne's homestead was near a Methodist colony and if people played cards, "they did it very surreptitiously." In a similar circumstance, Lillian Miles reported that in one "particular community, a lot of people frowned on card playing because practically all the families were of the Baptist Faith and this religion would not allow the playing of card games."

IN THE KITCHEN, BEDROOM, ANYWHERE YOU COULD MOVE

Another way to get acquainted with the neighbours, while at the same time alleviating the loneliness and monotony of the homestead, was to take part in dances and parties. Most often, in the early years before schools or other town structures were built, dances occurred within people's homes, regardless of the dwelling's size. Esther Goldsmith explained, "All the dances were in homes. Turns were taken and no one was left out even though the houses were small." Usually, one or two people in the crowd had brought some sort of musical instrument with them, such as the mouth organ, violin, or fiddle. If there was enough room to move around, people would square dance, waltz, polka, dance the two-step, or dance the way they had in the old country. The neighbours brought a variety of food for a

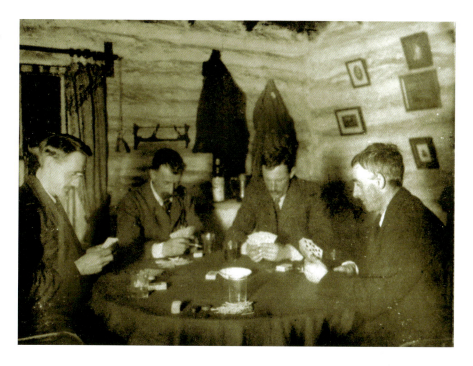

ABOVE: Four men playing cards in a home at Cannington Manor, Saskatchewan. n.d. PAS R-A8202.

A Form of Entertainment That Went Awry

Alfred Mann described an evening of entertainment he and his fellow settlers attended. Unfortunately, it did not go as planned, with many people scared for their lives.

A British Guardsman retained his uniform and saber and was asked [to perform] at a social. He offered to put on a display of his swordsmanship. As he proceeded, the flashing sword caused a panic and the audience bunched up screaming. They were afraid he would not be able to keep his hold on the saber.

Needless to say, the guardsman was not invited to demonstrate his expertise at any other social functions.

midnight luncheon, and beds were made up for tired babies and small children in the corner of the room or they were placed on the tops of blankets and coats that had been piled on a bed.

Another settler, Mrs. Frank Robertson, described the dances that were held in her home. She said, "We always had a party at our house.... We crowded 45 people into two small rooms. Took beds down to make room." They had an organ for music and they offered everyone homemade ice cream for dessert. Gilbert Haydon also remembered how people danced everywhere, in every room in his small home. He said people danced "in the kitchen, bedroom, anywhere you could move." Sometimes, if there were a large number of people, they would spill out of the house and dance in the yard if it was warm out. For settlers who had just built new granaries, barns, or even new homes, a celebratory dance was always held. John McChesney recounted how a new bachelor in the neighbourhood had just completed building a large-sized shack:

One evening word went around, "get ready tonight, we are having a dance at T.M.'s homestead and don't let him know we're coming." One ox team with a hay rack bottom might pick up 8 or 10 people. The homesteader was generally gone to bed—if so, so much the better. When all arrived, a loud cheer went up and the homesteader knew something was up. The women rushed in with babies, bundles of goods, blankets etc. The dance was on. We had our own music and there was plenty to eat. It was winter and we got home at 8 or 10 in the morning—fine.

Another popular location for dances was the local railway station, particularly if the station was built with a large waiting room. As recounted by one settler, "There were a good many dances in the railroad station in Pense as the room was larger than in most houses."[4] Likewise, Charles Davis mentioned how he attended his first dance in the waiting room of the railway station at Whitewood in 1883. He helped the event by playing the mouth organ, and everyone had a good time.

After the local school was built, settlers used this building for entertainment purposes rather than the railway station. According to William Brazier, "After 1910, the school house was definitely the community centre where dancing, socials or meetings of any kind were generally held." People came from miles around to attend the dances, and they brought a variety of food with them for the late night snack. William Hodgson pointed out that people had such a good time at these dances that sometimes they danced until early morning before they decided it was time to head home. If a storm had developed during the evening, many people would spend the night in the schoolhouse until the storm passed the next day. John Woodward wrote, "Sometimes during storms there would be as many as 12 or 14 sleeping on the floor, covered by horse blankets."

Instead of putting on dances, some settlers arranged surprise

TOP RIGHT: Railway station at Peerson, Saskatchewan, 1910–20. PAS S-B7122.

BOTTOM RIGHT: Dance at Park Bluff School, Park Bluff, Saskatchewan, 1913. PAS R-A3403.

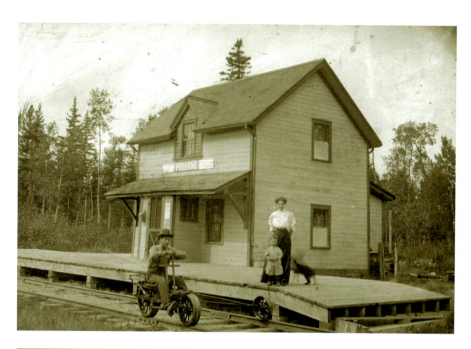

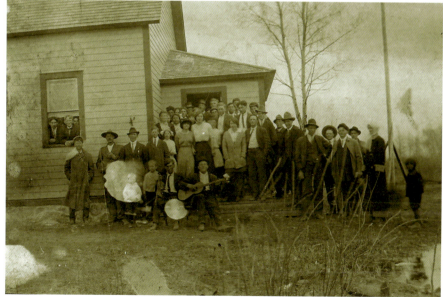

parties in other people's homes. Edith Stilborne said, "In the 1890s we used to have surprise parties, a sleigh load of young people would drive to the home of a settler, taking refreshments and announce a surprise party and spend the evening in sing-song and games." Mrs. H. J. Kenyon also remembered these events, as "the only parties we had were surprise parties in the winter. People would gather from a radius of 15 miles sometimes. I have been at parties when the weather was so cold, we would have to stay all night. Coming home from one of those, I had my heels, toes and finger tips frost-bitten, but it was worth it. There was so little fun or entertainment otherwise."

Mrs. H. J. Kenyon also mentioned the fun she had at surprise parties and how everyone would attend. "There was no definite time, but we had a party about once a month. The family chosen was not told we were coming. We tried to make it a real surprise. We took our own refreshments of course, and had a lot of fun. Everybody went, old and youth, no age limit." Lawrence Kelly reported that in his vicinity,

there was a weekly surprise party at someone's home. These were organized at the current party and you would know that if you were not told about it, it would be at your home the next week. I think we held these every Friday. The transportation was organized too as it was easier to take a team from the furthest place and then leave them part way going on with the next fellow's team, at last there would be about 3 or 4 teams with each a sleigh box full of people.

Along with surprise parties, some people enjoyed planning birthday parties. Mary Birkett fondly remembered when the women in the district got together and came to her house to help her celebrate her birthday. They brought a gift and enough food for a light

FUN AND FESTIVITIES 143

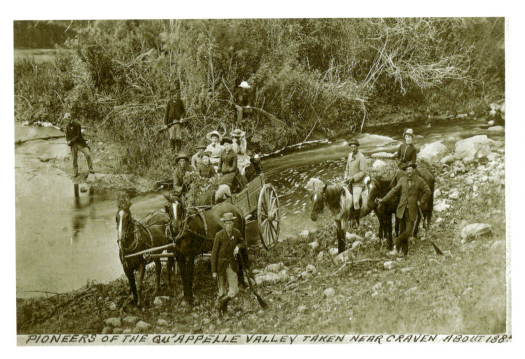

ABOVE: Settlers from the Qu'Appelle Valley going on a picnic near Craven, Saskatchewan, in 1885. PAS R-A2145.

sloughs when they froze in the fall.... These depended on the slough in question freezing smooth which often didn't occur. And in any case, the season for such parties was restricted as the snow usually came early and in sufficient quantities to make skating impossible." One year, between 1903 and 1907, a skating rink was built in the town of Grenfell, and Thomas remembered the excitement surrounding this event. As he stated, once a month, everyone

lunch. Charles Davis recounted how he and others would help to celebrate a settler's birthday: "If we knew a person's birthday, man or woman, if married, people within 6 miles radius would be notified. Each would take cake, pies, meat sandwiches and other supplies [for the event]."

In addition to birthday parties, some settlers and their families enjoyed skating parties in the winter. The people in Thomas Brownridge's community loved skating parties: "We were enthusiastic skaters and would, of course have skating parties on

would congregate at one of the homes on the way to Grenfell and make up a load and drive into town to skate on the rink there. A rack was built to fit on the top of a single sleigh box which supported planks that projected over the sides to sit on this giving two seats the length of the box with people facing each other and with their feet in the box. With plenty of robes, this was considered the acme of luxury. Two teams of horses tandem were hitched to the sleigh and they would make quite good time on the drive to town. After an evening's skating, we would have lunch and then drive home.... At times the sleigh would upset but this only added to the merriment.... I may say that these years represented the high point of community life in our district for all time.

ALL OUT FOR AN ENJOYABLE TIME

Along with dances and parties, settlers also looked forward to the annual picnic held in their vicinity. Mrs. Silas MacFarlane said it was a highlight event, since "most of the older folks were real hungry for a visit with other folks. As far as the children were concerned, it was real fun meeting other children to play games."

The picnic was held at a common meeting place, such as the school grounds or at a favourite meadow or grassy area near a stream or at a local farm. The picnic in Norman McDonald's area was always held "on the John Burke farm twelve miles southwest of Wapella." People came from miles around to

attend this special event. Sydney Chipperfield recalled how the entire community would show up at the annual picnic and that many others came from neighbouring communities, such as "Pheasant Forks, Lorlie, Kenlis, Hill Farm and Abernethy." People would arrive in any type of wagon or buggy imaginable. Some came in buggies or carts, while others travelled in lumber wagons. Some were hitched to horses, while others were hitched to oxen. Some even had smudges attached to them to protect people and their animals from attacking insects. Eloise Anderson said, "As we drove to the picnic, we passed a wagon which had a smudge pail smoking away on it. The mosquitoes were awful, both for size and number."

Once people arrived at the picnic, children sought each other out, while the men unhitched and settled their horses and oxen and women carried their homemade goodies to the lunch tables. William Gange recalled these tables, made of long planks, came to hold every type of food you could think of: "cold meats, prairie chicken, sandwiches, salad, cakes, pies and cookies." Mrs. Fannie Dunlop said, "Everybody brought huge baskets of food.... The ladies all brought their very best cooking and it was all placed on the table. Homemade cakes, pies, bread, salads, and wild strawberries." Frank Baines also listed the various types of food on offer: "Bread, Johnnie cake, rice pudding, fried chicken, pork, and hard tack (round hard biscuits)." Mrs. George Tucker remembered the pickles at her community's table, in particular hard-boiled eggs pickled in beet juice. Everyone really enjoyed eating these pickles and felt they were a real delicacy. As for beverages, tea was popular, with the women brewing it in large wash boilers. Lemonade was also provided, as was coffee. Sometimes, for a treat, someone would have made ice cream for dessert. Food in hand, everyone sat down to eat, on sheets or blankets spread on the ground.

After lunch, everyone played games. There were ball games, where married men played against single men, there was tug-of-war

RIGHT: The Crabb family on their way to Long Lake, Saskatchewan, in 1914. PAS R-A17221.

FUN AND FESTIVITIES

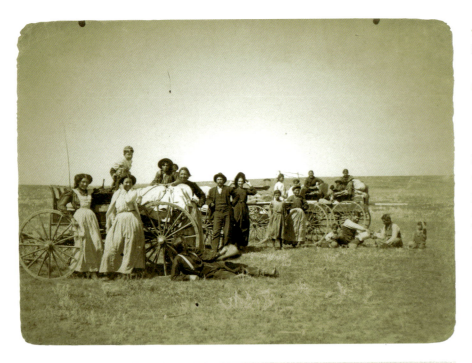

TOP LEFT: Settlers out for a picnic at Notre Dame d'Auvergne, Saskatchewan, in 1905. PAS R-A19713-1.

BOTTOM LEFT: An oxen wagon race for the women. Oxbow, 1908. PAS R-A15365.

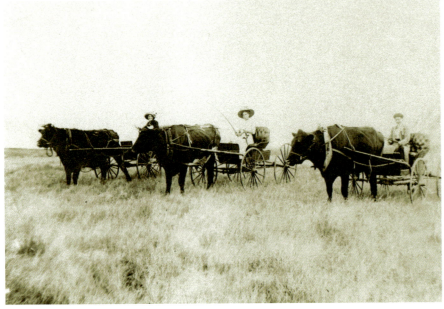

for all ages and sexes, as well as obstacle races, three-legged races, potato sack races, egg-on-a-spoon races, and nail-driving contests. There were also running races, with married women competing against each other, "fat women races,"[5] fat men's races, as well as children's races.[6] There were also horseback races, bareback races, and oxen wagon races. There was also the "slow race," which was just as it sounds. Frank Baines explained the winner was not the one who came in first, but, rather, the last one to cross the finish line.

There were also some chasing contests, one of which Myrtle Moorhouse, and other women from the picnic, took part in. As Myrtle stated, "One time, they turned a red rooster loose and I nearly caught it. Would have, except I was protecting my new dress." Then after that, there was a greasy pig contest where the men had to chase after and catch a greased pig. Myrtle also described another race she had watched that was created for the younger boys in the crowd. However, for two boys, things did not work out as planned. Myrtle said, "There was a race for boys to run, take off their shoes and run to the other end and come back and pick up their shoes out of a pile and put them on and run back again. Two brothers had a fight over their shoes," and lost the race as they could not remember which pair of shoes belonged to them.

While many people left the picnic when it started to turn dusk, a few others remained and slept overnight. This was generally done if people lived too far away from their homes and could not make it home before dark. One young settler, Marie Jordens, said she and her girlfriends stayed overnight in a tent. This was quite an adventure and was a highlight of the picnic, as she and her friends were "laughing and crowing like cockerels and

146 THE HOMESTEADERS

TOP RIGHT: German picnic with men raising beer steins, 1887. PAS R-A2270.

BOTTOM RIGHT: A Jewish community picnic, Dravland School District No. 99. n.d. PAS R-A12891.

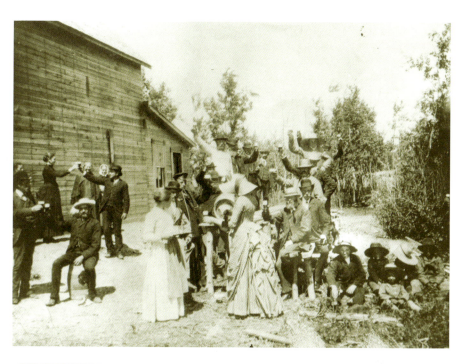

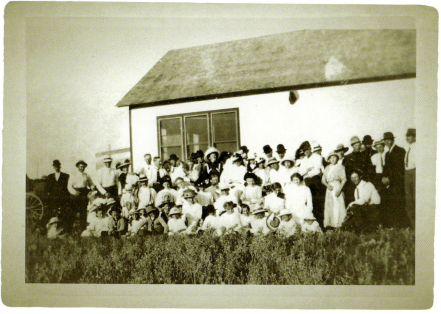

pullets til all hours of the night." Marie also remembered the feel of the early morning chill and being bitten by fleas and mosquitoes. She stated, "It was an experience, never to be forgotten nor ever repeated." Frank Baines also related a story about a family who had decided to stay the night after a picnic. During the midnight hour, their oxen got loose and started heading for home. By the time the family awoke in the morning, they had to track down their animals so they could be hitched to the wagon for the return trip.

Annual picnics gave settlers an opportunity to meet their fellow neighbours, relax, and relish their moments away from the homestead and daily chores. It also allowed children of the same ages to meet and play games and enjoy each other's company. People of all ages remembered with fondness the picnics they attended during the early years. William Gange put it succinctly: "I thought the people were so wonderfully sociable and all out for an enjoyable time."

OCCASIONALLY, A TRAVELLING MINISTER WOULD COME

For many people, regularly attending church, the synagogue, or other religious institution was an important part of their lives. Regrettably, they found when they moved to Saskatchewan during the early years of the pioneer era there was no organized religious instruction offered by denomination, nor were there any buildings in existence for the sole purpose of sermons, prayer, or the singing of hymns. In fact, in many cases, there were no schools or public buildings for a number of years in the rural areas. As such, if people wished to continue to have religion in their lives, they had to adapt to the circumstances. Charles Sargent said people, regardless of denomination, would meet at

Two Mean Little Girls

Mrs. Susan Tucker recounted one picnic where two little girls, who were mercilessly teasing two little boys, did not adhere to proper manners. Stated, "I remember two rude little girls with arms locked, running around singing, 'Swedie, Swedie, sucking on a straw. Can't say anything but Yah Yah Yah.' The two little Swedish boys were very embarrassed." Unfortunately, Mrs. Tucker did not elaborate on if the girls were chastised for their bad behaviour or what happened with the boys.

farm homes (in their sod shacks), congregate in an empty stable, or even gather together at the river for a service among the trees. Sometimes even the local post office or an empty storage space within a store in the local town was used as a meeting place. William Cahoon recounted,

> Settlers began moving into the Macrorie district in 1904 and from the beginning our people were very much interested in Christian worship. From 1906 to 1909, services were held at the farm home of Mr. George Parsons who resided on a farm two miles N.E. of the present site of this village.... The first services in Macrorie were held in 1912 by a Reverend Scott who came from somewhere near Lucky Lake.... These services were Presbyterian and were held over the Evans and Lougheed store, which later became the D. L. Gallup store.

Another settler, Harry Winder, reported that in 1907 the people in his area had rallied together to build a school and, then, after that point, the school was used for religious services on the weekend.

When it came to weekly services, Charles Sargent remembered that people of all faiths would be in attendance:

> The congregations consisted of Anglicans, Presbyterians, Methodists, Baptists, Norwegian Lutherans, German Lutherans, Seventh Day Adventists, one Christian Scientist, two or three Roman Catholics, one Jewish person, and one Marxian Socialist (whom a good many considered to be an avowed atheist, only he wasn't). There was also one genuine Mormon with two wives.

Settler John McChesney reported, "Everyone in his district worshipped under the same roof," and "no one talked about their creed or dogmas." Everyone came together for worship and prayed to their own religious entity without disdain, criticism, or disapproval from others. In order to be inclusive, Charles Sargent said the weekly sermons were nondenominational:

> In the pioneer days, we were all like little boats tossing on the prairie ocean of dry land, only taking a chance on success or failure on an unpredictable adventure and we needed an anchor, and we found it in gathering together and singing the old familiar hymns and in feeling we were in the presence of God in spite of the lack of buildings, vestments, and ordained clergy, doing our feeble best to worship from the heart to make up in other ways.

In his discussion of the weekly sermons, he also set out a typical prayer that was spoken at the time:

> Here we are Oh Lord, a bunch of scattered human sheep on these trackless prairies; strangers to one another; all brought up with different ideas about Thee; but we do need the bond of community brotherhood and where shall we find it but in the worship of and in the supplication to the One Heavenly Father in all of us?

Charles said they also sang a hymn, such as "God Be with You till We Meet Again," and then everybody would shake hands in friendship before they departed.

Even when ministers, pastors, priests, or other clergy became available for services, settlers were not concerned about the

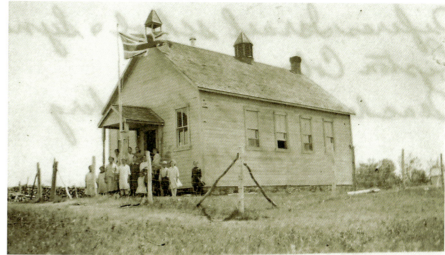
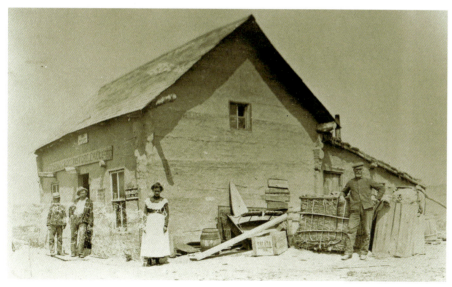
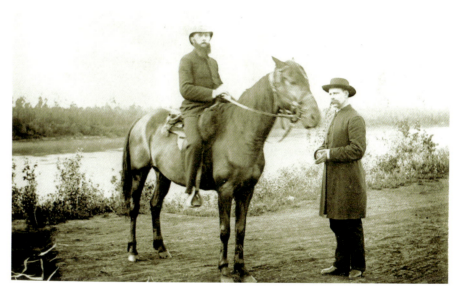

CLOCKWISE FROM TOP LEFT: If a building was not available for church services and it was a beautiful summer day, parishioners would attend outdoor church services. In this photograph, Reverend Sikora conducts a service outside at Albertown, Saskatchewan. n.d. PAS S-B9204; A school used as a synagogue, Lipton, Saskatchewan, ca. 1915–18. PAS R-A12684; Arthur Wright (standing) and Reverend E. K. Matheson (on horseback), ca. 1887–88. Arthur Wright was a travelling missionary for the Anglican Church in the Prince Albert district. PAS R-A4764; The Eagle Creek Store, owned by the Forsyth Family, served as a café, post office, and church. Mr. Forsyth is shown at the back door and his daughter, Edith, is at the corner. ca. 1907. PAS S-B7491.

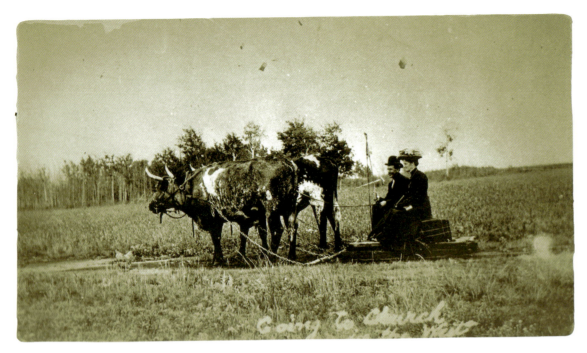

ABOVE: Going to church in the west in 1912. A team of oxen pulling a couple on a stone-boat early on a Sunday morning. Note that the couple are wearing their finest clothes and hats. PAS R-A2473.

denomination of the individual. Rather, they were happy to have someone stop by and offer any type of religious instruction. As Mrs. Frank Robertson wrote, "In the very early days, before the school was built, church services were held in our house whenever we could get a preacher of any denomination and we had them all! My dad always had a Sunday school even if there wasn't a preacher." Jemima Dowling, who lived at Fish Creek, would get together every Sunday with her neighbours at someone's home. They would "read a sermon, a selection from the Bible and sing hymns. Occasionally, a travelling minister would come and we would enjoy his service."

Florence Kenyon also recounted how a travelling minister in her district travelled up to six miles in order to deliver a sermon, while Wava Spratt recalled how the minister in her area walked ten miles between three schools where he held services. She also remembered his congregation was very few in number at one school, particularly given the effort it had taken him to get there. The congregation at this final destination consisted of just two people: her mother and herself.

Settler George Shepherd remembered the greater distances some clergy travelled, as the minister in his district travelled up to thirty miles in one day:

As I recollect, Reverend Ben Bott preached the morning service in Craik and at the end of the service, he had a horse and buggy waiting and jumped right in and drove out to the Rosehill district. He would be due for Sunday dinner at Jim Botts and we would be watching for his coming.... The noon meal over, we all piled into a democrat or some of us walked to the Rosehill Church which was only a small frame building about a mile away. The afternoon service over, the Minister would hitch up his horse and buggy and drive about nine miles to Girvin. He would get supper there and then conduct the evening service for the Girvin people. After that service, he would drive back to Craik—a total of around thirty miles of driving and three services.

Richard Lloyd recalled how the job of being a travelling minister could not only be stressful but also dangerous, particularly during the winter months:

150 THE HOMESTEADERS

In 1912, Rev. W. H. Walker (Baptist) had homesteaded. I recall that the life of a pioneer minister was not exactly a bed of roses. Most homesteaders had their problems and hard manual labour was the order of the day. Mr. Walker had a fair sized family and a typical minister's wife, tempermentally unable to adjust herself to the rigors of homesteading. Added to all of these handicaps, a Sunday sermon to prepare, and on Sunday, hitch a team to a stoneboat and drive six miles to church. He was very faithful and many days we have watched his coming on that stoneboat with it pounding the horses heels on each down slope, sliding sideways, landing the Reverend in a snow drift with his books flying in various directions. However, he managed to surmount all difficulties and carry on.

For those districts that eventually built a church or other religious house of worship, typically after the school was constructed, parishioners would travel by horse and buggy or by oxen and stoneboat to attend religious services. Depending on the distance and the weather, some people would walk. Ellen Hubbard said, "We often walked six or seven miles to church as horses were scarce and worked hard but often we went in a wagon or walked five miles to the neighbours and went in a wagon with them to special services as Easter and Thanksgiving." Similarly, Maud Goldsmith and her husband would travel a number of miles to their church, as did John Andres, who travelled 1.5 miles.

THE RULE OF ETIQUETTE...HAD TO BE THROWN OVERBOARD

Another exciting event for settlers was a wedding. Whether they were part of the wedding party, or were invited as guests, or whether they took part in the chivaree afterward, everyone wished the newlyweds well and congratulated them. Sadie McCallum remembered a couple of weddings held in her district. Both were very low-key, as funds were limited.

One wedding was a home ceremony in a tiny village and took place in late spring in mid-winter. There were the bride's family and about six or eight close friends. The bride wore a navy blue serge suit with a stiff white blouse, and a small black hat. The minister came on the train from an adjoining town, for there was no ordained clergyman in the village. There were no bridesmaids or groomsmen, but two young friends were witnesses. The wedding lunch was served with guests seated at a dining table and was cold ham, potato salad,

ABOVE: Mrs. C. H. Black and her Sunday School class at Regina, Saskatchewan, ca. 1905. PAS R-A7515.

FUN AND FESTIVITIES 151

An Inconvenient Mishap

A farmer, his wife, and their teenage daughter went to evening services in a school and left for home after dark.

*The buggy bogged down in a slough. The farmer got out, but the old horse still could not pull the buggy. He carried the daughter to land and started to carry his wife. She was heavier and his feet bogged down. He told her she would have to walk the rest of the way. She said, "In my new Easter clothes? I will not!" and grabbed him around the neck. They fell. His wife then started talking. The horse ran home with the buggy. Man and wife discussed the incident while walking home. Daughter walked very silently.**

* PQ: File #2504, Charles Riley.

with condiments and charlotte russe for dessert. A lovely wedding cake was in the centre. After the wedding, the bridal pair boarded the train to a little station at the end of the line for a weekend honeymoon, then went to the groom's homestead. Necessity eliminated fuss. Huge weddings and receptions were unknown.

The circumstances of the second wedding were somewhat different. Rather than bringing the clergyman to the village to perform the ceremony, the bride and groom left most of their family and friends behind and took the train to the nearest town to find a clergyman to marry them.

It was not usual for weddings to be performed in churches among country people. Brides then, as now, liked to have somewhat special doings, but the obstacles were practically insurmountable. Usually the couple just drove or took the train, if they could get one, to a large centre. The rule of etiquette of the bride's family conveying her to the altar simply had to be thrown overboard. Then the couple would go to the manse of their own denomination and have the ceremony. If possible, someone from the respective families would accompany the couple. If they could get away, the bridal couple had a honeymoon and usually this was accomplished. In the summer, a few days away.... One thing nearly always was done, the groom gave a wedding dance either before or after the honeymoon. It was held in the local school, or at a house, if large enough, or sometimes a barn. The groom provided the lunch served. He arranged usually with friends for the music. Invariably, after lunch someone took up a collection which was presented to the bride, a very nice present.[7]

Regardless of where it took place, there were some accessories people felt were required for a wedding. More often than not, many people believed in the old adage that the bride should wear "something old, something new, something borrowed and something blue."[8] However, some brides had to manage with whatever was on hand. Rob Sanderson stated that "a good dress" was all that was needed for the marriage ceremony, along with a ring for the bride that had been furnished by the groom. Similarly, Mrs. Howard Olmstead said a bride just needed a "sensible dress," along with a wedding ring. She noted that even if a woman had received an engagement ring, it would not have contained any diamonds. Others, like Elias St. John, reported that his wife, who was quite skilled with a needle and threat, had made her own wedding dress, while Sidney May knew of a woman who had worn her grandmother's wedding dress. It was also customary for brides to carry a bouquet up to the altar. For those who were married close to home, wildflowers would be picked and tied together for the bride to carry. In other cases,

flowers and ferns might be taken from the garden and arranged into an acceptable bouquet.

After the wedding ceremony was conducted, it was not unusual to find jokes being played on the newlyweds. For example, some couples found the wheels on their buggy had been switched. John Theissen recounted, "[Often] buggy wheels were changed around with the big wheels in front and the small ones to the rear." Others would find shoes, old cans, and chains tied to the back of their buggies. If they were returning directly to their homestead, they might find their main gate had been locked and that shenanigans had also occurred within their home. Fred Baines wrote about how he and his friends had tied a cowbell under the bed, Philip Stapleton recounted how one couple found a pig in their cellar, and Eric Neal said a newlywed couple's sheets had been sewn together in their bed. Another settler remembered a joke where the slats were taken out of the bed frame and replaced with a few willow sticks, just enough to hold the feather bed up. When the couple went to lie down on the bed, it collapsed. For the newlyweds who went on a honeymoon rather than returning to their home, many would find jokes had been played on them as well. Finding rice in their suitcases when they opened them, or discovering that the legs of their pants had been sewn together, were common tricks.

Typically, after a couple had settled back into their home after a day or two, neighbours would chivaree the newlyweds. Chivarees occurred in the late evening, when the couple had retired for the day. Friends would gather around the newlyweds' home and make "a great racket, ringing cow bells, beating on tin pans, tooting horns, and singing until they were invited in for lunch."[9] In Jason Barrie's area, a group of young fellows would shoot off shotguns and bang tin cans and make as much noise as possible until they were invited into the home.

If these various tactics did not work, and people were not invited into the house for lunch, a drink, or given a certain amount of money ($3.75 to $5.00 to buy a keg of beer), then the revellers would stuff the stovepipe with rags so the couple would be smoked out of their home.[10] In another case, when the couple did not wish to take part, the revellers left but returned when the newlyweds were away on their honeymoon and placed some chickens and a pig in their home in retaliation. Charles Sargent explained that when a couple did not take part in the chivaree, bad feelings could occur. In fact, Charles knew of one case where neighbours continued to make noise until 5:00 in the morning but were still not welcomed into the couple's home. He said, "There was a bad feeling in the community for months after." John McChesney said if the couple was not amenable to

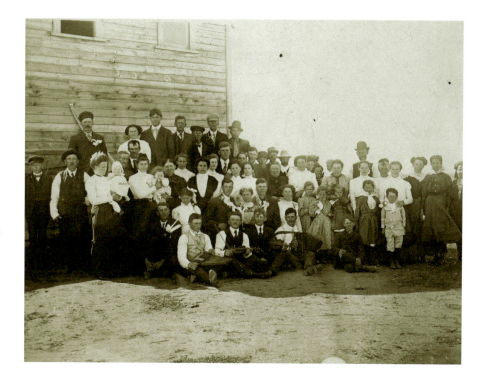

ABOVE: The marriage of Joe Zeman and Sophie Voytilla, Kenaston, Saskatchewan, May 1911. All family members and friends were in this picture including those who played musical instruments (front row). Library and Archives Canada, c-089702.

FUN AND FESTIVITIES 153

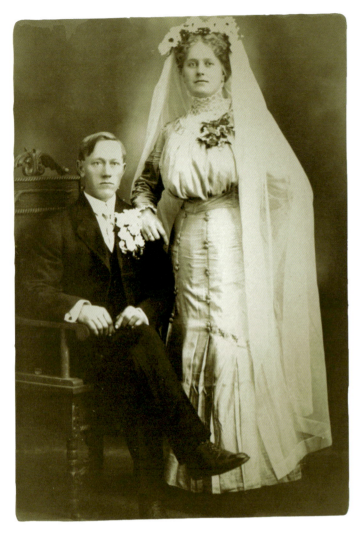

ABOVE: A wedding photo dated 1905. Note the wild daisies used as decoration in the bride's headpiece, which was attached to the veil. PAS R-A4537.

the efforts of their neighbours, it took a long time for them "to regain standing in the community." One couple had refused their neighbours entry and, in fact, had dowsed them with pails of cold water from an upstairs window. Eventually, the couple did apologize to everyone.

Chivarees could even become dangerous. Maggie Whyte wrote, "There was always a chivaree when the bride and groom returned. One almost proved fatal when the old mother of the groom shot a pistol into the crowd taking the collar button off one man's shirt and nicking his throat. The crowd soon got out of there, thankful no one was hurt." Mrs. Hugh Cossar also recalled how people could get pretty angry—she knew of one man who threatened to shoot his visitors. Mrs. Lila MacFarlane remembered the time when friends were chased off from someone's home and "told not to be such fools."

While some couples were not inclined to take part in chivarees, others took the chivaree in stride and, in fact, made the best of it and enjoyed themselves. In Jessie Cameron's community, a new husband had just brought out his wife on the CPR from Ontario. The wife did not know what a chivaree was, so when the neighbours came to their home and demanded entry, the "young bride was frightened to death. The husband opened the door and told them his wife was staying upstairs and could not come down. They all yelled 'Bring her down! Bring her down!' He did and she sobbed on his shoulder all the way down the stairs, but there was no pity in the hearts of the chivareers. However, the husband explained to her that they were his friends, rough and ready as they were, and she brightened up and acted the real sport. She went upstairs, donned her wedding gown, came down stairs in all her glory and prepared a good substantial lunch for the whole group. From that moment on, she was a real favourite in every way."

In other instances, instead of presuming the couple should provide a meal or drink or money, neighbours brought food and drink with them when they chivareed the new couple. Frank Baines wrote, "About 20 people met with cow bells, coulters and beaters, a steel axle carried by two with a wire on each end and beaten by rods of iron. They surrounded the house after all were asleep and broke out all at once. When they had exhausted their surplus energy, they went in with refreshments they had brought and had a real sociable evening. The young couple were then said to be officially welcomed." Mrs. Arthur Kelly also recounted how neighbours brought food with them and were welcomed into the couple's home. When the visiting was done, the neighbours left with good wishes and good feelings all around. Mrs. Charles Pickard also mentioned a situation where the couple and their neighbours were all in good spirits after the chivaree and, in fact, the couple made sure to invite everyone to come and visit them again.

MINCEMEAT, PUDDINGS, AND PIES

For many settlers who celebrated Christmas, it was a time of year that triggered excitement, enthusiasm, anticipation, and delight. H. A. Anslow stated, "How we used to count the days for at least a month before this most important day of the year!" Families would work on preparations far in advance of December 25, to make sure everything was ready, particularly if visitors were expected. William Gange spent his first Christmas in Saskatchewan in 1889:

The house had to be whitewashed both inside and out, then we children spent evenings making tissue paper chains, cut in inch strips and in red, white and blue, stuck together with flour paste, while mother was busy cooking and sewing. The house was decorated with spruce boughs and the paper flowers my mother made. We always had a Christmas tree and decorated it with some paper chains, rose hip chains and popcorn strung on thread.

F. J. Bigg's family also decorated their home. They covered their Christmas tree with coloured paper and tinsel, when they were able to buy it from the local store, and small candles were placed in different locations on the tree to light it up. Typically, spruce trees were used for Christmas trees, but for those who did not have spruce trees in their area, people would use a small poplar tree. When these latter trees were used, people would decorate them by wrapping all of the limbs with green-coloured tissue paper. Lewis Thomas's family would use any "scrubby little prairie tree" and cover it with cotton batting, while other settlers, like Koozma Tarasoff, explained their Christmases were a little simpler. Their homes were not decorated and they did not put up a Christmas tree; however, they did wash the floors and prepared special foods for the holiday.

Different kinds of foods were also prepared well in advance, with some special ingredients needed for baking (like orange and lemon peel) being ordered through the Eaton's catalogue. Mrs. M. M. Whyte said even children were expected to help out with food preparations:

For weeks before, preparations for cakes, plum puddings and the luscious mince pies began. The raisins for them all had to be seeded by hand and the bigger of us children had to help at it in the evenings. A large bowl of raisins which had been covered by boiling water to plump them and water then drained off, was set on the table and we children with hands fresh from soap and water had to squeeze out the seeds. Often when the parental eye was turned, these slippery seeds were shot from thumb and finger across the table at an

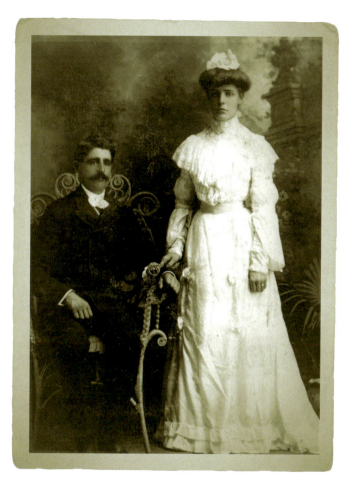

ABOVE: A wedding photo dated 1905. The bride typically stood in formal wedding photographs, while her husband sat in a chair. This was done to display the elegance and style of the wedding dress. PAS R-A23914.

FUN AND FESTIVITIES

Christmas Fruitcake

Below is a recipe for Christmas fruitcake from Mrs. T. Lake:

1 lb butter
12 eggs
1 cup molasses
1 lb flour
4 teaspoons each of cinnamon, allspice, and mace
1 nutmeg grated
¼ teaspoon soda
3 lbs raisins seeded and cut up
2 lbs sultana raisins
1½ lbs citron peel, thinly sliced and cut in strips
1 lb currants
½ lb preserved lemon rind
1 cup brandy
1 square of chocolate—melted
1 tablespoon hot water

Cream butter, add sugar gradually and beat thoroughly. Separate yolks from whites and beat till thin and lemon coloured. Add to first mixture, then add flour, except 1/3 cut which is used to dredge fruit mixed with sifted spices, add fruit and chopped peel, brandy and chocolate and whites beaten till stiff and dry, just before putting in pan, add soda in hot water. Bake for 4 or 5 hours and if possible, leave in oven overnight. Makes 12 lbs.

unsuspecting child. . . . Many a reprimand we got with a threat of "no cakes" if we did not stop.

She also discussed how currants had to be cleaned and washed by the children and that orange, lemon, and citron peel, which had been purchased in chunks, had to be cut into smaller pieces before being used in their mother's Christmas baking. Her mother also baked shortbread and doughnuts. Mrs. Mary Jordens's mother made doughnuts but, in addition, made double-crust raisin pies. Her family also learned how to make another treat, Christmas pudding, from a Belgian settler. They followed his instructions and made the pudding with raisins, spices, sugar, eggs, water, and some chopped suet, and then boiled it in a cotton cloth bag for six hours. When the pudding was used on Christmas day, they topped it with a warm caramel sauce made from brown sugar. Lewis Thomas recalled a special treat his mother would make for Christmas: "Taffy making and pulling was great fun and everybody joined in at this. It was made with brown sugar, although maple sugar may have been used. . . . To cool the taffy, it was poured in strings on the snowbanks."

While pies, cakes, and puddings were all important for Christmas festivities, many settlers also remembered the meat that was presented for Christmas dinner. Often, settlers ate a turkey, goose, or partridge, which had been stuffed with a bread, raisin, or onion stuffing, while others ate roast venison, roast beef, or roasted barnyard chickens with dressing, gravy, and garden vegetables. Edith Stilborne recounted how her mother prepared rabbit using an old English recipe called "Jugged Hare." She also served mashed potatoes and onions with the rabbit, and, for dessert, she made plum duff pudding. Links of pork sausage were also popular. Mrs. Mary Jordens remembered well her family's preparations for making sausage:

First we'd kill a pig, make blood sausage and pork sausage. For this, father would bring in a clean, cut stump of a large tree. This would be filed smooth and washed. Pieces of lean pork would be laid on top and cut with a chopper. The meat would be cut up fine by whoever was the most able. I know I tried when I was only eight. Mother would clean the guts, then blow in them to make sure they were nice and bright inside and out, then she'd fill them with the

prepared pork and I know she used clove and onions.

For the Christmas meal, settlers would invite others to join them if they had enough food available. Sometimes they would invite the local bachelors, so they did not have to spend Christmas alone, or new settlers might be invited over. At other times, settlers might travel to a relative's home in order to celebrate Christmas traditions. When Lottie Meek was a child, she and her family went to her grandfather's place for Christmas. They "had a wonderful time. It was eight miles to go with a very slow farm team. If [they] could not go, [they] Christmased with an uncle and aunt and cousins and sometimes other neighbours."

Regardless of how little settlers may have had, there was still gift giving at Christmas. Many children were excited about the prospect of receiving gifts on Christmas morning. As H. A. Anslow wrote, "The great night came and we went to bed early only to wake up in the middle of the night to feel our stockings which were always hung at the head of the bed and speculated as to what the various objects inside them might be. At last, the morning would come and we were able to open our gifts." Mrs. M. M. Whyte recalled her own anticipation as a child:

Every last child had a bath in the wash tub by the kitchen stove and hustled off to bed earlier than usual to keep in with Santa but not before the stockings were all hung in a row and leaving a lunch for good old Santa. The boys would sometimes leave some oats under the tree for his reindeer. What a mad rush in the early morning to get those stockings with a few candies, an apple, an orange and some little gift for each. My doll was no Eaton's beauty, but a very plain wax doll with matted hemp for hair— and oh, how I loved her!

The magic of Christmas was not reserved for just the store-bought toy. Lena May Purdy remembered with affection a homemade gift that was made for her and her brothers and sisters:

I remember one gift Father made for us children that gave us a great deal of pleasure. He used a piece of a wide board, about four feet long, and one foot wide. He rounded the ends and covered the board with brown [material] stretched very smooth. He tacked a wooden barrel hoop, nicely sandpapered, to make a rim around the edge. Then he made neat wire hoops and nice pegs, and arranged a croquet set. He made mallets of sections of a broom handle with nicely whittled handles and then provided four sets of marbles so each player could have a separate color.

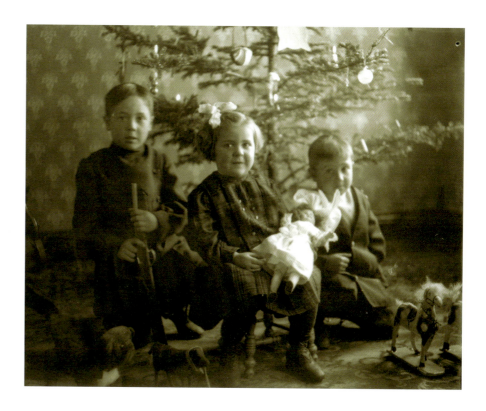

ABOVE: The Weber children in front of their Christmas tree, showing off their Christmas gifts, Muenster, Saskatchewan, 1910. PAS S-B959.

German Crepes on Christmas Morning

One of the Martens family traditions was to have German crepes on Christmas morning. The amount of ingredients used depended on the number of crepes one wanted to make.

eggs
milk
flour
vanilla
salt
(Use 6 eggs to every 2 cups of milk—in this ratio, use about ½ tsp of vanilla and a pinch of salt.)

Whip eggs and add the milk. Add vanilla to taste. Salt as desired. Mix sifted flour until the batter is about half-thick. You do not want it to be too thick. Heat a pan with butter and pour a very thin layer and flip once it sets up. Then it is ready to serve. The crepes must be only ½-inch thick with batter and poured extremely thin. Then add favourite toppings (such as strawberries and whipped cream), or simply enjoy with a sprinkle of white sugar and fold and roll.*

* Nolan Martens's family recollections, 2015.

Settlers remembered other unique Christmas gifts that had been received over the years. One settler wrote that her father made chairs out of keg barrels and gave those away as gifts, while others received water colour paint sets, storybooks, china dolls, handkerchiefs, clothes, or socks. Some settlers could not afford to buy presents. In those cases, Christmases were spent singing Christmas carols such as "Oh Holy Night," "Good King Wenceslas," "Silent Night," or "Angels We Have Heard on High," visiting with neighbours or relatives, or, if someone played a musical instrument, people could dance in the evening.

Sometime during the Christmas season, many communities held a Christmas concert, either at the local school or church, if one had been built in their area. Jessie Cameron described the concert as a thrill for everyone in the community. The day before the event, people would take the day off and help decorate the building and bring in a tree. Lena May Purdy talked about the number of people who were involved. She stated, "The Christmas of 1883, we were in Regina. My mother, Mrs. A. Neville, had charge of practicing music for a Christmas entertainment in the Methodist Church. The teachers helped the children prepare recitations and there were practices in the church for the Christmas music."

At the end of the concert, children would receive a bag of candy or a small gift from under the tree, which had been placed there by teachers or parents. If someone dressed up as Santa Claus, this added additional excitement. Unfortunately, in one case, the children were not so easily fooled. Sydney May said he once dressed up as Santa Claus at a Christmas concert. However, everyone knew who he was, as his dog Jip followed him up on the platform and sniffed at his legs. Sydney said, "This gave the game away right away."

The Christmas season would end with the excitement of New Year's Eve. Settlers would travel from miles around to attend a New Year's Eve party and reacquaint themselves with their neighbours. As set out by Charles Bray, a friend of the family, who had been travelling in the area, stopped by to rest for a bit a few days after Christmas. He told the Bray family he was putting on a New Year's celebration and that they were all invited. He also mentioned he had been inviting people "all within a radius of twenty miles and that they're all coming, young and old, and cowboys and all the instruments they have." The Bray family jumped at the chance to go to this party. Charles said,

We rose to the occasion and preparations started. Mince-meat, puddings and pies were made. We had poultry and all kinds of game and a dandy four year old steer hanging up. [His wife] was an expert candy

The Spirit of Christmas Is the Real Santa Claus

Mary Anderson recalled her first Christmas in Saskatchewan and how special it was for her and her family.

A month or more before the important day arrived, my eldest sister, a little girl who had quite lately passed her twelfth birthday, told me very emphatically that our happiness depended on ourselves. We are big enough to know that there is no magic in Christmas gifts, they must be made by someone, and it is the Spirit of Christmas that is the real Santa Claus. We must do something to make others happy if we were to be happy ourselves.... There were no stores here to buy anything, so if we would have presents to give our little sisters, we must make them. We planned to ask Mother to let us sit up a little later at night than the little ones so that we could sew in the evenings after they had gone to bed and we could make each one of them a rag doll.

Mother had a truly wonderful rag bag as she had been doing our sewing for years and years and always saved the scraps. We soon got among the scraps and chose the best and prettiest to dress our dollies. But of course, we had to speak very quietly as our house was small and all one room, only curtains hung around the beds.

First, we must make the heads and bodies for the dolls. We wished we could have chosen china heads as we had on some of our dolls but that couldn't be, so we just had to make them of cotton and sew the eyes and all the features in with black thread. We had to cut out the cotton many times to get a suitable figure for our lady dolls and we must not waste any cloth, so they usually started large and got smaller before we could make them a good shape. Heads were the hardest to make and we suffered much discouragement in getting them of proper dimensions, and many tired and much pricked little fingers we had before we got even the bodies made. Mother helped us with advice and cutting, but we must learn to sew and make a neat job of it.

We enjoyed the sewing but had only a short time each evening before we too must go to bed. It seemed to take many evenings before we had a dolly for each of the three little girls. One was a bright red one, another a royal blue and the other had a plaid skirt with a red blouse. All the underwear was of fine white cotton, neatly hemmed and with buttons and button holes.

We two older ones were very happy in that the little ones would find something in their stockings on Christmas morning and we were big girls now and knew better than to expect to get anything in ours.... In the early morning, we made the fire as the little ones wanted to see what was in their stockings and we wanted to see their surprise. Then we found a surprise in our stockings. A small package of raisins and cookies with real currents in them!

[Later that day], mother made a lovely dinner of cooking stuffed beef's heart, potatoes and a boiled pudding for dessert. After dinner we had another surprise, Mother had a card with two little brooches on it and there was one for each of us older girls.... I treasured mine for over thirty years.

> We must do something to make others happy if we were to be happy ourselves....

FUN AND FESTIVITIES

LEFT: Nick Lazarowich of Hague, Saskatchewan, standing beside a small Christmas tree, 1904–05. PAS S-B7285.

OPPOSITE PAGE: Schoolchildren at a Christmas concert. n.d. PAS R-A20095.

maker. She had taffy and nut mixtures, peppermints, and fudge and even chocolates. The big day arrived, so did the countryside. They came in sleighs and on horseback.

Charles went on to say that a blizzard began that same evening, and people brought in blankets and fur robes and they all packed into the house. There was dancing and merriment all around. The women helped to prepare the meals and chokecherry wine was served. The party lasted until the wee small hours of the morning, when everyone grabbed some floor space and made up their beds. The next morning, the men helped their host with his stable chores and the women put together a large breakfast. Everyone was "sleepy but happy," and "those who had the longest way to go home started home first while others stayed to help with the clean-up." Charles finished his story by saying, "Those were the days and the country where good fellowship prevailed."

Instead of visiting neighbours or relatives to celebrate the New Year, other families held more private and quiet affairs within their own households. Mary Jordens said celebrating New Year's with her family meant cherishing one another and wishing each family member well:

On New Year's morning, father would get up very early and sit on a chair near a table lit by one candle and decorated by dishes of candies, apples and plums sometimes. Mother would wake us up and send us in this room one by one starting with the oldest boy or girl. When my turn came, this is what mother had told me to do. Kneel down in front of my father for his blessing.... Then he stood up and gave me a kiss, then I went around and kissed my brothers who were already there, wishing each other a Happy New Year! Mother then passed around the pretty candies, mostly peppermints.

At dinnertime, the festivities continued, as Mary's family would enjoy a special New Year's dinner of meatballs in gravy made from pig knuckles and other bones.

Chapter 8
Laying a Good Foundation

Settling Saskatchewan was a unique experience that many people were able to share as they homesteaded across the province. Travelling to Saskatchewan from such mother countries as England, Scotland, and Wales; Germany; Switzerland; Poland; and Russia, looking for adventure or hoping for a better life, linked all of these diverse peoples together with a common objective: obtaining 160 acres of free land. This was a dream come true for many, particularly those who had escaped a life of poverty, religious and political purges, or the inability to ever own land of their own. Even for those who had migrated from Central and eastern Canada, the chance to become part of the population who developed the West was a once-in-a-lifetime opportunity.

While hopes were high and excitement abounded among those travelling to Saskatchewan by ship, train, or Red River cart, the realization of the hard work homesteading entailed for all members of the family, young and old, became readily apparent. Reaching their homestead and finding less than pristine conditions would have been a worry for many. Serious problems were encountered that would have to be overcome. For instance, how would they build a home when there were no trees in sight? Or, if their homestead was covered in trees, how would they be able to break and crop thirty acres of land in just three years so they could gain title? For those who did not have a stream or freshwater lake nearby, how would they obtain water for themselves, their families, and their stock? How was it possible to survive under such adverse conditions?

Even though obstacles existed, many settlers adapted to the situation in which they found themselves. For those who had no trees, they used the natural sod they found on their land. By cutting the sod into bricks, they were able to pile these sod pieces on top of one another and build a home and stables for their animals. For those who had trees on their property, they were able to cut down the trees, strip

them of their branches and bark, and use the logs for building. As for collecting water, some settlers dug wells, others relied on drinking slough water, while others travelled many miles on stoneboats to collect barrels of water from a stream.

This ability to adapt and alter the way things were done was stated expressively by one settler, John Peacock, who recounted the life of his family when they became homesteaders in 1912 on the Saskatchewan prairie:

We were 65 miles from a railroad. Mother, Father and eight children. I was the oldest at 17. The youngest was nine months. We just had enough money to pay our tickets on the freight on a car of settlers' effects from Ontario and when we landed on the homestead, we were broke. What we lacked in cash we made up with enthusiasm. Never once did we think of going back to Ontario. We adapted ourselves to the country. We gathered cow chips for fuel for the summer. In the winter we hauled brush from the sand hills 12 miles away or bigger wood from the river 20 miles away. When other supplies ran out, we ate boiled wheat or porridge made from ground wheat. We did not have a power grinder so we ground our wheat in the coffee grinder. We used to pass it around from one to the other at night to get enough ground for porridge in the morning. We were short of meat for the first year or two. We always carried a gun and many a jack rabbit and prairie chicken came home to be stewed or roasted. We were 65 miles from a doctor for the first few years, but we never needed one. If one of us was not feeling well, father would put his hand on our forehead. If he felt a little fever, he would say to mother "Give him a dose of castor oil, that will fix him" and it usually did.

Along with the ability to adapt, a settler and his family also had to be ready to work hard, as another aspect of homesteading life was the breaking and cropping of land in the spring, as well as harvesting in the fall. Such work was labour-intensive, with each task having to be done in a quick and efficient manner. Normally, one person alone could not do the work. Rather, all hands were expected to take part. In fact, a settler relied heavily on his family members, particularly his wife and children, to help him with the fieldwork. Edith Stilborne stated, "We all helped with the farming operations. My brother, who was five when we came from England in 1883, helped with harrowing when he was eight, before he could guide the oxen to turn them, mother used to help him turn around at the ends of the row." Koozma Tarasoff remarked on the hard work done not only by his wife and children but also by his elderly mother. He wrote, "Two boys, wife and mother helped with the farming operations. My wife and sons helped me on the field binder work, threshing, and plowing." Charles Bray also acknowledged how all of his family members took part in their homesteading operation: "We had a large family and all were good helpers on the farm." George Hickley remembered how his wife helped with "haying and stooking sheaves when man help was not available. She also helped milk cows during busy times."

From time to time, even neighbours stopped by to lend a hand or share their farm equipment. Thomas Bates said, "Farmers worked alone, but showed the greatest kindliness to each other by lending their machinery, horses and milk cows without charge." James Cooper remembered one family who was particularly helpful: "The Cannon family were the real pioneers of this district as they helped out the first farming settlers by supplying them with potatoes, garden plants and shrubs, horses and cattle." George Hickley referred to the community spirit of the homesteaders: "We worked together and helped each other sometimes with the [building] of shacks and stables. To exist was quite a hard struggle in those early days."

Just as there were times of hardship and adversity being a homesteader in the province's early years, there were periods when settlers were able to enjoy the company of friends and neighbours. Greeting each other on the trails, meeting in town, going visiting on a Sunday afternoon, taking part in dances and skating parties or picnics, and celebrating those who were newly married with chivarees all appealed to those who worked most of the year on their 160 acres of land. Taking time away from all the hard work would have been a luxury for many; however, a brief respite from the daily chores may well have been welcome from time to time.

While many settlers appreciated the social events in the community, they also took pleasure in the solitude and quietness of prairie life. N. Scott Branscombe stated, "The most wonderful experience in my early farming on my homestead and which I never can forget were the lovely mornings, the crisp air, and the sound of the prairie chickens. You felt like a million!" Simeon Hiltz also set out his feelings about homesteading. He said there were "heartaches, backaches, hardships, and loneliness" living on the land, but it was these shared characteristics that "helped to make a district and home which we would not want to leave." Like Simeon, W. S. Rattray could not leave the prairies either, having resided on them as a homesteader. In fact, he wrote the following poem, which illustrates the strong bond he had with the province.

SASKATCHEWAN

I arrived in Saskatchewan
Many years ago,
I've travelled over Canada
Thru summer heat and snow,
I've worked in lumber
 camps and mines,
I sailed the salty sea,
But now I'm heading home again
Saskatchewan for me.

I'll see the homestead once again,
Meet mother at the door
The meadowlark will greet me
As in the days of yore
Tis then I'll settle down for life
With friends who've stood the test
Of all the lands I've travelled
Saskatchewan is best.

I see the fields of waving grain
The cattle in the run
A tiger lily here and there
A noddin' in the sun
My heart is filled with rapture,
As my prairie home, I scan
The breaks are set, the
 train has stopped,
Back home Saskatchewan.

Saskatchewan became more than just a province for those immigrants and migrants who travelled many miles to homestead in the late 1800s and early 1900s. Not only did many settlers develop a love for the land and a fondness for being a Saskatchewanian but the province became a symbol to them, to their families, and to the generations who have followed, a symbol representing courage, bravery, daring, and nerve. It also stood for commitment, determination, and fortitude—all characteristics settlers and their families needed in order to survive. Through the perseverance and toil of these settlers, they were able to develop the land, but, more importantly, they created homes, communities, and community spirit. They crafted a Saskatchewan heritage, a long-lasting one that will be remembered by future generations. As remembered by George Harris, who was an elderly gentleman in the 1950s but had pioneered at the turn of the century,

We the pioneers enjoyed life, but it was not play. It was a struggle against very adverse conditions and we bravely carried on fighting difficulties and overcoming them. Many of those referred to have passed on to their reward, but I feel that they have left pleasant memories behind and the ones coming after will feel a debt of gratitude to those who bore the burden and heat of those early days which has helped to lay a good foundation for the prosperity of our community around us, and we pay tribute to their efforts, who during the last half century have made this community a worthy one.[1]

Author's Note

As noted earlier in the book, I have written a number of detailed journal articles using the Provincial Archives of Saskatchewan Pioneer Questionnaires. For a more extensive description of how settlers built soddies and log homes, see "Sod, Straw, Logs, and Mud: Building a Home on the Canadian Prairies, 1867–1914."[1] For more information on one-room schoolhouses, see "Slates, Tarpaper Blackboards, and Dunce Caps: One-Room Schoolhouse Experiences of Pioneer Children in Saskatchewan, 1878–1914."[2] For a more in-depth analysis of medical practices, refer to "Flax Seed, Goose Grease, and Gun Powder: Medical Practices by Women Homesteaders in Saskatchewan (1882–1914)."[3] The push and pull factors of immigrants leaving their mother countries and moving to Saskatchewan is discussed in "Steerage, Cattle Cars, and Red River Carts: Travelling to the Canadian Western Prairies to Homestead, 1876–1914,"[4] while details on settlers and their food consumption is discussed more extensively in "Jackfish, Rabbits, and Slough Water: Pioneer Diet on the Canadian Western Prairies."[5] It should also be noted that I have used excerpts from all of these journal articles in this book. For the three *Journal of Family History* articles mentioned above, Sage Publishing has published the definitive versions.

Endnotes

FOREWORD

1. Provincial Archives of Saskatchewan (PAS), SX-2.

PREFACE

1. Agreement dated November 24, 2015.

INTRODUCTION

1. In this book, "Saskatchewan" refers to the territory that became the province of Saskatchewan in 1905. Prior to 1905, the land was known as Rupert's Land and the North-West Territories.
2. For more information on the homestead regulations and fee, see the Dominion Lands Act, 1872 (Canada).
3. See Canada, Census and Statistics Office, Fifth Census of Canada, 1911, vol. I: Population (Ottawa: C. H. Parmalee, 1912), Tables V and VII.
4. The number and titles of each of the questionnaires are set out as follows.
 - No. 1: What Did Western Canadian Pioneers Eat?
 - No. 2: Pioneer Experiences, A General Questionnaire
 - No. 3: Pioneer Schools
 - No. 4: Pioneer Churches
 - No. 5: Pioneer Recreation and Social Life
 - No. 6: Pioneer Farming Experiences
 - No. 7: Pioneer Folklore
 - No. 8: Pioneer Health Survey
 - No. 9: Pioneer Housing
 - No. 10: Local Government
 - Christmas Questionnaire
5. For more detail on children and their experiences with homestead life, see Sandra Rollings-Magnusson, *Heavy Burdens on Small Shoulders: The Labour of Pioneer Children on the Canadian Prairies* (Edmonton: University of Alberta Press, 2009).

CHAPTER 1: A LAND OF OPPORTUNITY

1. K. N. Lambrecht, *The Administration of Dominion Lands, 1870–1930* (Regina: Canadian Plains Research Center, 1991).
2. For details on this economic depression, see Hans Rosenberg, "Political and Social Consequences of the Great Depression of 1873–1896 in Central Europe," *The Economic History Review* 13 (1943): 58–73.
3. Herman Ganzevoort, *A Bittersweet Land: The Dutch Experience in Canada, 1890–1980* (Toronto: McClelland & Stewart, 1988), 18.
4. After Sifton's term in office, Frank Oliver took over the position from 1906 to 1911. Oliver changed Sifton's immigration policy so fewer individuals would be accepted from Central and Eastern Europe. This change was implemented due to concerns relating to the increasing levels of racial degeneration within Canada. For more information, see Angus McLaren, "Stemming the Flood of Defective Aliens," in *The History of Immigration and Racism in Canada*, ed. Barrington Walker (Toronto: Canadian Scholar's Press, 2008), 189–204.
5. The United States National Archives and Records Administration, The Homestead Act of 1862, accessed May 1, 2015, http://www.archives.gov/education/lessons/homestead-act/.
6. See James Gray, *Boomtime* (Saskatoon: Western Producer Prairie Books, 1979), and Reg Whitaker, *Canadian Immigration Policy since Confederation* (Saint John, NB: Keystone Printing and Lithographing Ltd., 1991).
7. D. J. Hall, *Clifford Sifton*, Volume 1 (Vancouver: UBC Press, 1981).
8. Harvest excursions referred to two different kinds of events. On the one hand, the concept could refer to a railway company's practice of offering cheaply priced railway tickets to those who indicated an interest in purchasing railway-owned lands on the western prairies. On the other hand, the concept could pertain to the large number of men, primarily from the Maritimes, who would travel by train to the western prairies to help with the wheat harvest. This was seen as an opportunity for temporary/seasonal employment, but it also gave the men the chance to experience western living and perhaps register for a homestead themselves. See W. J. C. Cherwinski, "The Incredible Harvest Excursion of 1908," *Labour/Le Travailleur* 5 (Spring 1980): 57–79, and John Thompson, "Bringing in the Sheaves: The Harvest Excursionists, 1890–1929," *Canadian Historical Review* LIX, no. 4 (1978): 467–489.

9. For information on Jewish farming colonies in Saskatchewan, see H. Gutkin, *Journey into Our Heritage: The Story of Jewish People in the Canadian West* (Saskatoon: Jewish Historical Society of Western Canada, 1980).
10. For more information about pioneering and St. Peter's Colony in Muenster, Saskatchewan, see *Our Roots, The Legacy of St. Peter's Colony*, accessed May 4, 2013, http://www.ourroots.ca/e/toc.aspx?id=6058.
11. The Temperance Colony trail was a main transportation route that ran between Moose Jaw and Saskatoon. The elbow is located on the South Saskatchewan River.

CHAPTER 2: GETTING SETTLED

1. PAS, Accession No. 81-279, Delia Crawford, interview transcript, n.d.
2. Some settlers had cellars in their homes. Cellars were typically dug out before the house was built; however, dirt could also be removed during or after house construction. The cellars, which were reported being approximately six by eight feet in size, were covered with wooden hatches or trap doors.
3. PQ: File #416, Lena May Purdy.

CHAPTER 3: WORKING THE FIELDS

1. Lambrecht, *The Administration of Dominion Lands.*
2. PQ: File #2183, Lena May Purdy.
3. Shorts is a course flour.

CHAPTER 4: FEEDING THE FAMILY

1. PAS, File #A266, D. Gush, "Prairie Years, 1905–1909."
2. PAS, File #R-E624, Amy Arn, "Prairie Trails."
3. PAS, File #R-E3289, Kathleen Lennox Smith, "Memories of Kathleen Lennox Smith."
4. PAS, File #R-E445, F. M. Page, "A Few Reminiscences of Our Early Life in the North-west: Written for My Children."
5. PAS, File #581-36, Helen E. Regier, "My Grandmother and Her Family."
6. Provincial Archives of Alberta, Accession No. 77.39, E. McLeod File.
7. Regier, "My Grandmother and Her Family."
8. PAS, File #R-E446, Jessie Beckton, "Cannington Manor: A Tale of Early Settlement Life."
9. PAS, File #R-273, Mrs. F. B. Reilly, "Early Days in Moose Jaw, Saskatchewan."
10. Reilly, "Early Days in Moose Jaw."
11. PAS, File #X173, E. L. Olsen, "Memories Are Such Fragile Things."
12. PAS, File #A81, Wilhelmina Taphorn, "My Pioneer Days from 1906 to 1955."
13. PAS, File #R-E2880, Edith Caroline Stewart, "Dad and His Six Women."
14. Beckton, "Cannington Manor."
15. PAS #R-E157, Augustine Koett, "Pioneer Days."
16. PAS, #R-E514, Aaron Biehn, "Autobiography."

CHAPTER 5: HEALTH AND ILLNESS

1. According to the Mayo Clinic, "typhoid fever is caused by a virulent bacteria called Salmonella typhi. . . . The bacteria that causes typhoid fever spreads through contaminated food or water and occasionally through direct contact with someone who is infected." Accessed July 15, 2015, http://www.mayoclinic.org/diseases-conditions/typhoid-fever/basics/causes/con-20028553.
2. PQ: File #2682, Lena May Purdy.
3. *Census of Manitoba, 1885–86* (Ottawa: MacLean, Roger and Co., 1887); Canada, Census and Statistics Office, Fifth Census of Canada.
4. Canada, Census and Statistics Office, Fifth Census of Canada.
5. The first nurse-training program in Canada was not established until 1873 in St. Catharines in Ontario. Training expanded quickly to Toronto in 1881, Winnipeg in 1887, Medicine Hat in 1889, Regina in 1891, and Calgary in 1895. By 1900, twenty nursing schools were open in towns and cities along the transcontinental railway. See Martha Batson, Inez E. Welling, and Anne Slattery, *Pioneers of Nursing in Canada* (Montreal: The Canadian Nurses' Association, n.d.); PAS, File #R-E738, LaVerne Graham, "Autobiography"; Isabel M. Stewart and Anne L. Austin, *A History of Nursing: From Ancient to Modern Times, A World View*, Fifth Edition (New York: G. P. Putnam's Sons, 1962); Catherine Nunn Smith, "Marion Moodie: From Proper Lady to New Woman," *Alberta History* 49, no. 1 (2001): 16–20.
6. For a detailed history of hospital development in the prairie region from inadequate units established by the North West Mounted Police and the Canadian army during the 1885 Riel Rebellion to cottage hospitals and general-purpose hospitals founded in urban areas, see PAS, File #R-E2322, Joan Feather, "Hospitals in Saskatchewan in Territorial Days"; Elizabeth Domm, "Called to Duty: Medicare and Nursing Care at Saskatoon and Moose Jaw during the Northwest Rebellion in 1885," *Saskatchewan History* 58, no. 2 (2006): 15–23; and Malcolm G. Taylor, *Insuring National Health Care: The Canadian Experience* (Chapel Hill: University of North Carolina Press, 1990).
7. The 1901 T. Eaton Company Limited Catalogue (Toronto: The Musson Book Company, 1970).
8. PQ: File #2657, Harry Martyn.
9. PQ: File #2519, Charles Davis.

CHAPTER 6: THE ONE-ROOM SCHOOLHOUSE

1. According to Gerald Friesen, in his 1987 publication, *The Canadian Prairies: A History* (Toronto: University of Toronto Press), these school lands were "to be auctioned at the best available price and the proceeds set apart for the purposes of education" (184). In other words, the monies received from the sale of this land would be used in financing the construction of schools.
2. PAS, File #C130, Robert H. Wooff, interview by D'Arcy Hande.
3. Eaton Company Limited Catalogue.
4. PQ: File #1507, Lawrence Kelly.
5. PQ: File #1399, Esther Bailey; PQ: File #1364, Gladys Saloway; PQ: File #1446, Frederich Humphrey; and PQ: File #1376, James Entwistle.
6. A. Gagnon, "Our Parents Did Not Raise Us to Be Independent: The Work and Schooling of Young Franco-Albertan Women, 1890–1940," *Prairie Forum* 19, no. 2 (1994): 169–188.
7. PAS, File #X-119, M. Matheson, "Looking Back over My Fifty Years in Saskatchewan."
8. PQ: File #1254, Marion Anderson.
9. PAS, File #A209, Mrs. J. Larmour, "Recollections of a Pioneer Schoolma'am."
10. M. Prokop, "Canadianization of Immigrant Children: Role of the Rural Elementary School in Alberta, 1900–1930," *Alberta History* 37, no. 2 (1989): 1–10.
11. In his study of the history of the Canadian prairies, Gerald Friesen noted that the "lessons of the education system in each province were consciously directed at the creation of a new British-based western Canadian race. Students memorized the classic verses and songs of British imperialism," and "history classes were built around an appreciation of British history and parliamentary government." Friesen also noted that all schools were required to fly the Union Jack. However, some concessions were made. In Saskatchewan, for example, public schools were permitted to give instruction in another language for one hour at the end of the school day. See Friesen, *The Canadian Prairies*, 346.
12. PQ: File #1533, Mrs. M. J. Seeman.
13. PQ: File #1336, Lewis Anderson.
14. PQ: File #1437, S. E. Clack.
15. PQ: File #1367, Edward Watson.
16. E. S. McLeod, "School Days at Willow Brook," *The Beaver* 312, no. 2 (1981): 45.
17. PQ: File #1271, Maggie M. Whyte.
18. McLeod, "School Days at Willow Brook."

CHAPTER 7: FUN AND FESTIVITIES

1. PQ: File #2400, Lena May Purdy.
2. PQ: File #2124, Mrs. A. B. Bjerke.
3. PQ: File #1953, Mrs. H. J. Kenyon.
4. PQ: File #1906, Lena May Purdy.
5. PQ: File #1964, M. J. Downie.
6. PQ: File #2168, Sydney Steward.
7. PQ: File #2458, Sadie McCallum.
8. PQ: File #2510, Herbert J. Abrams.
9. PQ: File #2636, Mrs. J. M. Telfodd.
10. PQ: File #2475, George Gerwing.

CHAPTER 8: LAYING A GOOD FOUNDATION

1. PAS, File #623, George A. Harris, "Some History and Pioneer Experiences of Heward, Saskatchewan from Its Settlement in 1900 to 1914."

AUTHOR'S NOTE

1. Sandra Rollings-Magnusson, "Sod, Straw, Logs, and Mud: Building a Home on the Canadian Prairies, 1867–1914," *Journal of Family History* 40, no. 3 (2015): 399–423.
2. Sandra Rollings-Magnusson, "Slates, Tarpaper Blackboards, and Dunce Caps: One-Room Schoolhouse Experiences of Pioneer Children in Saskatchewan, 1878–1914," *Prairie Forum* 35, no. 1 (Spring 2010): 21–52.
3. Sandra Rollings-Magnusson, "Flax Seed, Goose Grease, and Gun Powder: Medical Practices by Women Homesteaders in Saskatchewan (1882–1914)," *Journal of Family History* 33, no. 4 (October 2008): 388–410.
4. Sandra Rollings-Magnusson, "Steerage, Cattle Cars, and Red River Carts: Travelling to the Canadian Western Prairies to Homestead, 1876–1914," *Journal of Family History* 39, no. 2 (April 2014): 140–174.
5. Sandra Rollings-Magnusson, "Jackfish, Rabbits, and Slough Water: Pioneer Diet on the Canadian Western Prairies," *Prairie Forum* 37, no. 2 (Fall 2012): 211–254.

Bibliography

MANUSCRIPT COLLECTIONS

Arn, Amy. "Prairie Trails." Provincial Archives of Saskatchewan.

Beckton, Jessie. "Cannington Manor: A Tale of Early Settlement Life." Provincial Archives of Saskatchewan.

Bibbing, Winnifred Theresa. "Autobiography." Provincial Archives of Saskatchewan.

Biehn, Aaron. "Autobiography." Provincial Archives of Saskatchewan.

Crawford, Delia. Interview. Transcript, n.d. Provincial Archives of Saskatchewan.

Feather, Joan. "Hospitals in Saskatchewan in Territorial Days." Provincial Archives of Saskatchewan.

Graham, LaVerne. "Autobiography." Provincial Archives of Saskatchewan.

Gush, D. "Prairie Years, 1905–1909." Provincial Archives of Saskatchewan.

Harris, George A. "Some History and Pioneer Experiences of Heward, Saskatchewan from Its Settlement in 1900 to 1914." Provincial Archives of Saskatchewan.

Koett, Augustine. "Pioneer Days." Provincial Archives of Saskatchewan.

Larmour, Mrs. J. "Recollections of a Pioneer Schoolma'am." Provincial Archives of Saskatchewan.

Matheson, M. "Looking Back over My Fifty Years in Saskatchewan." Provincial Archives of Saskatchewan.

McLeod, E. File. Provincial Archives of Alberta.

Men, Lai. Homestead File. Provincial Archives of Saskatchewan.

Noon, Lai. Homestead File. Provincial Archives of Saskatchewan.

Olsen, E.L. "Memories Are Such Fragile Things." Provincial Archives of Saskatchewan.

Page, F.M. "A Few Reminiscences of Our Early Life in the North-west: Written for My Children." Provincial Archives of Saskatchewan.

Pioneer Questionnaires. Provincial Archives of Saskatchewan.

Regier, Helen E. "My Grandmother and Her Family." Provincial Archives of Saskatchewan.

Reilly, Mrs. F.B. "Early Days in Moose Jaw, Saskatchewan." Provincial Archives of Saskatchewan.

Sing, Wong. Homestead File. Provincial Archives of Saskatchewan.

Smith, Kathleen Lennox. "Memories of Kathleen Lennox Smith." Provincial Archives of Saskatchewan.

Stewart, Edith Caroline. "Dad and His Six Women." Provincial Archives of Saskatchewan.

Taphorn, Wilhelmina. "My Pioneer Days from 1906 to 1955." Provincial Archives of Saskatchewan.

Veevers, William. Homestead File. Provincial Archives of Saskatchewan.

Wooff, Robert H. Interview by D'Arcy Hande. Transcript, n.d. Provincial Archives of Saskatchewan.

SECONDARY SOURCES

The 1901 T. Eaton Company Limited Catalogue. Toronto: The Musson Book Company, 1970.

Bancroft, Jessie H. *Games for the Playground, Home, School and Gymnasium.* New York: The MacMillan Company, 1913.

Batson, Martha, Inez E. Welling, and Anne Slattery. *Pioneers of Nursing in Canada.* Montreal: The Canadian Nurse's Association, n.d.

Canada. Census and Statistics Office. *Fifth Census of Canada, 1911.* Vol. I: Population. Ottawa: C. H. Parmalee, 1912.

Census of Manitoba, 1885–86. Ottawa: MacLean, Roger and Co., 1887.

Cherwinski, W.J.C. "The Incredible Harvest Excursion of 1908." *Labour/Le Travailleur* 5 (Spring 1980): 57–79.

"Cooking Tips." *The Nor-West Farmer*, April 1898.

"Cooking Tips." *The Nor-West Farmer*, May 1898.

"Cooking Tips." *The Nor-West Farmer*, November 1885.

Dominion Lands Act, SC 1872, c 31.

Domm, Elizabeth. "Called to Duty: Medicare and Nursing Care at Saskatoon and Moose Jaw during the Northwest Rebellion in 1885." *Saskatchewan History* 58, no. 2 (2006): 15–23.

Duncan, Dorothy. *Canadians at Table: Food, Fellowship, and Folklore: A Culinary History of Canada*. Toronto: Dundurn Press, 2006.

Friesen, Gerald. *The Canadian Prairies: A History*. Toronto: University of Toronto Press, 1987.

Gagnon, A. "Our Parents Did Not Raise Us to Be Independent: The Work and Schooling of Young Franco-Albertan Women, 1890–1940." *Prairie Forum* 19, no. 2 (1994): 169–188.

Ganzevoort, Herman. *A Bittersweet Land: The Dutch Experience in Canada, 1890–1980*. Toronto: McClelland & Stewart, 1988.

Govia, Francine, and Helen Lewis. *Blacks in Canada*. Edmonton: Harambee Centres Canada, 1988.

Gray, James. *Boomtime*. Saskatoon: Western Producer Prairie Books, 1979.

Gutkin, H. *Journey into Our Heritage: The Story of Jewish People in the Canadian West*. Saskatoon: Jewish Historical Society of Western Canada, 1980.

Hall, D.J. *Clifford Sifton, Volume 1*. Vancouver: UBC Press, 1981.

Lambrecht, K. N. *The Administration of Dominion Lands, 1870–1930*. Regina: Canadian Plains Research Center, 1991.

McLaren, Angus. "Stemming the Flood of Defective Aliens." In *The History of Immigration and Racism in Canada*, edited by Barrington Walker, 189–204. Toronto: Canadian Scholar's Press, 2008.

McLeod, E.S. "School Days at Willowbrook." *The Beaver* 312, no. 2 (1981): 40–46.

Morton, James. "The Prairie Fire." *The Nor-West Farmer*, October 20, 1900.

"Oatmeal Drink Recipe." *The Nor-West Farmer*, July 20, 1901.

Prokop, M. "Canadianization of Immigrant Children: Role of the Rural Elementary School in Alberta, 1900–1930." *Alberta History* 37, no. 2 (1989): 1–10.

Reed, Alonzo. *Word Lessons: A Complete Speller*. New York: Effingham, Maynard & Co., 1890.

Rollings-Magnusson, Sandra. "Flax Seed, Goose Grease, and Gun Powder: Medical Practices by Women Homesteaders in Saskatchewan (1882–1914)." *Journal of Family History* 33, no. 4 (October 2008): 388–410.

———. *Heavy Burdens on Small Shoulders: The Labour of Pioneer Children on the Canadian Prairies*. Edmonton: University of Alberta Press, 2009.

———. "Jackfish, Rabbits, and Slough Water: Pioneer Diet on the Canadian Western Prairies." *Prairie Forum* 37, no. 2 (Fall 2012): 211–254.

———. "Slates, Tarpaper Blackboards, and Dunce Caps: One-Room Schoolhouse Experiences of Pioneer Children in Saskatchewan, 1878–1914." *Prairie Forum* 35, no. 1 (Spring 2010): 21–52.

———. "Sod, Straw, Logs, and Mud: Building a Home on the Canadian Prairies, 1867–1914." *Journal of Family History* 40, no. 3 (2015): 399–423.

———. "Steerage, Cattle Cars, and Red River Carts: Travelling to the Canadian Western Prairies to Homestead, 1876–1914." *Journal of Family History* 39, no. 2 (April 2014): 140–174.

Rosenberg, Hans. "Political and Social Consequences of the Great Depression of 1873–1896 in Central Europe." *The Economic History Review* 13 (1943): 58–73.

Sears Roebuck Catalogue. New York: Crowne Publishers, 1902.

Shephard, R. Bruce. *Deemed Unsuitable*. Toronto: Umbrella Press, 1997.

Smith, Catherine Nunn. "Marion Moodie: From Proper Lady to New Woman." *Alberta History* 49, no. 1 (2001): 16–20.

Stewart, Isabel M., and Anne L. Austin. *A History of Nursing: From Ancient to Modern Times, A World View, Fifth Edition*. New York: G. P. Putnam's Sons, 1962.

Taylor, Malcolm G. *Insuring National Health Care: The Canadian Experience*. Chapel Hill: University of North Carolina Press, 1990.

Thompson, John. "Bringing in the Sheaves: The Harvest Excursionists, 1890–1929." *Canadian Historical Review* LIX, no. 4 (1978): 467–489.

"Uses Snow in Cakes." *The Grain Grower's Guide*, May 7, 1913.

Valverde, Mariana. "Racial Purity, Sexual Purity, and Immigration Policy." In *The History of Immigration and Racism in Canada*, edited by Barrington Walker, 175–188. Toronto: Canadian Scholar's Press, 2008.

Whitaker, Reg. *Canadian Immigration Policy since Confederation*. Saint John, NB: Keystone Printing and Lithographing Ltd., 1991.

Pioneer Questionnaire Participants

Abrams, Herbert J., File #2510

Adler, Winnifred, File #2123

Aikenhead, Amanda, File #2216, File #3013

Allan, John MacDonald, File #884

Almond, George, File #2258

Anderson, Eloise, File #1967, File #2462

Anderson, Lewis, File #1336

Anderson, Marion, File #1254, File #1891, File #2387

Anderson, Mrs. Marion, File #388

Anderson, Mary K., File #45

Andres, John J., File #522

Anslow, H. A., Christmas Files

Archer, Charles, File #2540

Archer, Mrs. Charles, File #239

Archibald, E., File #89

Atkings, Christopher Ormond, File #887

Bailey, Esther, File #1399

Baines, Frank, File #391, File #1892, File #2177, File #2388

Baines, Fred, File #12, File #1893, File #2389

Ballantine, George, File #2

Barrie, James, File #3104

Barrie, Jason, File #2541

Barschel, J. F. Paul, File #545

Bates, Thomas Brehon, File #2243

Bayles, Richmond Ewart, File #2204

Bigg, F. J., Christmas Files

Birkett, Mary, File #2024

Bishop, Mary, File #24

Bjerke, Mrs. A. B., File #2124

Bloodoff, Mike William, File #2211

Bonas, Joseph, File #676

Borwick, Mrs. E., File #60

Bowering, Edgar Alfred, File #524

Branscombe, N. Scott, File #677, File #2244

Bray, Charles C., File #2390

Bray, Charles Cantlon, File #2178, File #2390, Christmas Files

Brazier, William, File #2091

Bridle, Emily, File #3073

Brownridge, Thomas R., File #1936

Bruce, George Fred Wallis, File #750, File #2245

Buckingham, Nellie, File #1112

Burn, Thomas William, File #605

Butterworth, Bertram, File #1084

Cahoon, William, File #1688

Cairns, Robert, File #3032

Cameron, Alexander, File #642

Cameron, Mrs. Jessie Elizabeth, File #91, File #1971, File #2224

Campbell, David Livingstone, File #527

Campbell, Elsie, File #151

Campbell, Mrs. Elsie S. (Taylor), File #829

Cardwell, Phyllis, File #1114

Carmichael, Mrs. W. B., File #2689

Carmichael, Mrs. W. B, File #2698

Carson, Harvey, File #2517

Carson, Harvey Richard, File #2261

Carson, Wm. P. (Bill), File #753

Chase, Robert, File #2466

Chipperfield, Sydney, File #1894, File #2179

Christian, Mrs. Ada, File #78

Christian, Mrs. Ada Evelyn (Morrison), File #397

Clack, S. E., File #1437

Cobb, Wilfred, File #831

Cooper, James, File #2230, File #3033

Cossar, Mary Elizabeth, File #2985

Cossar, Mrs. Hugh, File #1301, File #1939

Covey, Nathan, File #2199

Cowell, John, File #2288

Davis, Charles, File #1407, File #1886, File #2029, File #2519

Davis (nee Clark), Mary Elizabeth, File #398

Day, Mrs., File #3166

Day, Richard, File #2604

de Balinhard, Mrs. Annie, File #393, File #2391

de Balinhard, William S., File #367

deSion, Sr. Marie Fabian, File #800

Deusterbeck, Martin, File #513

Dickey, John Bates, File #2200

Diggle, Lottie, File #1, File #2945

Diggle, Mrs. Lottie Clark, File #2180, File #2676

Dowling, Jemima, File #479

Downey, Alice Wilhelmina, File #2350

Downie, M. J., File #1964

Downie, Mrs., File #2461

Drever, Thomas, File #2351

Duncan, Elizabeth Margaret, File #1911, File #2187

Dunlop, Fannie, File #1975

Dunn, Mayfred, File #3191

Ehrlich, Herman, File #908

Elderton, Albert, File #1086

Elderton, Albert Edward, File #2338

Ellwood, Samuel, File #2233

Emery, Isaac Selby, File #607

Entwistle, James, File #1376
Entwistle, Mrs. J., File #137
Evans, John, File #50
Evans, William, File #533, File #2986
Fennell, Mrs. Flora, File #2440
Ferguson, Susie Louella, File #1457
Fletcher, Lewis, File #2035
Ford, Harry, File #687, File #2234
Franks, Mrs. Sorine, File #1179
Fraser, W. O., File #99
Frazer, Mr. G., File #515
Gange, W., Christmas Files
Gange, William, File #1949
Gardner, Edwin, File #766
Gauthier, François, File #1411
Geddes, Mrs. Alice Gertrude, File #367
Gerwing, George, File #2475
Gibson, Alfred Reginald, File #610, File #2217
Goldsmith, Mrs. Maud, File #2405
Goldsmith, Mrs. Esther, File #1912
Goldsmith, Mrs. Esther Maud, File #2688
Gray, James, File #914
Griffiths, Ernest Wynn, File #915
Gubberud, Mrs. Gust, File #3081
Gudmundson, G. F., File #841
Hall, Nelson, File #41
Hall, Stephen Sneden, File #693
Hancheroff, Wasil N., File #2268

Hargarten, William, File #182
Harrigan, Elizabeth, File #136
Harris, George A., File #623
Harrison, Herbert, File #3038
Hartwell, George, File #2174
Hartwell, George Arthur, File #371
Haydon, Gilbert, File #2117
Helstrom, Detlof Edward, File #844
Hickley, Stanley George, File #2353
Hill, Mrs. Jean, File #2151
Hiltz, Simeon, File #2317
Hoffer, Clara, File #2814
Hoffer, Mrs. Clara, File #2610
Homersham, Elizabeth Rose, File #572
Hosie, William Alexander, File #1232
Howes, Ruddy, File #220
Hubbard, Ellen, File #60, File #561
Hubbard, Mrs. Ellen, File #1950
Humphrey, Frederick, File #1446
Humphrey, Frederick William, File #929
Irvine, Howard, File #2318
Irving, Norman, File #81
Jameson, Ethel, File #111
Jameson, Ethel Etta, File #625
Jameson, Mrs. Ethel E., File #2480
Jameson, Mrs. John, File #64
Jamieson, Edwin, File #404
Johnson, Mrs. George, File #43
Jordens, Marie, File #1915

Jordens, Mary, File #25, Christmas Files
Jordens, Mrs. Mary, Christmas Files
Kajewski, Mary Edith Alicia, File #590
Kelly, Arthur George, File #1058
Kelly, Lawrence, File #1507, File #2119
Kelly, Mrs. Arthur, File #1990
Kenyon, Mrs. Florence Amy, File #569
Kenyon, Mrs. H. J., File #1953
Kenyon, William, File #851
Keyser, Mrs. J. F., File #2733
Kidd, Mrs. James, File #247
Kirkby, Joseph Francis, File #612
Knaus, Mrs. John C., File #937, File #2066
Krischke, Francis, File #3086
Kusch, Frank M., File #406, File #2394
Kusch, Frank Michael, File #2181
Lake, Mrs. T., Christmas Files
Lang, Mrs., File #116
Langgard, Eric, File #2272
LaRose, Mrs. Flora May Winn, File #708
Law, Mrs. Ethel Jane, File #939
Line, Ernest P., File #1061
Lloyd, Richard, File #1820
LoRose, Lora, File #1991
Loyns, Richard H., File #1418
Ludlow, Ernest, File #223, File #2581
Ludlow, R. Ernest, File #853, File #1419
Luttman-Johnson, Kenelm, File #931

MacFarlane, Lila (Mrs. Silas MacFarlane), File #2109
Maginnes, David, File #190
Mann, Alfred, File #2071
Marriott, George Parks, File #2330
Martyn, Harry, File #2657
May, Sydney, File #2168, File #2658
McCallum, Sadie E, File #2458
McChesney, John, File #1383, File #1702, File #2010
McConwell, George, File #1137
McDonald, Norman, File #1903, File #2948
McLellan, Margaret, File #413, File #1905
McMannes, Margaret, File #3119
McWilliams, Sam, File #22
McWilliams, Samuel Henry, File #2189
Meek, Lottie, Christmas Files
Miles, Lillian, File #1920, File #2194
Miles, Mrs. R. (Lillian), File #25, File #2696
Mitchell, Eva, File #2072
Mohl, Joseph, File #2110
Mohl, Joseph G., File #1064
Monaghan, William, File #3063
Moorhouse, Mrs. D. A., File #2649
Moorhouse, Myrtle, File #2155
Morhart, Mrs. Regina, File #858
Neal, Eric, File #199, File #859, File #2520

Nelson, Mrs., File #283

Olmstead, Millie, File #1277

Olmstead, Milly, File #34

Olmstead, Mrs. E. Howard, File #2409

Orth, Mrs. William, File #230

Otterson, Misella, File #2562

Payne, J. B., File #286

Peacock, John Wesley, File #2375

Pearse, Spencer, File #57

Pepper, Mrs. George, File #288

Persson, Godfrey, File #1946

Pickard, Mrs. Charles, File #2013

Pickard, Mrs. Charles George, File #789

Potts, John, File #566

Prafke, Ida M., File #1546

Pugh, Mrs. L. B., File #231

Purdy, Lena May, File #16, File #416, File #1906, File #2183, File #2400, File #2682, Christmas Files

Rattray, W. S., Christmas Files

Rattray, Wellwood, File #31, File #1924

Reidpath, Allan, File #1530

Rice, William, File #3169

Riley, Alfred Julian, File #794

Riley, Charles, File #2504

Robertson, Mrs. Frank, File #1981

Rogers, Hilda, File #3123

Salamon, Andrew, File #233, File #963

Saloway, Benjamin, File #3044

Saloway, Gladys, File #1364, File #1994

Sanderson, Robert, File #2385

Sargent, Charles E., File #2157

Sargent, Charles Evans, File #1850, File #2650

Seeman, Mrs. H. J., File #2141

Seeman, Mrs. M. J., File #1533

Sentance, Ethel, File #325

Sentence, Clarence, File #3160

Shepherd, George, File #1812

Sinclair, Marie, File #728

Singleton, John Milton, File #1194

Smith, Kenneth, File #3094

Smith, Margaret, File #1890

Smith, Mrs. Margaret, File #969

Spencer, Mrs. N. H., File #235

Spratt, Wava, File #971

St. John, Elias, File #2599

Stapleton, Philip, File #2532

Steward, Sidney, File #2506

Stewart, Mrs. Clarissa Antoinette, File #731

Stilborne, Edith, File #18, File #1907, File #2184, File #2953

Stilborne, Edith Mary (Franks), File #2684

Stirling, Kate, File #311

Stirling, Kate Belle, File #599

Stratychuk, Jacob, File #3030

Stueck, Harriet May, File #2415

Tait, Andrew, File #972

Taphorn, Minnie, File #2079

Tarasoff, Koozma John, File #600, File #2215, File #2454, Christmas Files

Taylor, Mrs. Harvey, File #2486

Taylor, Winnifred, File #121, File #2240

Teece, Mrs. Harry, File #2694

Telfodd, Gertrude Steinhoff, File #2636

Telford, Mrs. J. M., File #2636

Theissen, John S., File #2533

Therens, Mrs. Susan, File #1236

Thomas, Lewis, Christmas Files

Thompson, Rosanne, File #53

Thomson, Percy, File #2572

Tilford, Arthur, File #2228

Tower, Courtney Leigh, File #876

Travey, Mrs. Hugh, File #236

Tucker, George S., File #1430

Tucker, Mrs. George, File #1430, File #2052

Tucker, Susan, File #163

Tucker, Mrs. Susan T., File #2052

Tulloch, James Davidson, File #577, File #1956, File #2208

Upton, Wanda, File #327

Veitch, Andrew M., File #735

Vicars, William George, File #386

Vickar, Sam, File #976

Wallace, Rachel M., File #1163

Watson, Edward, File #1367

Wheeler, Arthur James, File #209, File #2312, File #2352

White, Ellen Elizabeth, File #601

Whyte, Mrs. Maggie M., File #1271, File #2401, File #2685, Christmas Files

Widdess, Robert, File #2955

Widdess, Robert Webster, File #2186

Wilmot, Edward, File #880

Wilson, Alwyn, File #123

Wilson, Frank, File #2242

Wilson, John, File #2639

Wilson, Joseph C., File #815, File #2255

Wilson, Mrs. Robert, File #543, File #2203

Winder, Harry William, File #668

Witt, Windsor Charles, File #739

Wood, Robert Golder, File #544

Woodward, John, File #1432, File #2093

Wyman, Mrs. Lyle, File #1555

Young, Catherine, File #122

Young, Herbert C., File #881

Zacharias, John, File #3003

SANDRA ROLLINGS-MAGNUSSON is the author of *Heavy Burdens on Small Shoulders: The Labour of Pioneer Children on the Canadian Prairies* and is an associate professor with the Sociology Department at MacEwan University. She lives in Edmonton.